IMAGES
of America

EARLY LAKEWOOD

IMAGES
of America

EARLY LAKEWOOD

Robert and Kristen Autobee
with Lakewood's Heritage Center

ARCADIA
PUBLISHING

Published by Arcadia Publishing
Charleston, South Carolina

Library of Congress Control Number: 2010941644

For all general information, please contact Arcadia Publishing:
Telephone 843-853-2070
Fax 843-853-0044
E-mail sales@arcadiapublishing.com
For customer service and orders:
Toll-Free 1-888-313-2665

Visit us on the Internet at www.arcadiapublishing.com

To Joan Howard, archivist, historian, friend, and matchmaker

CONTENTS

ACKNOWLEDGMENTS

We gratefully acknowledge Lakewood's Heritage Center and the city of Lakewood for the use of many photographs of our hometown. These images are credited throughout the book as belonging to Lakewood's Heritage Center. The hospitable assistance of historians, natives, and longtime residents was all invaluable, and we personally thank Lyle Miller; the Rittenhouse, the Milne and O'Kane families; Christopher J.J. Thiry of the Arthur Lakes Library; the Colorado School of Mines; Daisy Koffman Masoner; and Joe Craighead for their collaboration. Kenton Forrest from the Colorado Railroad Museum provided encouragement and found just the right images of trains and trolleys. Dr. Jeanne Abrams of the Beck Archives, Coi Drummond of the Denver Public Library, and Eric Bittner of the Rocky Mountain Region of the National Archives were helpful and gracious. Lastly, we say thank you to Philip, Chris, and Ryan Candela from Mountain States Imaging for digitizing the photographic collection at Lakewood's Heritage Center—our past has never looked so good.

INTRODUCTION

There was never a Lakewood, Colorado—at least not until the 1969 incorporation. There was Maple Grove, Washington Heights, Bear Creek, Mountair, Montana, Kendalvue, Bancroft, Vasquez, Daniels Park, and two Lakewoods. These are only some of the communities located in the 40-plus square miles that encompass today's Lakewood. The comment that Lakewood suffers from an identity crisis is often heard, and it is blamed on the city's gradual evolution from a handful of neighborhoods. It is also attributed to the absence of a recognized, cohesive downtown. City officials at the end of the 20th century attempted to create a downtown Lakewood through planned development. But such developments of the new urbanism lacked a feeling of permanence, pride of place, and history.

There were competing visions of what Lakewood was or would become in each period of the city's history. Before incorporation, the pleasantly named communities mentioned above were considered part of Denver, Golden, or Edgewater, or simply in Jefferson County. In the late 19th century, three entrepreneurs subdivided a patch of farmland adjacent to Denver and named their plat Lakewood. This 1889 plat was not the first division of farmland into city lots, and it failed as a planned development. However, the community became a fine streetcar suburb with carefully planned streets, parks, and schools. This Lakewood was adjacent to the Denver Interurban trolley line. It was convenient for gentlemen who worked in Denver but wanted their wives and children to have the benefits of country living.

Just to the west, a very different view of community, work, and home life was developing. An 1891 application to establish a post office at West Colfax Avenue and Lakewood Road (today's Carr Street) described a new village consisting of a factory, 100 settlers, and an anticipated 400 more in two years. This post office was to be named Lakewood. The factory was later destroyed by fire. In the 20th century, Lakewood was both a suburb of Denver and a community of farmers who tried to find ways to stop the encroaching city, but Lakewood was developing into a town with its own identity. Gradually, during the early 20th century, the population increased beyond the initial vision of the first two Lakewoods. By the 1930s, the community had grown beyond a cluster of neighborhoods; a local newspaper referred to the intersection of West Colfax and Wadsworth Avenues as "the Busy Corner" and "the Business Center of Lakewood."

Beyond any perceived identity crisis is a community's rich, complex, and varied history. Between the time that Leonard Sims filed his homestead proof in 1866 and the end of World War II in 1945, the city today called Lakewood was several small farming, factory, and suburban communities recognized by their school's name, voting precinct, most prominent settler, or named plat.

By 1945, the ongoing growth of automobile- and tourism-related businesses along West Colfax, Alameda, and West Mississippi Avenues and the influx of wartime munition plant workers and their families created an environment that finally began to blur the lines between those small communities.

World War II gave Lakewood a new self-perception. For the first time, there was talk of incorporation as a city. The following traces Lakewood's earliest residents.

One

FIVE MILES FROM DENVER

LAKEWOOD'S EARLIEST RESIDENTS

Before Lakewood was a name on a map, native groups hunted, gathered, and lived on the land in the shadow of the Rocky Mountains' foothills. Colorado Archaeological Society–led digs at the Ken-Caryl Ranch south of Lakewood have uncovered pottery and other artifacts of the Woodland and Archaic Indian cultures from 10,000 BC to 800 AD.

In the late 1850s, gold-seekers came to the banks of Cherry Creek in Denver. Confronted with the futility of prospecting, the first homesteaders west of Denver were speculators, not pioneers. Those who decided to purchase land and build a life were later known as "fifty-niners."

Some of the earliest homesteaders—like Cason Howell from Missouri, Mexican-American War veteran Leonard Simms, and the young farmers William and Henry Lee—were typically the first generation of residents who established the first farms and businesses. In the summer of 1859, two brothers from New York, Joseph and William Hodgson, arrived in the collection of camps and cabins known as Denver. The Hodgsons soon acquired land in Jefferson County west of Denver. Between 1860 and 1864, they built a house from rocks taken from Bear Creek. Known as the Stone House, the structure still stands on South Estes Street (south of West Yale Avenue) and was the first building in Lakewood listed on the National Register of Historic Places.

For Lakewood's first pioneers, homesteading looked as quixotic as prospecting. There were no natural lakes, no ditches, and very few springs. The earliest attempts at irrigation did not stray far from the largest natural source of water in the vicinity, Clear Creek. Irrigation allowed some to find success growing apples and keeping bees, like Valentine Devinny did on his farm five miles west of Denver. The first plat featuring the name "Lakewood" entered Jefferson County records on July 1, 1889. Filed by three fifty-niners—William and Miranda Loveland and Charles Welch—Lakewood's initial boundaries were today's West Colfax Avenue south to West Tenth Avenue and from Harlan Street to the present Teller Street. Suitably christened as Lakewood, the town gradually developed a bucolic, agricultural character.

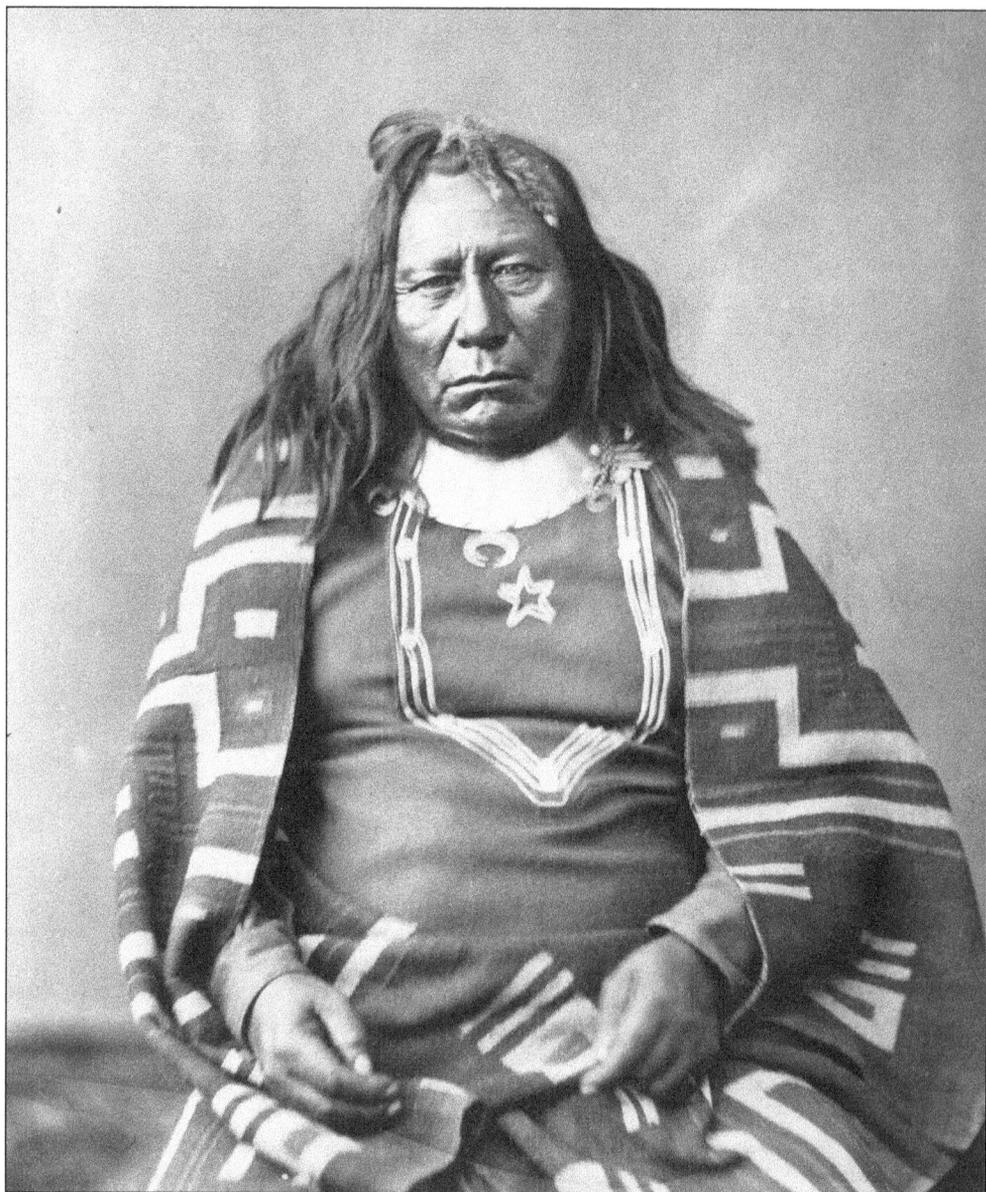

In the 1860s, the first wave of Euro-American settlers moved into Glenwood Canyon, northwest of Denver, and Ute chief Colorow launched raids on the newcomers from the Hogback Valley. Contemporary accounts stated that the chief's name was a misinterpretation of "Colorado." Colorow was an imposing figure, standing six feet tall and weighing 275 pounds. He and his tribe could not stem the gold fever that lured white newcomers to the mining camp of Denver and the hills to the west. The chief and members of his tribe would alternately threaten settlers or beg for food and clothing. After the 1879 Meeker Massacre, the US government exiled the Utes to the Uintah Indian Reservation along the Colorado-Utah border. In 1888, a posse of federal troops wounded Colorow in a skirmish. While attempting to recover from his wounds, Colorow developed pneumonia and died. A cave north of today's Ken-Caryl Ranch near the Hogback bears his name. (Courtesy of the Denver Public Library, Western History Collection, W.G. Chamberlin, Call No. X-19257.)

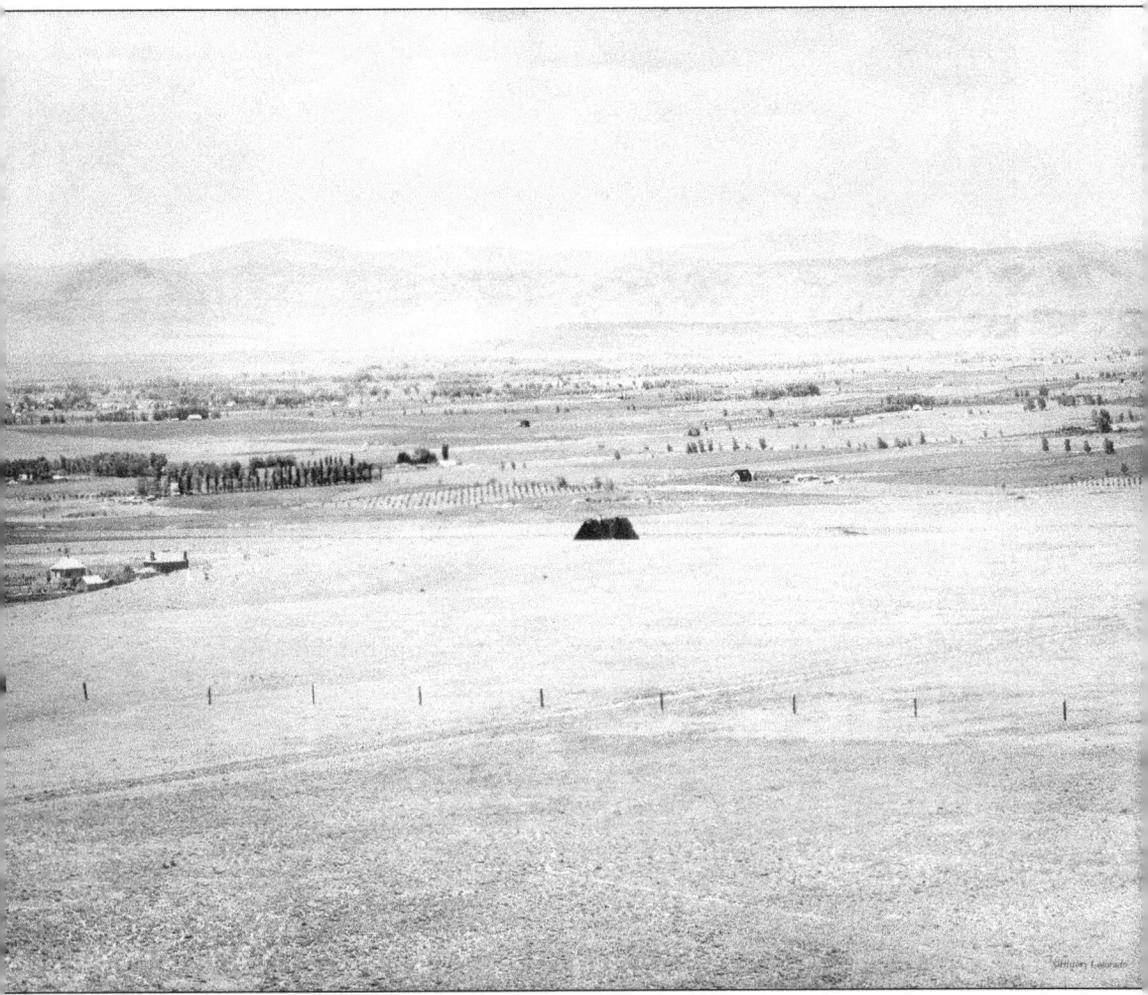

The spaces were wide open between Denver and the foothills of the Rocky Mountains during the last two decades of the 19th century. Noted photographer William Henry Jackson captured this panorama, which includes north Lakewood, in approximately 1880. In the 1870s and 1880s, most Lakewood farms averaged 160 acres, and only a handful of ranches covered more than 1,200 acres. Visible in the background is Table Mountain, and to the left are a few of Lakewood's earliest small farms. An acre was originally defined as the amount of land a man and two oxen could plow in a day. When Lakewood was settled, the modern definition of 4,840 square yards (or 43,560 square feet) was in place. (Courtesy of the History of Colorado, William Henry Jackson Collection, No. 20103754.)

11

In the 1870s, the Utes often visited the Howells on sojourns through Lakewood. Cason Howell's grandson Chester recounted that on one occasion, when all of the men were gone, the Indians wanted to trade a pony for his father, who was about two years old at the time. Chester's grandmother Elizabeth baked the whole tribe biscuits and a big meal. After the group had their fill, they were persuaded to leave. (Courtesy of Lakewood's Heritage Center.)

Cason Howell first purchased 80 acres in an area now known as Daniels Garden in 1868. The farm included an orchard, vegetable gardens, dairy cattle, and hay fields. Later, he purchased additional land at West Colfax Avenue and Kipling Street. Near this intersection, he oversaw the construction of this Italianate-style home. The house, which is located at 1575 South Kipling Street, was built around 1876 and is the oldest surviving structure along West Colfax Avenue. (Courtesy of Lakewood's Heritage Center.)

William A.H. Loveland lived 68 years, but he only spent a few years in the community he helped to name. Loveland was known as a pioneer, entrepreneur, and developer who possessed a cold logic and consuming ambition. In 1889, Loveland, his wife, Miranda, and partner Charles Welch platted Lakewood's original boundaries from West Colfax Avenue to West Tenth Avenue and from Harlan Street to Teller Street. Upon his death in 1894, the *Denver Republican* noted that his last years were "spent upon his Lakewood estate." (Courtesy of Authors' Collection.)

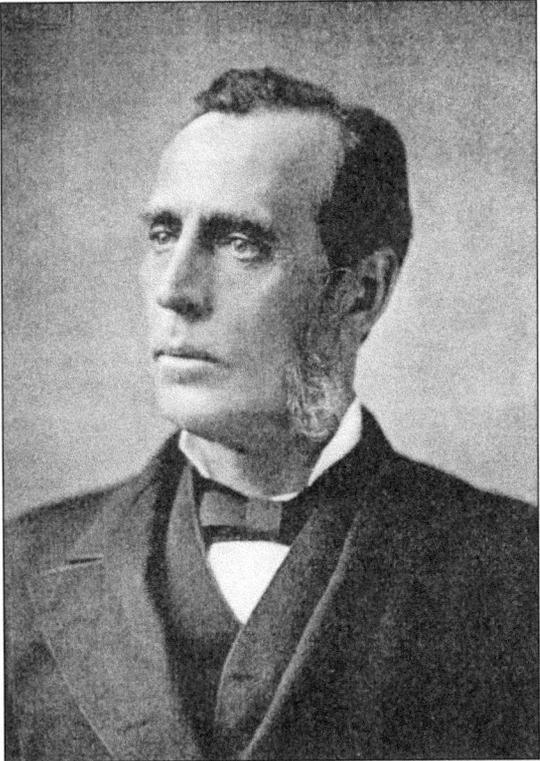

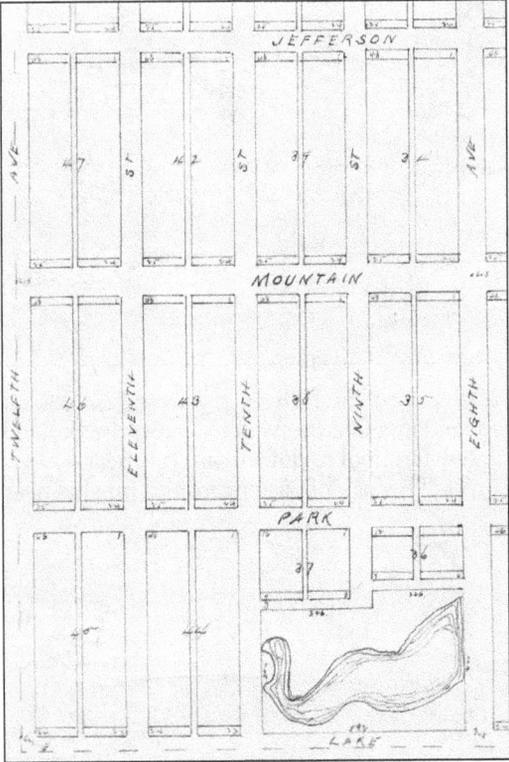

Lakewood first appears in Jefferson County records on July 1, 1889. William A.H. Loveland and his wife, Miranda Montgomery Loveland, along with Charles Welch, planned Lakewood as a streetcar suburb—a financial investment that never quite panned out—and as a stop for their Denver, Lakewood & Golden Railroad. All the street names have changed. Jefferson at the top of the image is now West Fourteenth Avenue, and Twelfth Avenue is now Teller. (Courtesy of the Jefferson County Archives.)

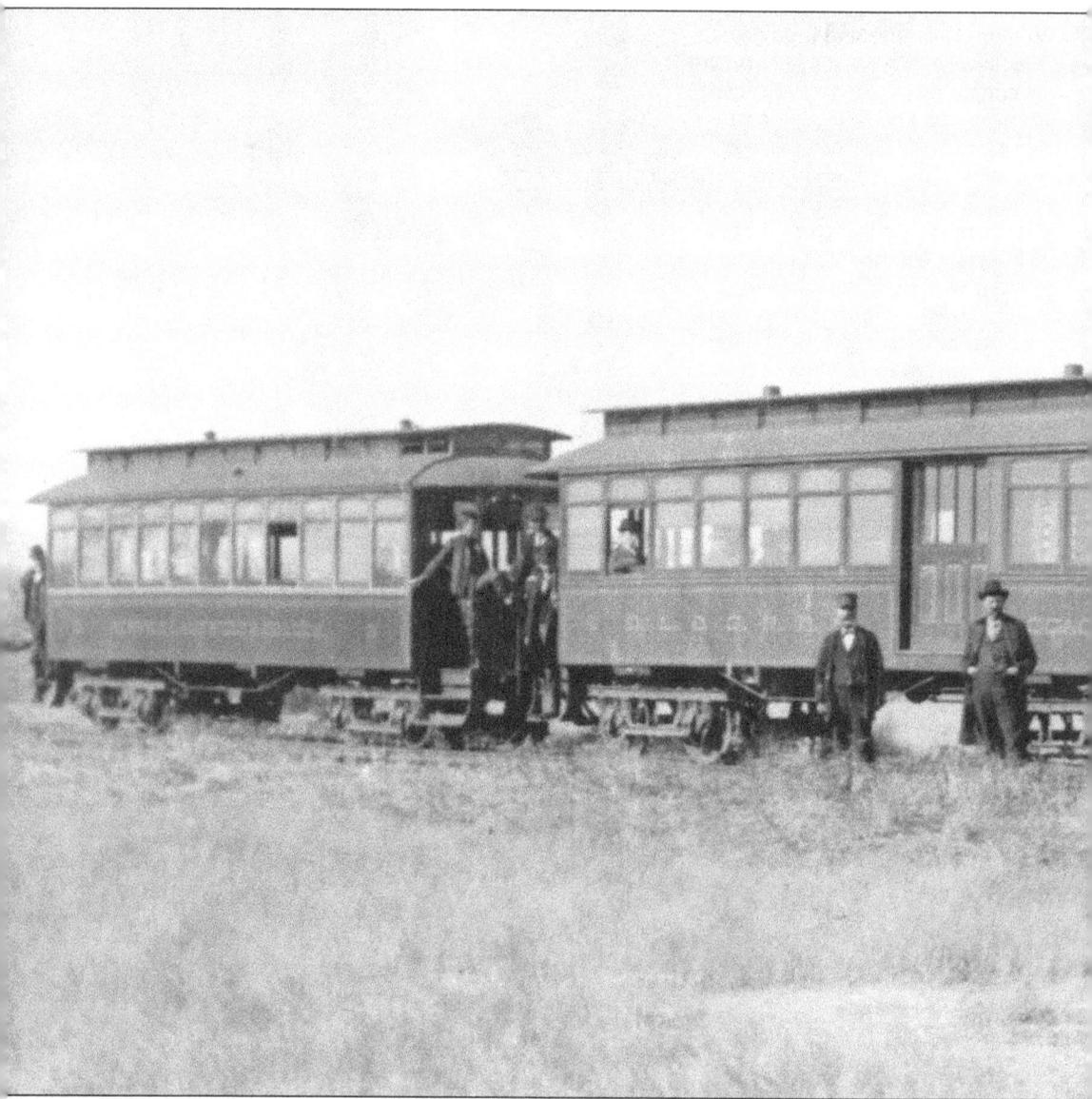

The *Rocky Mountain News* on January 2, 1892, described the Denver, Lakewood & Golden Railroad as "a humble affair." William A.H. Loveland and Charles Welch's enterprise boasted 15 miles of track and eight stations, with the closest terminal to downtown. It is near what is now the west end of the Colfax Viaduct in Denver. The lack of passengers and freights near

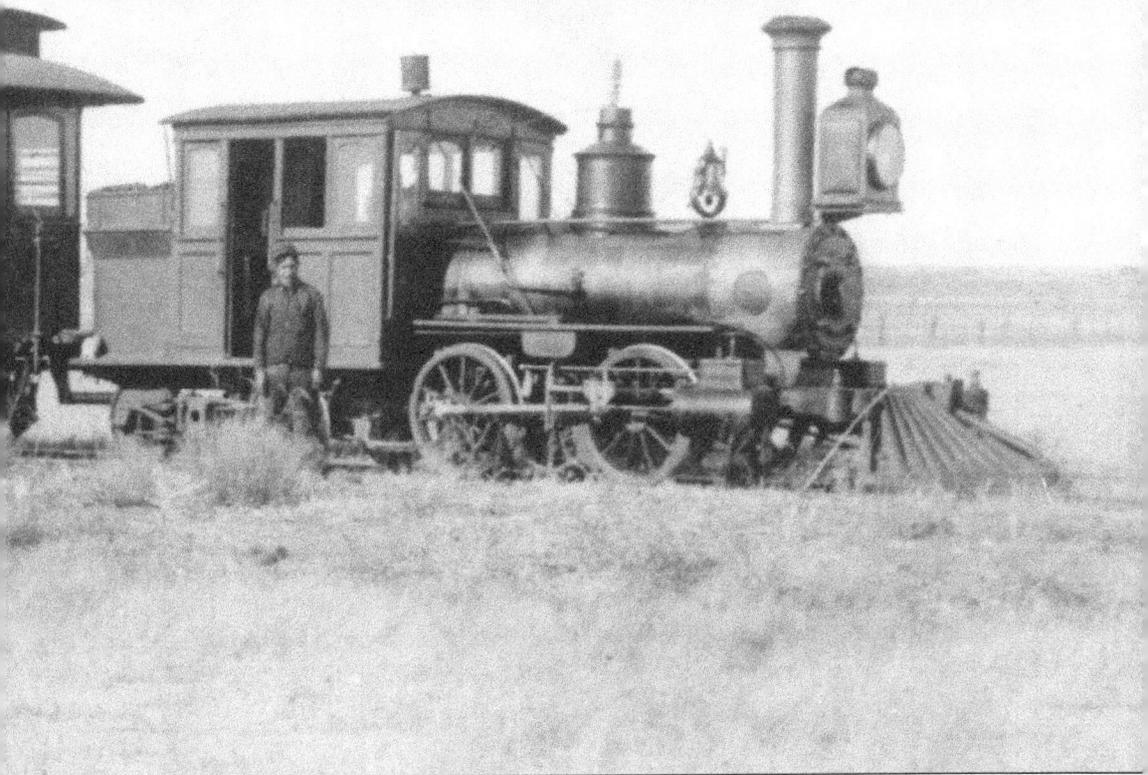

today's stop on West Thirteenth Avenue and Carr Street may indicate why the DL&G never became a successful business. The DL&G suspended operations in the early 1890s as a result of Loveland's death and the nation's financial depression of 1893. (Courtesy of the Colorado Railroad Museum Collection.)

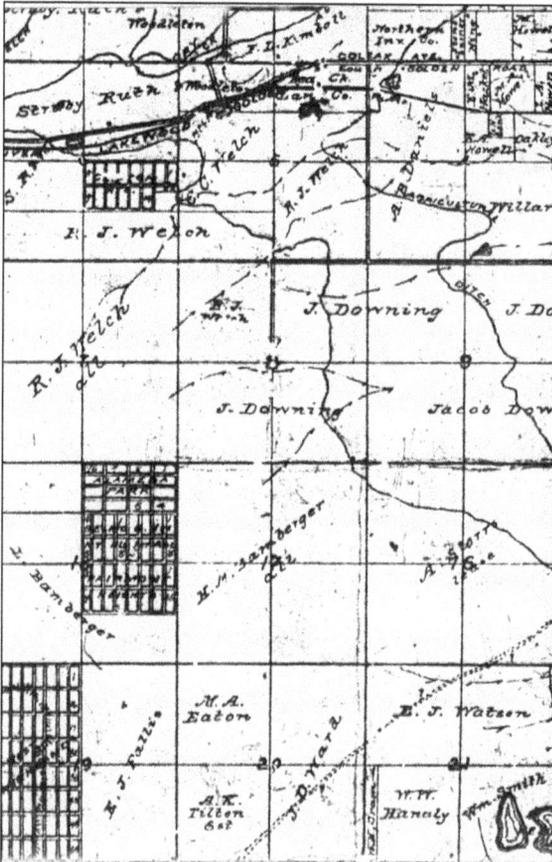

The onetime general store of the Denver Hardware Manufacturing Company still stands on Brentwood Street. In April 1892, William Robb applied to be the first postmaster of Lakewood and noted on the application, "It [Lakewood] is a new manufacturing village. Factory and dwellings, 100 settlers now living close by." In May 1896, a spark from a passing locomotive burned the factory to the ground. The store survived until 1909. Today, it is a private residence. (Courtesy of Lakewood's Heritage Center.)

Every homestead represented hope. A close examination of the 1899 Willits Farm Map indicates where some of the community's first families settled, and it also shows the acreages where they ran cattle, tended fruit trees, or mowed hay. For example, M.A. Eaton farmed a 160-acre tract. The highest horizontal line is West Colfax Avenue, the vertical line on the far right is Kipling Street, and the line at the bottom of the image is Jewell Avenue. (Courtesy of the Jefferson County Archives.)

In the early 1870s, Jefferson County cattlemen, like second-generation rancher Otis Rooney, marked their free-ranging herds with unique and identifiable brands. Brands were registered with the county. Carefully drawn to show both the brand and its location on the animal, the county's brand books illustrated the mark. The mark included the date and sometimes information about the herd. The Rooney family ran cattle and operated the Satanic Mine near the Hogback. (Courtesy of the Jefferson County Archives.)

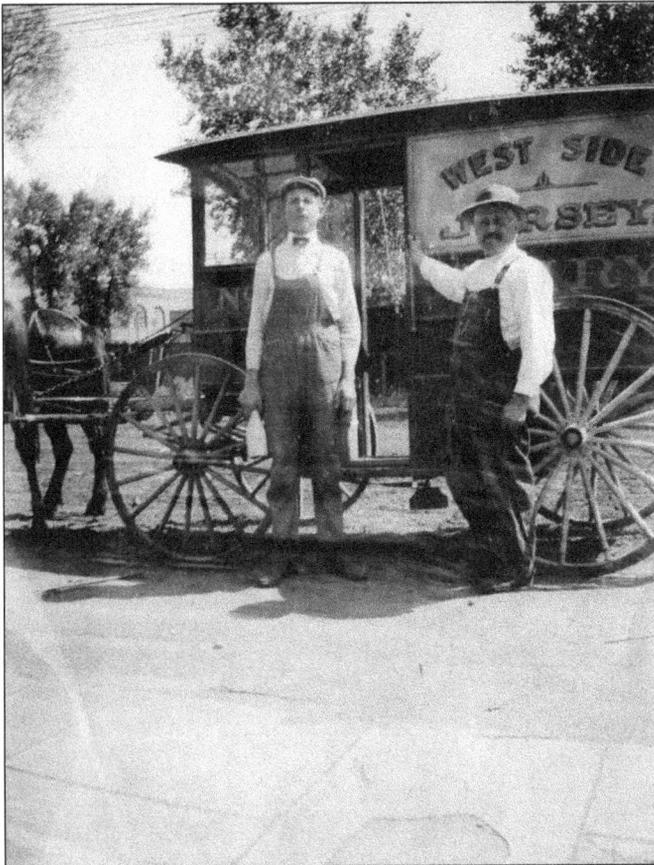

Austrian-born Joseph Jonke (right) ran the West Side Dairy. Here, he poses with an unidentified man in 1910. Towns like Lakewood emerged when farmers produced more than they needed for their own families and could sell or trade their produce for other goods and services. Jonke farmed on the north side of West Colfax Avenue at Ames Street. Barbershops, camera shops, gas stations, and realty offices soon flourished around his farm. (Courtesy of Kenneth and Faye Milne.)

An early Lakewood resident, Valentine Devinny (also spelled Devinney) started improving his 160-acre homestead around 1867. Devinny's land extended from West Sixth Avenue south to West First Avenue and from Wadsworth Boulevard west to Carr Street. As reported by the *Rocky Mountain News* in 1873, Devinny's farm was a garden of earthly delights, as three acres planted with strawberries produced 6,000 quarts. Devinny also kept bees, orchards, and many other berries and vegetables. The Jefferson County Agricultural Census show Devinny produced as little as 500 and as many as 5,300 pounds of honey each year from 1882 to 1899. He generally kept six milk cows and around 100 acres planted with crops such as corn, wheat, oats, alfalfa, and timothy. During the 1890s, the new house (right) overshadowed the original home to the left. These houses stood on the southwest corner of West Sixth Avenue and Wadsworth Boulevard. The arrival of wartime industry to Denver during the 1940s led to the widening of West Sixth Avenue and the removal of the Devinny house. (Courtesy of Lakewood's Heritage Center.)

George Devinny was a gold prospector in New Mexico when his brother Valentine acquired a relinquished homestead at a cost of $1,000. At his brother's request, George gave up the hit-or-miss life of a prospector to take up farming. Once in Lakewood, George dug ditches, cleared brush, and planted an orchard on his new home, which is near today's South Yukon Street. In 1885, at the age of 50, George married Mary Pullis, a dressmaker from the mountain mining camp of Leadville. After nine years of marriage, the couple had four children. In 1896, George died. Mary and the four children stayed on the farm and took in boarders to keep it operating. Even with land selling for as much as $300 an acre, Mary worked hard to keep the farm intact, eventually selling off only 10 acres. In this image, unidentified members of both George's and Valentine's families pose in front of George's house. (Courtesy of Lakewood's Heritage Center.)

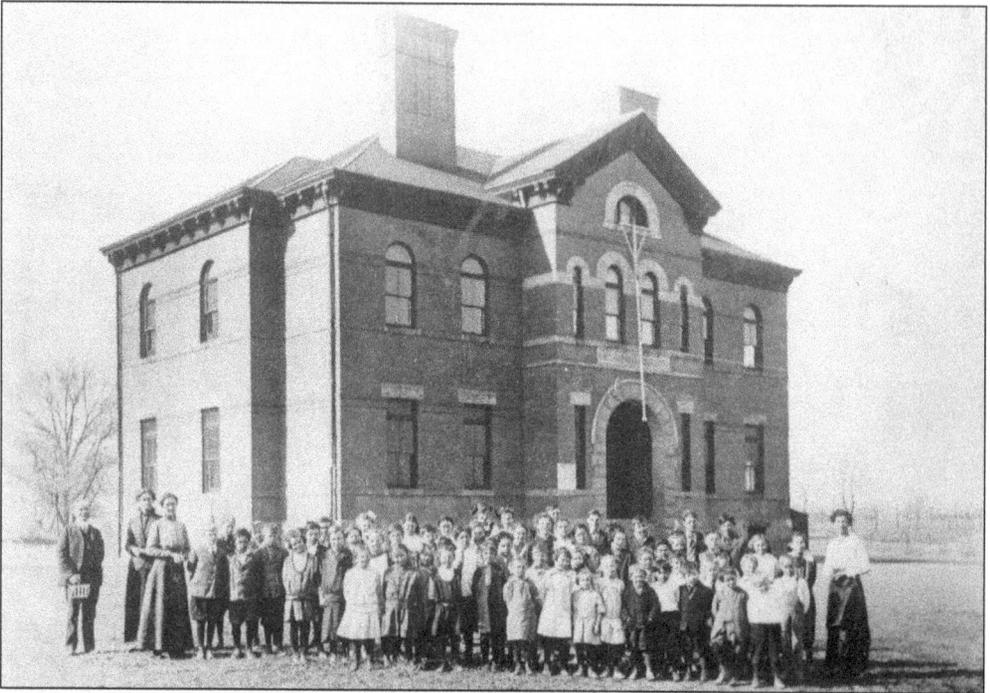

The 1915–1916 class gathers in front of the Lakewood School. Constructed in 1892 at Wadsworth Boulevard and West Tenth Avenue, Lakewood did not build a senior high school until 1928. Prior to that, Lakewood's students completed their public schooling in either Wheat Ridge or Denver. Mrs. Frank Pickett, the sewing teacher, stands to the far right of the group. The Picketts' orchard flourished about 10 blocks west of the school. (Courtesy of Lakewood's Heritage Center.)

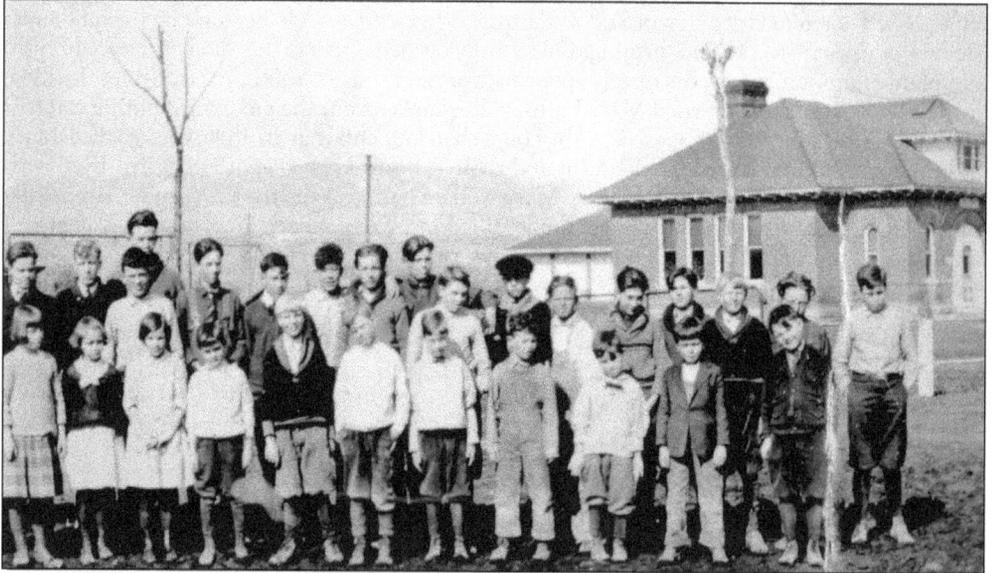

Constructed in 1894, the Montana School is one of Lakewood's early one-room schools that was administered by a school board. Many schools lacked textbooks and properly trained teachers as late as the 1940s. The Montana School stood to the west of the present-day Bear Creek High School and was eventually converted into a private residence. (Courtesy of Lakewood's Heritage Center.)

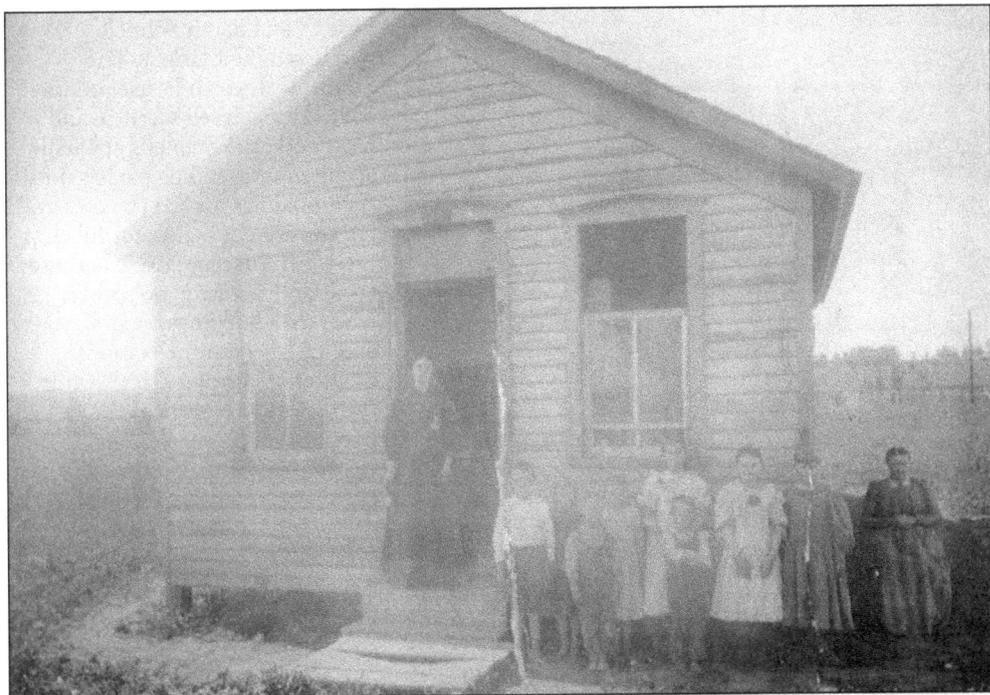

The one-room Midway was one of Lakewood's earliest schools. Shown here in 1896, Midway stood at the intersection of South Pierce Street and Jewell Avenue. During the early 20th century, all Lakewood schools were autonomous districts covering an average of three to four miles. A ballot issue in the 1920 election consolidated four surrounding schools, in spite of the fears of childless taxpayers that such a move would raise their taxes. (Courtesy of Lakewood's Heritage Center.)

Featuring an upstairs teacherage, or living quarters, that housed the principal and his family, this Bancroft School replaced an earlier wood-frame structure of the same name. George Bancroft donated the land for the school, which was on the edge of his dairy farm. His father, Dr. Frederick Bancroft, was a pioneer physician and dairyman who advocated for pasteurized milk. Bancroft is also believed to have brought dandelion seeds to Colorado. (Courtesy of Lakewood's Heritage Center.)

Fred C. and Sarah Schnell purchased their farm at 3118 South Wadsworth Boulevard in 1891. Through self-sacrifice and hard work, the Schnells gradually acquired surrounding parcels until their holdings totaled 60 acres. For the Schnells, a successful crop each year was more likely because their land featured two springs. The farm's buildings remain intact and are listed on the National Register of Historic Places, while the Colorado Historical Society honors them as a Colorado Centennial Farm. (Courtesy of Lakewood's Heritage Center.)

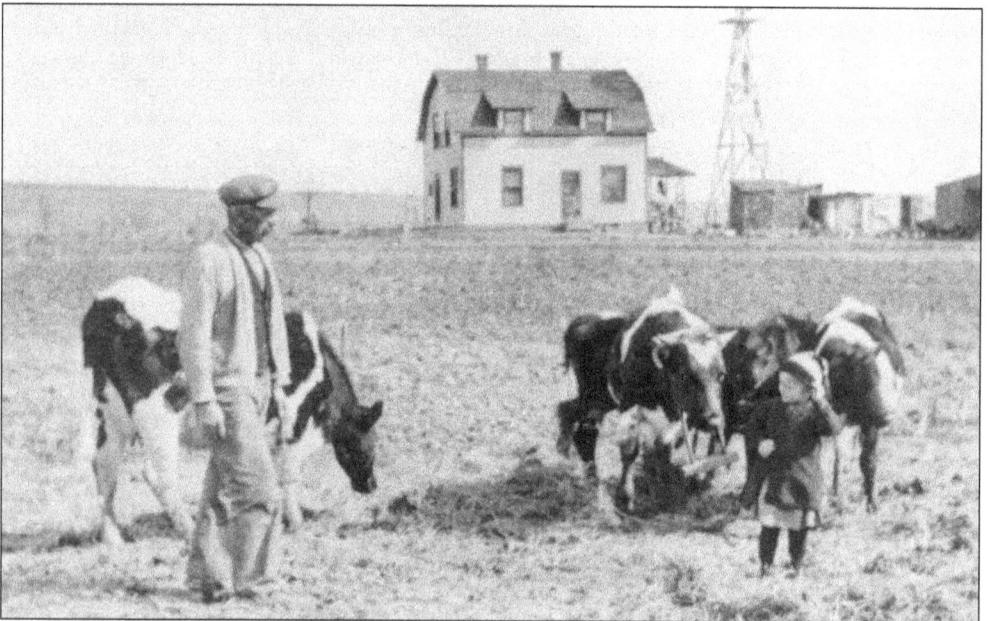

The Kramers farmed in Lakewood and neighboring Edgewater during the first decades of the 20th century. According to a handwritten notation in the margin of a 1910 US census form, their farm was located on Wadsworth Boulevard at West Twentieth Avenue. Henry Kramer, pictured here with one of his daughters, was born in Germany and made extra money as a carpenter. (Courtesy of Lakewood's Heritage Center.)

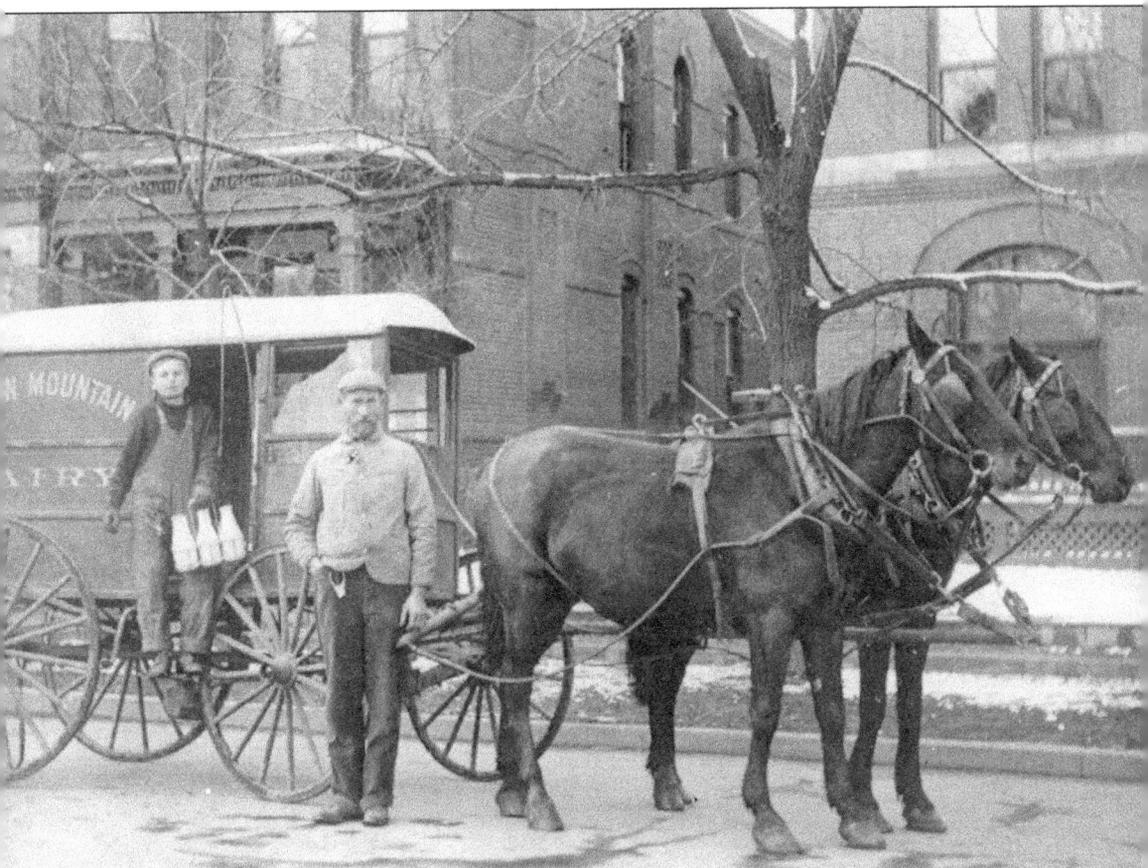

Harsh Lederman and his son Jake made a delivery in Denver in 1911. The Ledermans left Denver for Lakewood around 1903 after the city warned the family to not keep cows in their yard. Lederman purchased 10 acres from Mary Devinny, which were for his Green Mountain Dairy at the southwest corner of West First Avenue and Wadsworth Boulevard. The sale of this 10-acre tract enabled Devinny, who was a widow, and her children to remain on the farm that was established by her late husband. In 1914, Lederman moved his family to another farm near West Thirty-second Avenue and Youngfield Street. He drifted away from the dairy business after his purchase of a 20-acre poultry farm and motel near West Colfax Avenue and Pierce Street in 1929. The Lederman family found financial security in motels and the tourist trade, not farming. An elderly Jake Lederman recalled driving cattle in the snow from Littleton to Herbert Starkweather's farm on an early Thanksgiving Day in the 1920s, and, as a gift, he received "a fine dinner and $10." (Courtesy of Lakewood's Heritage Center.)

The Wight and Starkweather house, built in the 1890s, stands at 8650 West Colfax Avenue. Joseph Wight was Lakewood's third postmaster and had worked for the Denver Hardware Manufacturing Company. The house boasted two indoor baths and hot water, and it was surrounded by five acres of fruit trees. In 1915, Herbert Starkweather bought the house. Having made his fortune in mining, Wight decided to settle down and became a farmer. (Courtesy of Lakewood's Heritage Center.)

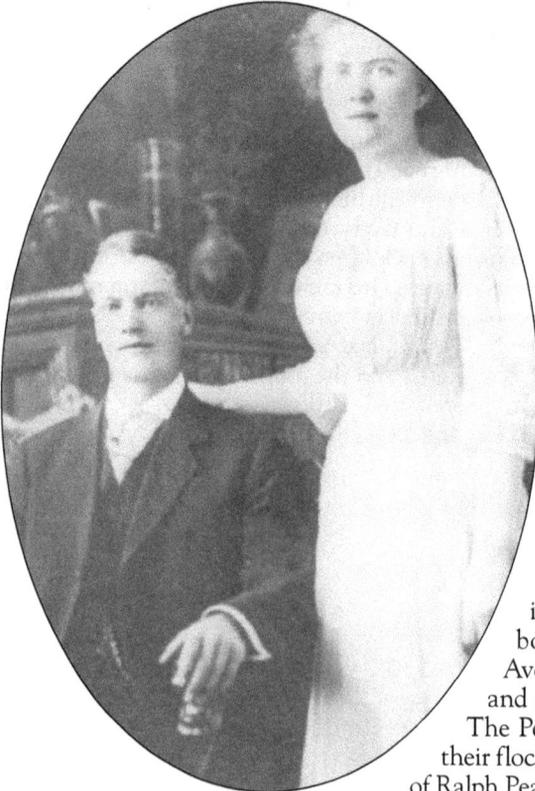

Pictured are Joseph and Elizabeth Pearson on their wedding day. Within a few hours of Joseph's arrival in Denver, he went to the Swedish Lutheran Church, because he knew there would be Swedish-speaking people who could help him find a job. They also introduced him to Elizabeth. The Pearsons bought a farm at Lakewood's Fourteenth Avenue and Holland Street. They sold apples and cherries from a stand on Colfax Avenue. The Pearsons also sold the wool they took from their flock of sheep at a market in Denver. (Courtesy of Ralph Pearson.)

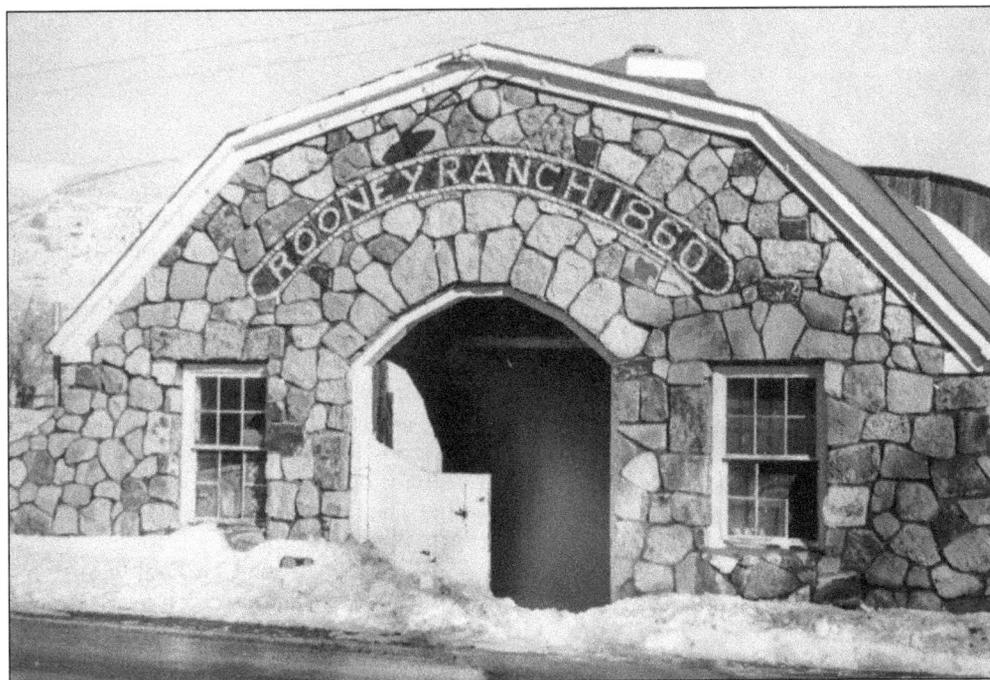

In 1859, Alexander Rooney was one of the many unsuccessful prospectors of Colorado's first gold rush in Cherry Creek. But Rooney was lucky to find water and a heavy growth of cedar trees on Green Mountain. He was the first of five generations of the Rooney family to ranch east of the Hogback. In 1860, Rooney brought the stone for this fine barn from Morrison, Colorado. The Rooney family's ranch eventually covered 4,480 acres east from the Hogback to Kipling Street. (Courtesy of Lakewood's Heritage Center.)

On June 15, 1930, a pilot and a student photographer, both from the US Army Air Corps' photography school at Lowry Air Base, were out practicing aerial reconnaissance. This image shows their flight path over the Satanic Mine area, the Hogback formation, and Green Mountain. By the end of the decade, the construction of West Alameda Parkway culminated in the loss of the mine and many of its outbuildings. (Courtesy of the Arthur Lakes Library, Colorado School of Mines.)

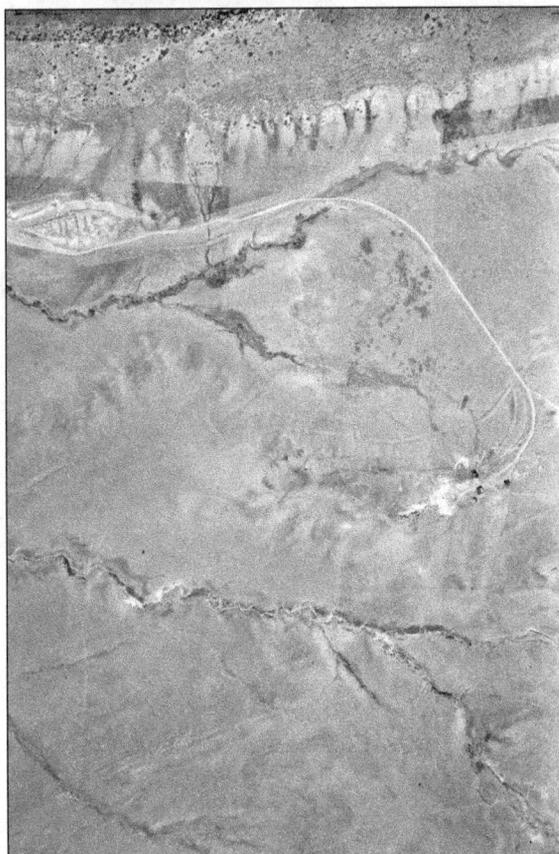

Alex Rooney, pictured at left, stands at the mine. Also seen below at the far right of a group of unidentified miners in the 1910s, Rooney was the second generation of the Rooney family to operate the Satanic Mine. In 1921, a fire consumed the mine, and six men lost their lives. The mine closed and was later reopened under the optimistic name of Bluebird. The Great Depression closed the Bluebird by the early 1930s. By mid-decade, the New Deal Works Progress Administration (WPA) oversaw the expansion of West Alameda Boulevard from Denver to the Hogback. Afraid that it might become a roadhouse, the WPA ordered the demolition of the Bluebird Mine's boardinghouse and buried the mine's opening. (Both courtesy of Lakewood's Heritage Center.)

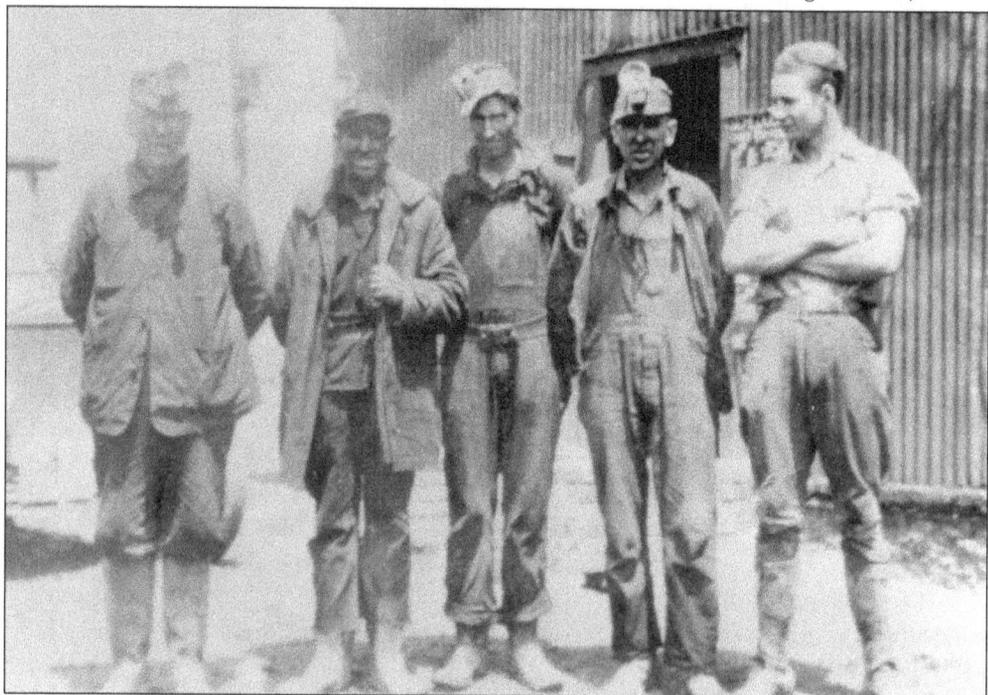

Pioneer Alexander Rooney, the father of Alex pictured on page 26, noticed coal outcrops after he settled near the Hogback in 1859. A hogback is a steeply tilted strata of rock protruding from the earth. In 1878, the Denver, South Park & Pacific Railroad built the Garfield branch line to the Satanic Mine and Garfield Quarry. For many years, the mine was the county's leading producer of coal. By the late 1910s, the mine employed more than 70 men and produced seven train carloads of coal each day. Most of the coal output was sold and used locally. But coal was not the only discovery beneath the Hogback. The ranch has seen three important paleontological finds. Arthur Lakes uncovered dinosaur fossils near the Rooney Ranch in 1877. Lakes's discovery preceded Dr. Edward Lewis's unearthing of dinosaur fossils elsewhere on the ranch. Lastly, during the mid-1930s, WPA workers expanding West Alameda Avenue discovered iguanodon footprints. (Both courtesy of Lakewood's Heritage Center.)

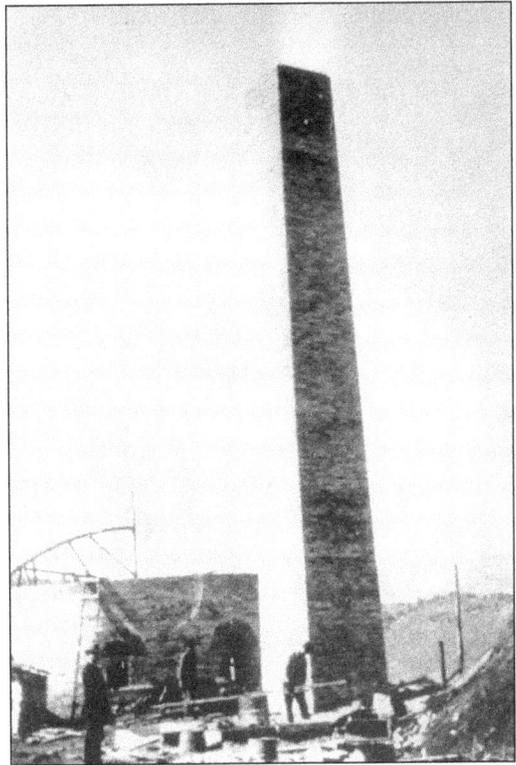

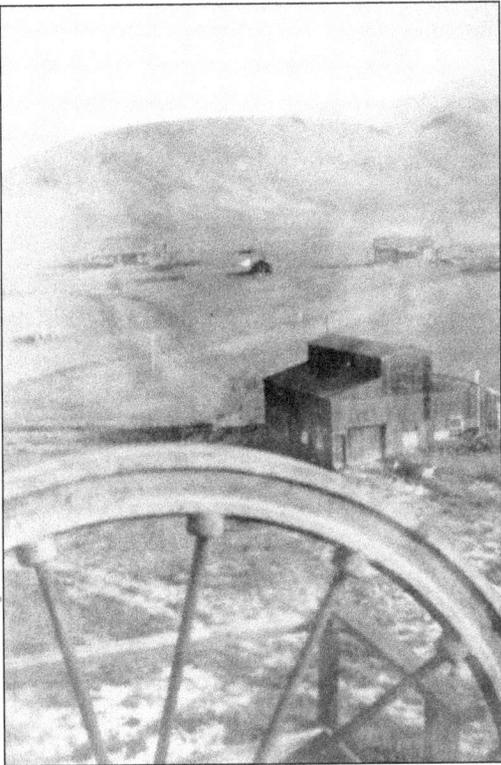

Boasting 1,000 fruit trees on 320 acres, J.J. and Margaret Brown named their summer home Avoca. It was located at the corner of South Wadsworth Boulevard and West Yale Avenue. Brown made his fortune in silver, and the couple was among Denver's nouveau riche. Margaret later survived the 1912 *Titanic* disaster, and aspects of her life inspired the musical and film *The Unsinkable Molly Brown*. (Courtesy of Lakewood's Heritage Center.)

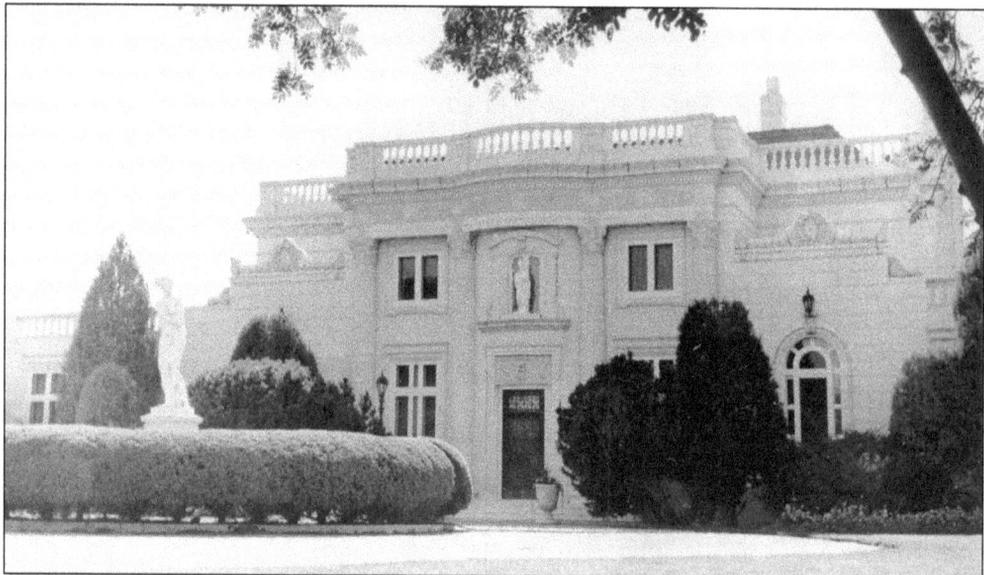

Several families of means came to Lakewood and built summer homes and hobby farms between 1890 and 1940. Heiress May Bonfils permanently relocated to Lakewood with flair. Bonfils had no real intention of farming, and she hired a farmer to raise white sheep and cattle. In 1937, she built this Beaux Arts–style mansion, complete with swimming pool and fountains, out of terra-cotta glazed blocks. (Courtesy of Lakewood's Heritage Center.)

Two

ORCHARDS, COWS, AND CHICKENS

LAKEWOOD'S AGRICULTURAL FOUNDATION

Beneath the asphalt and concrete of West Colfax Avenue and Wadsworth Boulevard, there were once orchards. It is hard to visualize, but apples, plums, and currants blossomed where lampposts now take root. Cattle, chickens, and turkeys roamed in the open prairie before it was covered by parking lots. For nearly a century, Lakewood was known for its rural nature. It was a place established by individuals who rebounded from earlier failures at gold mining by taking their shovels and digging ditches. These ditches slowly branched from Clear Creek, which was the only substantial natural water resource between Denver and Golden. Between the 1860s and 1870s, homesteaders dug three ditches that drew from the creek: the Rocky Mountain, the Welch, and the Agricultural. Supported by a growing network of laterals, these ditches ensured that the community had a fighting chance to overcome Lakewood's mercurial soil.

Because of irrigation, pioneers like Valentine Devinny were able to keep bees and settlers like Edward Krueger established orchards in northern and central Lakewood. Krueger's son Robert remembered that, in the first disheartening year, his family continuing farming even though their orchards died, all except for one purple plum. In 1974, Krueger recalled these idyllic moments of his boyhood 70 years earlier: "I still remember the clarity and stillness of the early morning and late evening air. We could whistle or shout at Green Mountain, and the clear echo bounced back." Families like the Downings, Rooneys, and Haydens successfully ran cattle over spreads that were as vast as 4,000 acres.

By the 1920s, many family farms in northern and central Lakewood were subdivided into smaller tracts that were sold to the next, less rural generation of homesteaders. It was the beginning of the end for Lakewood's beginnings. After World War II, returning servicemen came to Lakewood and looked for a tract home on the range.

Bernard O'Kane came from Ireland to Colorado to work in the mines near Telluride and Durango. In the mid-1890s, he married Elizabeth Madgellan. Their home and profitable five-acre Harp Dairy were located on West First Avenue between Teller and Newland Streets. O'Kane's dairy wagons featured an Irish harp painted on the side. Among O'Kane's notable customers were the working girls in Denver's red light district. A pail left on the windowsill was their signal for O'Kane to deliver milk. (Courtesy of O'Kane family.)

The O'Kane farm included orchards, gardens, the house, and outbuildings, which are largely unchanged. When Bernard died in 1918, Elizabeth was pregnant and had three living children: John, 13; Rosie, 9; and Annie, 5. The O'Kanes had one other daughter, Bridget, who passed away at age five. She died from burns after playing with matches. (Courtesy of the O'Kane family.)

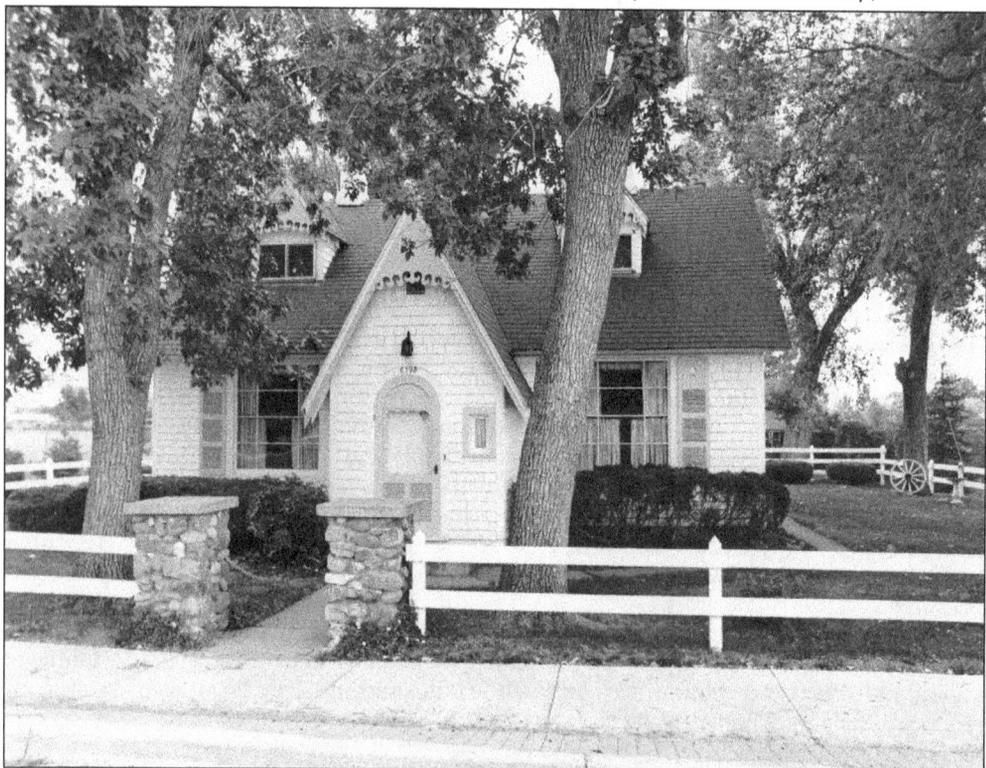

Twins Barney and Betsie O'Kane enjoy an August afternoon on their parents' farm in 1926. The youngest of six children, the twins are often in family photographs together. Their mother, Elizabeth O'Kane, worked hard to keep the farm after her husband's death, and she hired helpers for the dairy and orchard. The cow is unidentified. (Courtesy of the O'Kane family.)

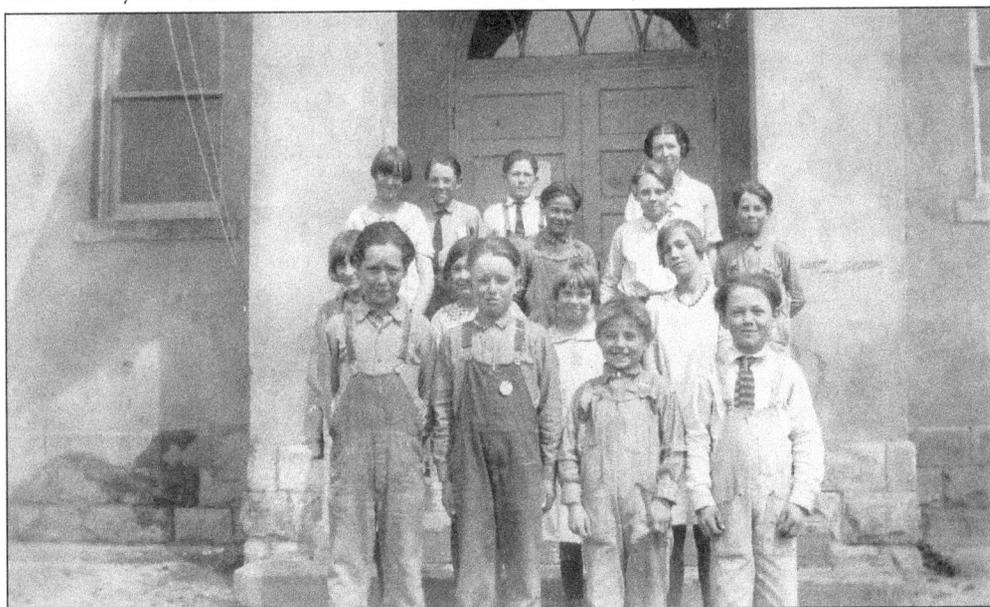

Dressed in their school-picture best, an elementary school class at Washington Heights School poses in 1926. Ralph Pearson, who attended Lakewood School, fondly recalled an annual trip to Golden to purchase new overalls for the school year. In November 2010, O'Kane family members commented that early-20th-century farm families in Lakewood "had to be really strong," and the community's foundation was a chain of "close-knit families." (Courtesy of the O'Kane family.)

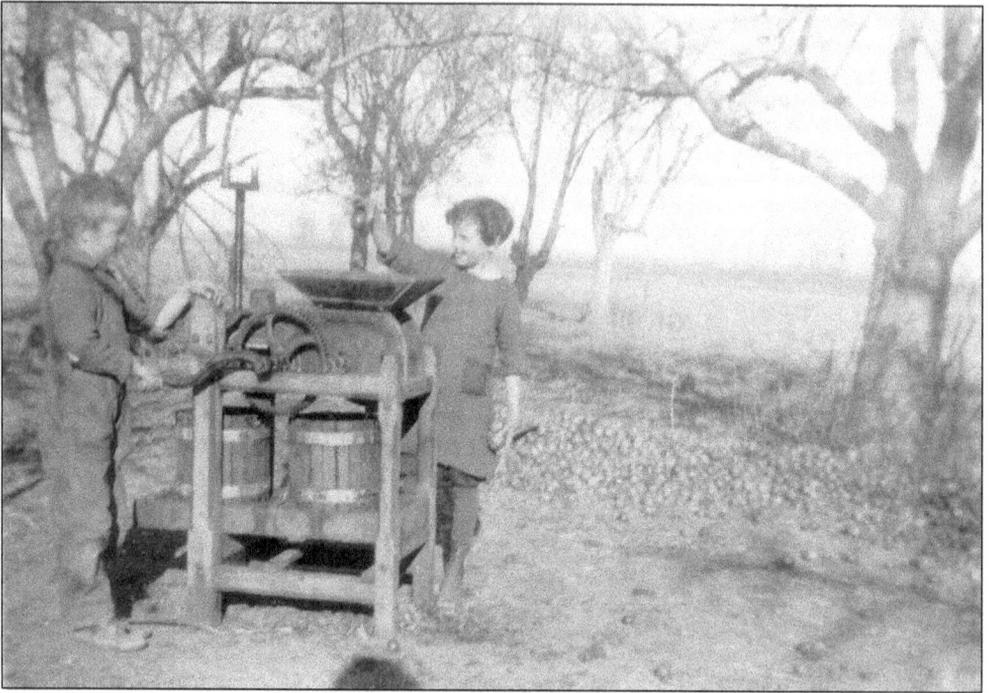

Mature apple trees covered many of Lakewood's farms as late as the 1920s. Barney and Betsie O'Kane pose next to the family's cider press in November 1926. After his service in the US Army Air Corps and graduation from Denver University, Barney (left) later served in the Colorado legislature and subsequently as a district attorney. (Courtesy of the O'Kane family.)

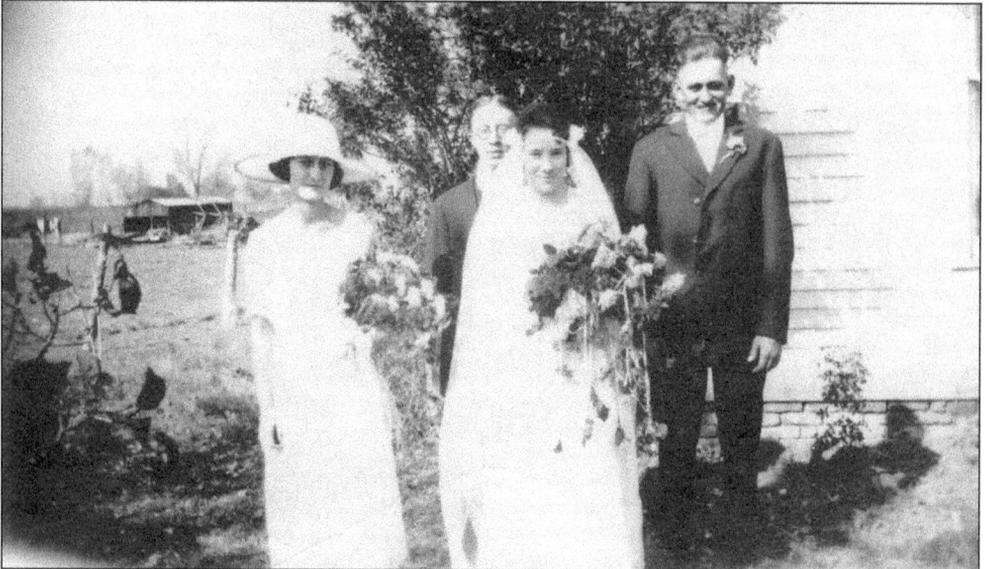

After harvest in November 1927, two established Lakewood farm families came together and celebrated the union of Lawrence Kerstiens and Lillie Brauch. The Brauchs lived three doors from the O'Kanes. Lawrence and Lillie raised 10 children on their West Fourth Avenue farm. Defying surrounding housing development until the mid-1970s, Lawrence still owned and lived on an acre of the original 15 acres his father, Moritz, purchased in 1905. (Courtesy of the O'Kane family.)

As with other farming communities, worship drove the lives of many Lakewood families. The St. Mary Magdalene Church was in the adjoining town of Edgewater. But for most of the late 19th and early 20th centuries, St. Mary's was the nearest place for Lakewood's Catholics to attend mass. Lakewood's first Catholic church, St. Bernadette's, was completed in 1947. (Courtesy the Denver Public Library, Western History Collection, Call No. X-8074.)

The Denver Hardware Manufacturing Company bought and developed the acreage south of the Denver, Lakewood & Golden Railroad around Brentwood and Balsam Streets for its workers. This structure was home for the Charles Roesener family for most of the 20th century. (Courtesy of Lakewood's Heritage Center.)

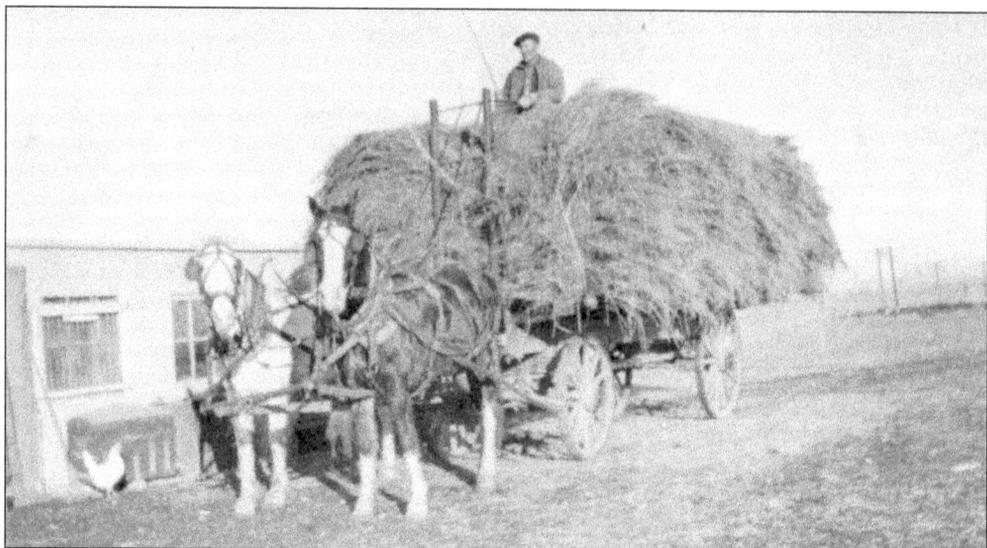

Lakewood farmer Axel Johnson gets an assist from his team, Tom and Jerry, during the 1919 harvest. The Johnson farm was in the Bancroft neighborhood. Eventually, Axel Johnson gave up farming and opened the Pleasant View Store on Morrison Road near West Alameda Avenue. He is said to have used the original Bancroft School as part of his store. In the 1920s, Johnson sold Texaco gas from a single pump in front of his store. (Courtesy of Lakewood's Heritage Center.)

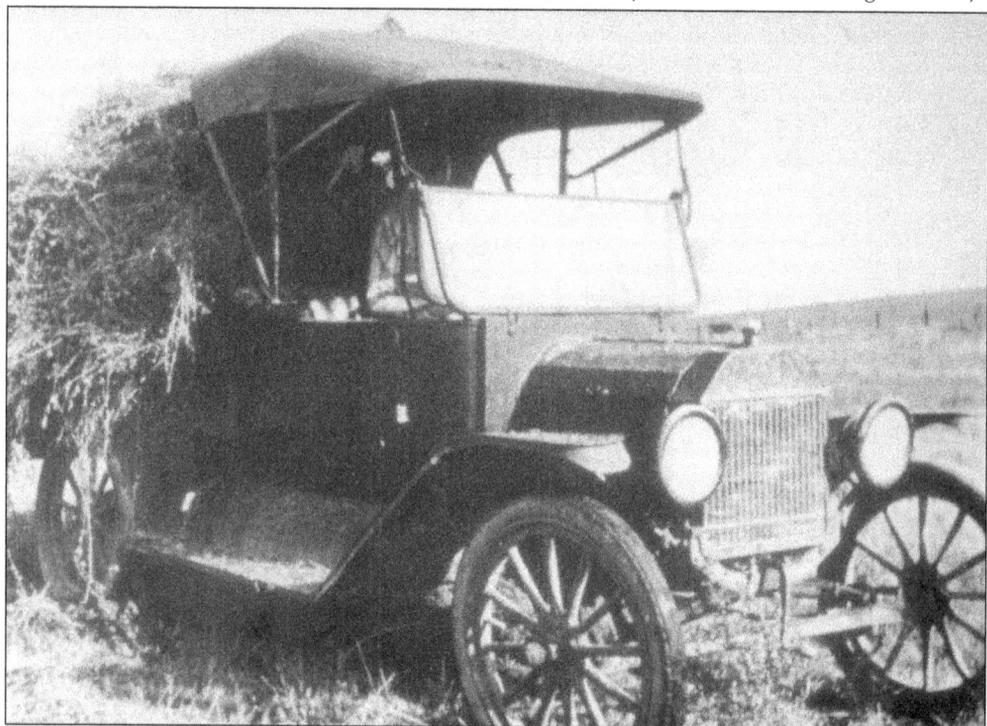

From Detroit's factories to the nation's farms, the horseless carriage was quickly put to the test by rural America. On a 1919 visit to the Bradford House, located south of Lakewood, Eunice Johnson Dowd's Brownie camera captured how the family car was sometimes used to get the harvesting done. (Courtesy of Lakewood's Heritage Center.)

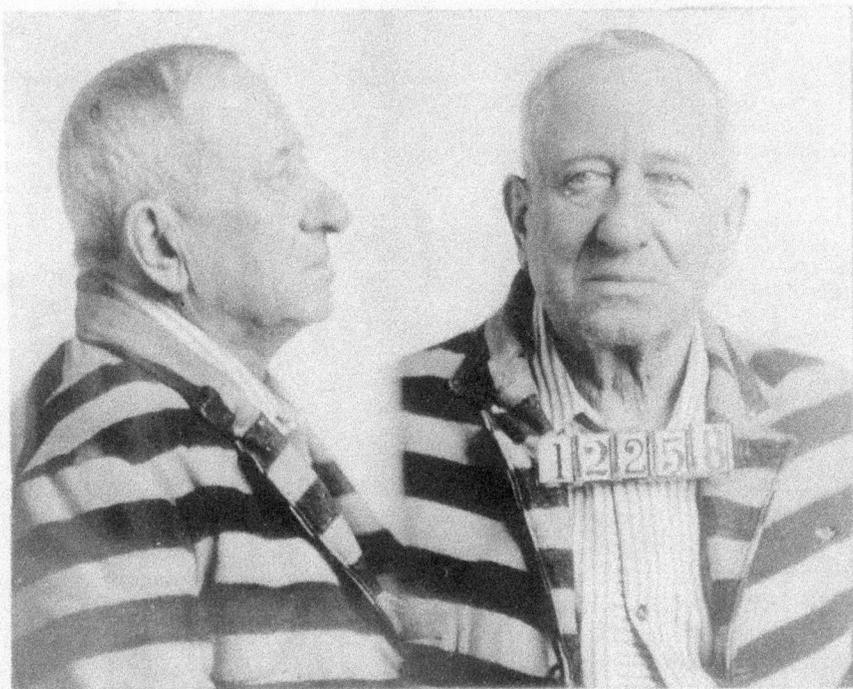

-Lou Blonger, King of the Bunks-
"The Fixer."
7 to 10 Years.
(Died in the Penitentiary)

Lou Blonger is Lakewood's Al Capone, except Blonger paid his taxes. From Blonger's cherry orchard along Kipling Street, he masterminded every confidence game and swindle operation in Colorado during the early 20th century. Known as "The Fixer," wagonloads of dark red cherries left his orchards as a subtle reminder to Denver judges, city officials, and police officers that he had control over the city's underworld activities. From every scam in Denver, Blonger demanded a 25 percent cut of the profits. The crusading Denver district attorney Philip S. Van Cise convicted Blonger of fraud and embezzlement. Blonger died in prison in 1924. (Courtesy of the Denver Public Library, Western History Collection, Robert R. Maiden Papers, Call No. F-46502.)

Part Dr. Kildare and part Dr. Faustus, Frederick J. Bancroft was one of Denver's prominent 19th-century physicians. Bancroft was a gourmand who weighed more than 300 pounds. He owned a farm near today's Morrison Road and Harlan Street. Unidentified members of his family are seen in this 1890s photograph. (Courtesy of Lakewood's Heritage Center.)

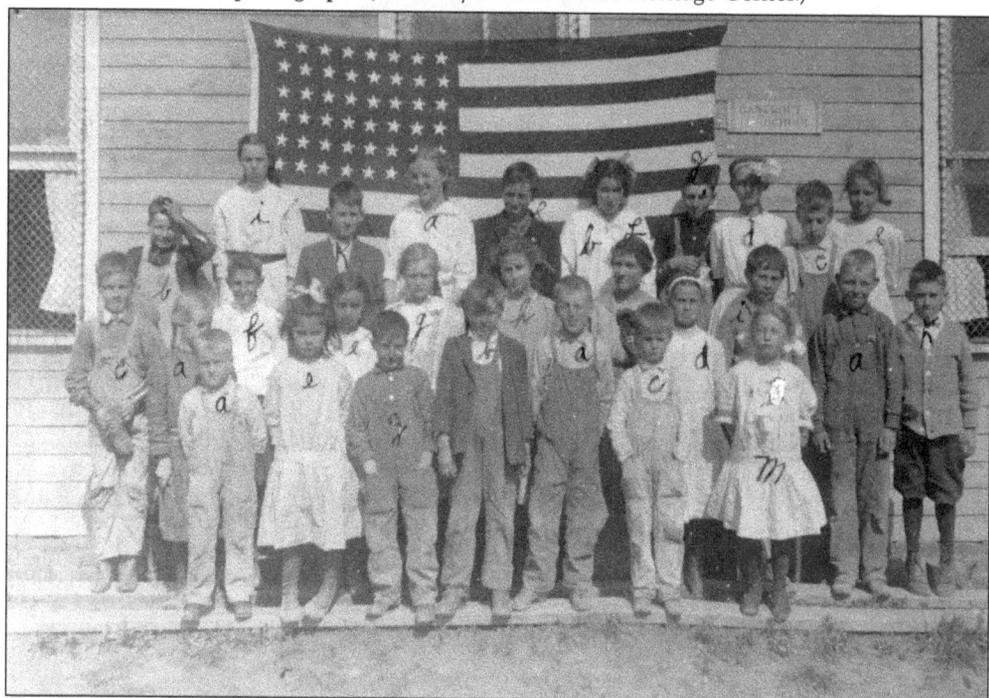

After his father's death, George Bancroft donated a segment of acreage near Morrison Road and Harlan Street, and a school was opened there for the children of the surrounding farm families. The class of 1912 stands in front of the one-room building. This wooden structure was referred to as "the real Bancroft School" for many years after the construction of a new brick school in 1919. (Courtesy of Lakewood's Heritage Center.)

Three generations of Everitts and Addenbrookes farmed south of West Alameda Avenue between Garrison and Kipling Streets. The original home, built by John Everitt in 1895, stood until 1954. In addition to farming, Everitt also hauled freight with his wagons. The barn (above) was completed in 1870 and stood until it burned to the ground in 1972. (Courtesy of Lakewood's Heritage Center.)

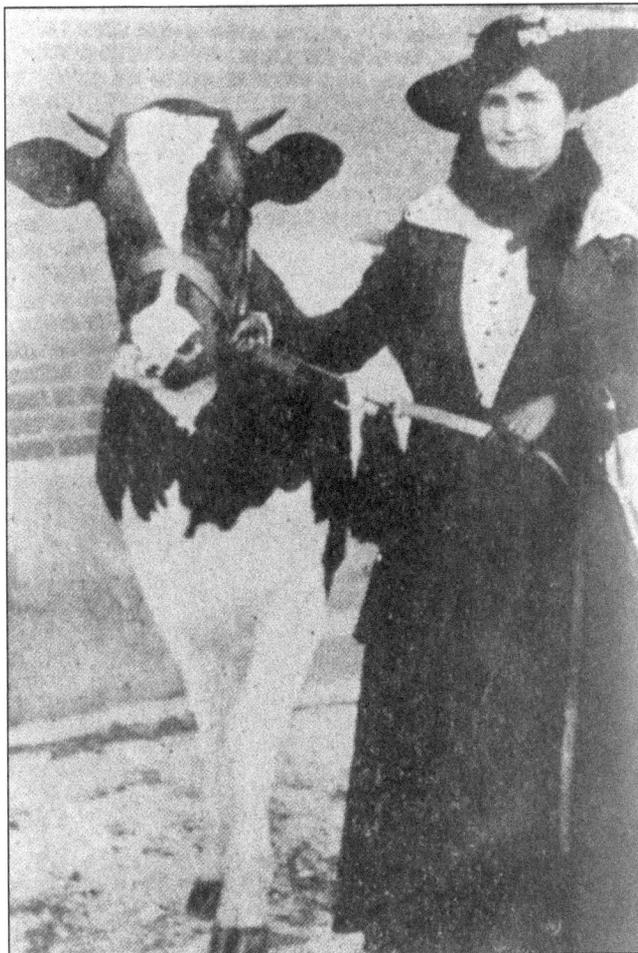

In the early 20th century, brothers Carlos and Storrs Hall purchased a Morrison Road farm. The Halls' Western Holstein Farm and Dairy soon established a reputation for choice cattle, which allowed Carlos to sell a heifer at an international dairy sale in Minnesota for $5,500 in 1920. Anna Hall exhibits one of the heifers. Carlos was later a director of the National Western Stock Show. (Courtesy of Lakewood's Heritage Center.)

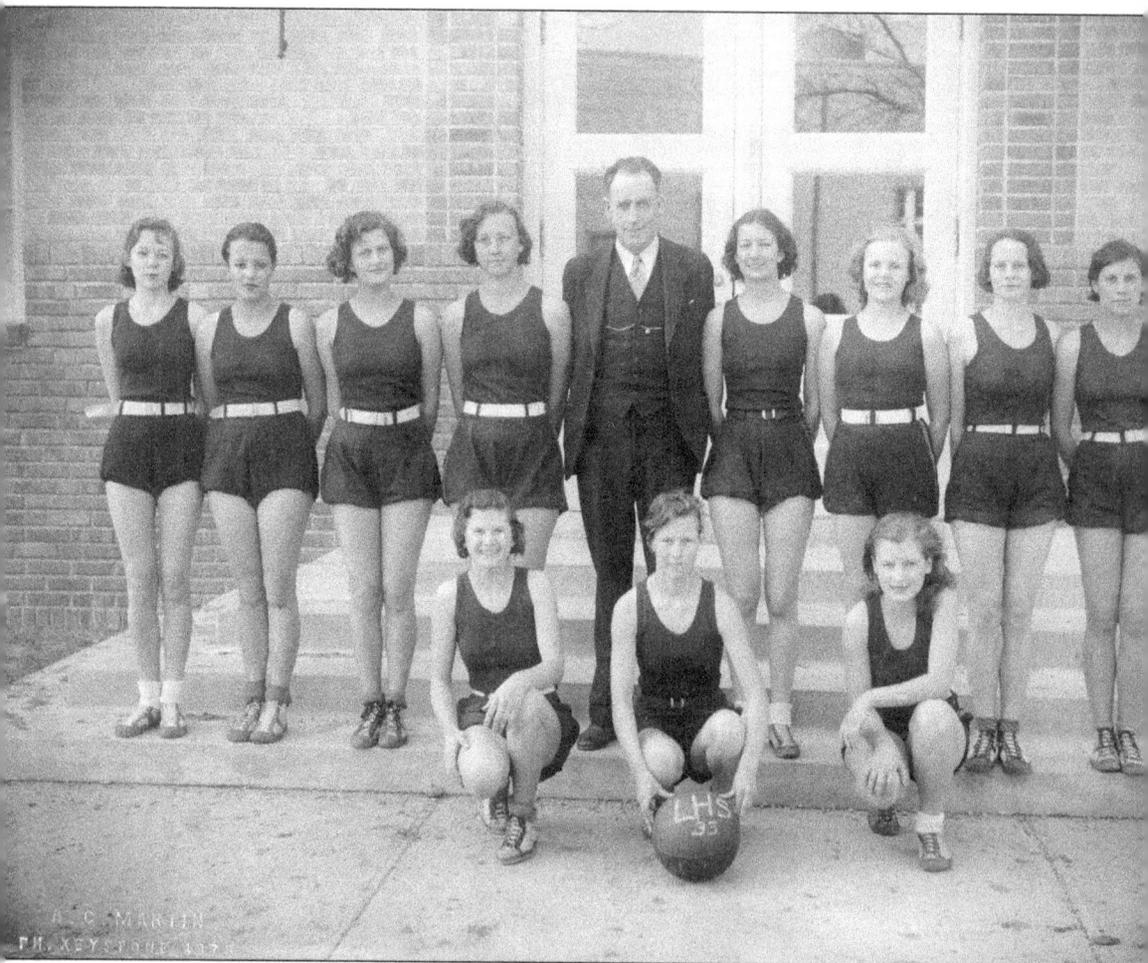

In 1891, James Naismith nailed two peach baskets on opposite balconies of the YMCA gymnasium in Springfield, Massachusetts, and a new sport was born. By 1895, girls' and women's public schools across the West had taken to the court. Changing attitudes toward women and athletics encouraged young women—like those on Lakewood High School's teams of the 1930s—to find their identities through sports. (Courtesy of Lakewood's Heritage Center.)

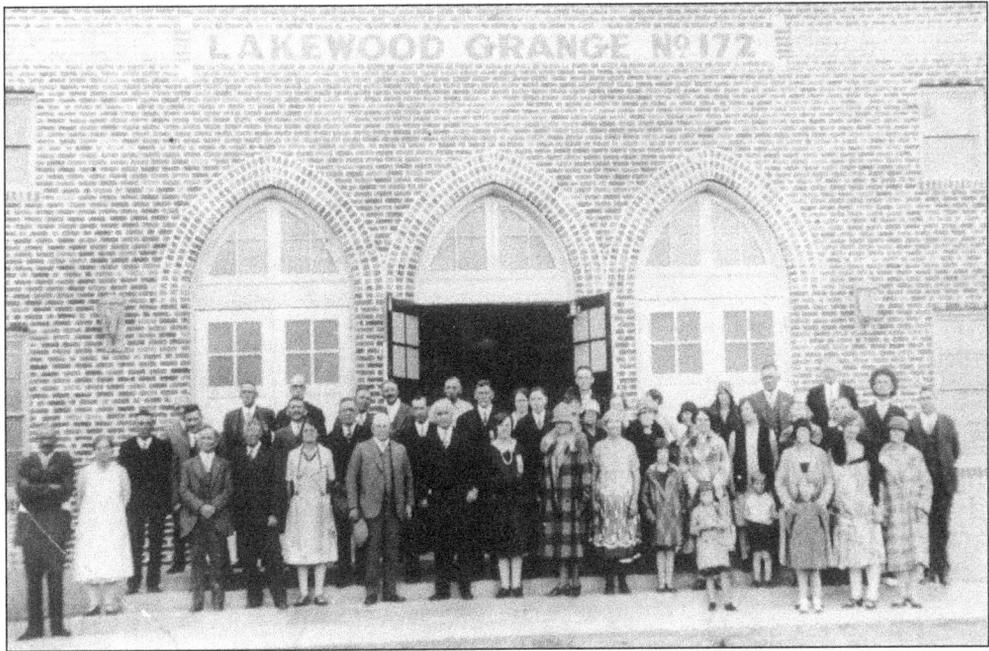

The Lakewood Grange, near the intersection of West Colfax Avenue and Carr Street, was more than a voice for the community's farmers and ranchers. It held dances and community suppers that helped strengthen the bonds between members. The Colorado Grangers protested against Daylight Saving Time when Denver adopted the tradition in 1920. They feared it would be difficult to hire help from the city if there was a conflict between city time and farm time. (Courtesy of Lakewood's Heritage Center.)

DANCE
Each Saturday Evening
LAKEWOOD GRANGE
50c Per Person, Tax Included
From 8:30 P. M. to 12:30 A. M.
— Music by —
MILE HIGH RAMBLERS

On February 28, 1946, the *East Jefferson Sentinel* reported that the Grange offered many social events that were open to the public for a small fee. Members performed community theater, presented lectures on various topics, and partnered with the Jefferson County Extension Service for home-canning demonstrations. Saturday evenings were reserved for public dances. (Courtesy of the *East Jefferson Sentinel*.)

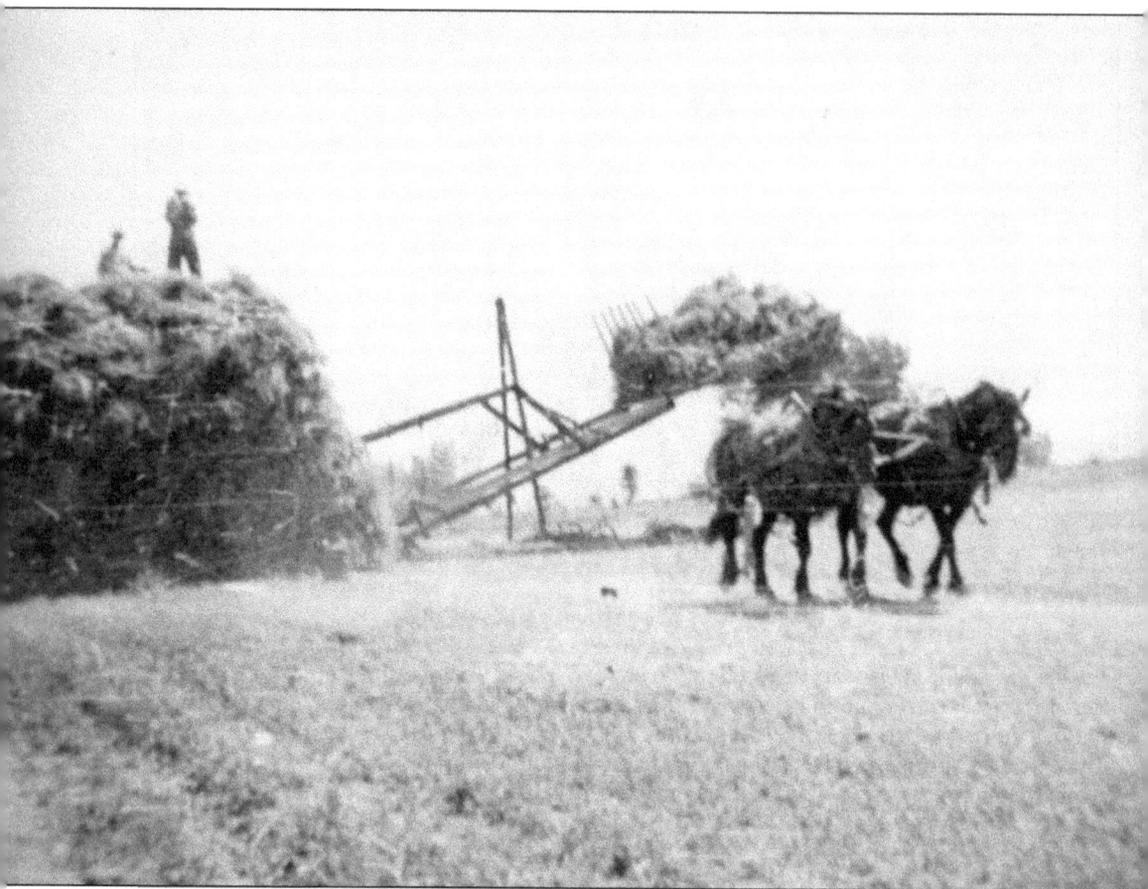

Frank Peterson came from Sweden to America in 1891, only to return home 10 years later. In Sweden, he married Amanda Bergtson, and the couple's sons, Victor and Harry, were born there. In 1905, Frank and Amanda came to Colorado with their young family. They bought an existing farmstead on South Depew Street. Following the births of three more sons and two daughters, they established a farming dynasty that lasted well into the 20th century. By World War I, the Peterson family owned 110 acres from Sheridan Boulevard west to Harlan Street and from West Alameda Avenue north to West First Avenue. When Amanda and Frank died in the early 1920s, the Peterson brothers and sisters stayed together with the older brothers raising the younger siblings and continuing to run the farm. Above, the family stacks hay during the 1937 harvest. (Courtesy of Lakewood's Heritage Center.)

A truck is nice for a couple of cows, but when it comes to moving a herd, a few men on horseback do nicely. Written on the back of this 1929 snapshot, a Peterson family member noted they were getting ready to drive their "first" cattle truck into Denver. The Petersons followed a route down West First Avenue across to Federal Boulevard and down Market Street in Denver to the stockyards. The image below shows the Petersons moving cattle along Alameda Avenue during a 1941 roundup. Today, Alameda Avenue has more cars and lanes, leaving no room for so many cattle. (Both courtesy of Lakewood's Heritage Center.)

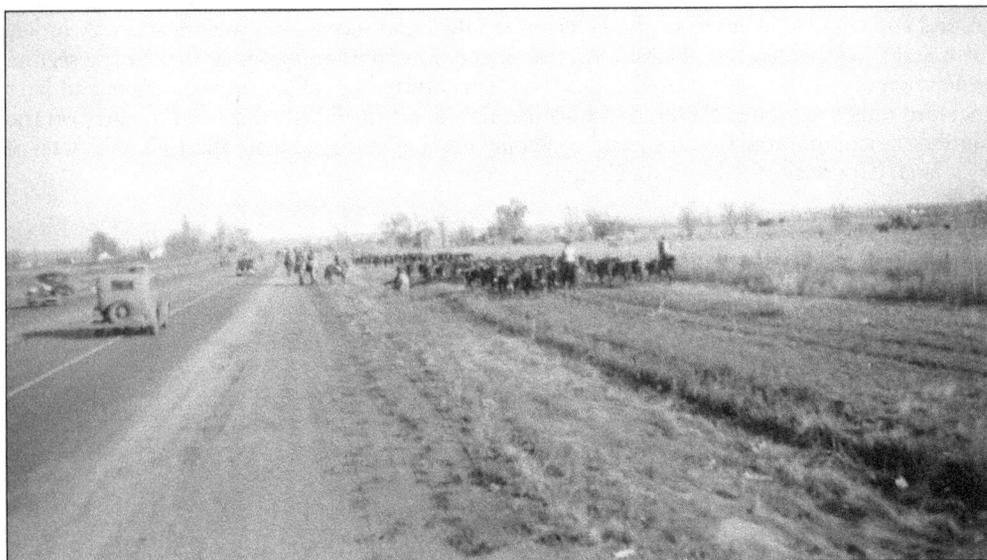

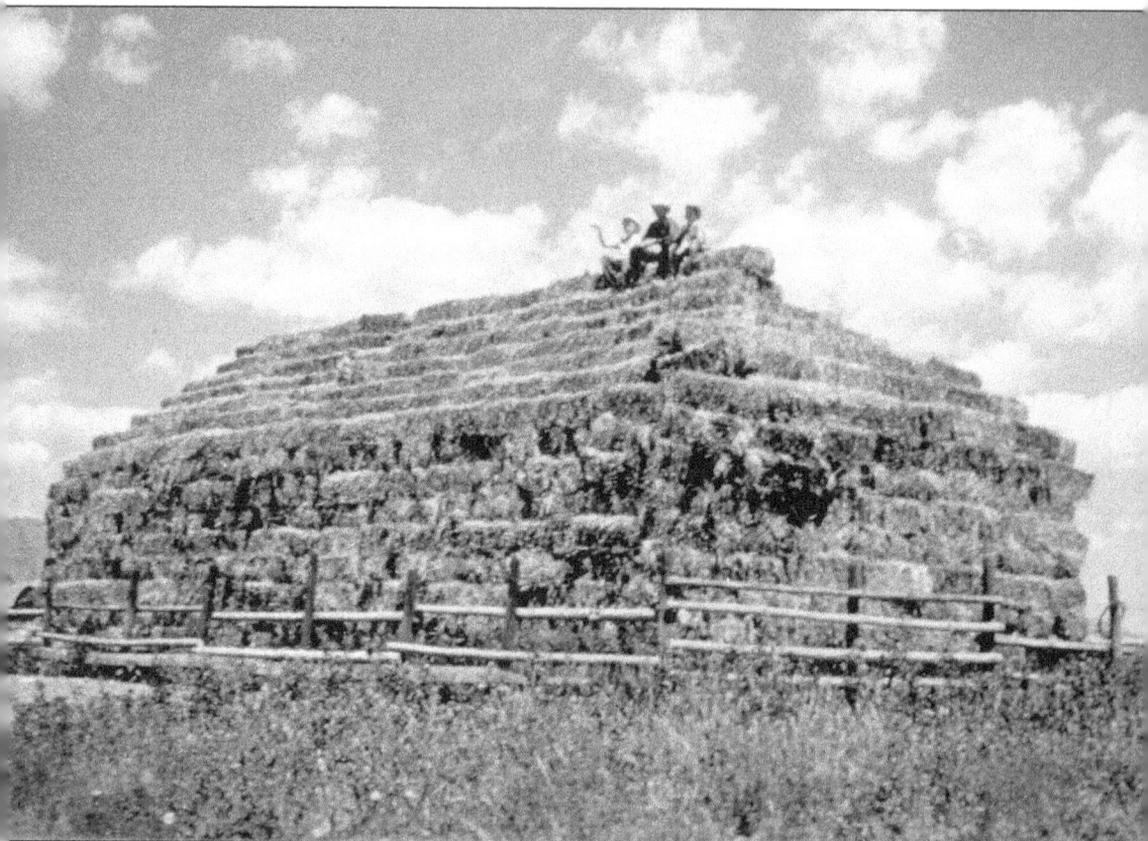

Brothers Ken and David Peterson, grandsons of Frank and Amanda Peterson, sit on top of the world after several hard days of haying one summer. The third person in the photograph is not identified. This mountain of hay shows why the Peterson family was able to survive in farming: they were willing to try new techniques. They moved from horse-powered equipment that stacked loose hay to a tractor-pulled machine that made bales of hay into uniform sizes and weights. The second and third generations of the Peterson family found success in diversification. A turkey farm and their Golden Pure Dairy were two of the other agribusinesses owned by the second generation. Typically, they started small. The dairy started by selling milk products and later included milk processing. David, a third-generation family member, continued to carry on the family's agricultural traditions by forming a company that managed more than 100,000 acres of farmland. (Courtesy of Lakewood's Heritage Center.)

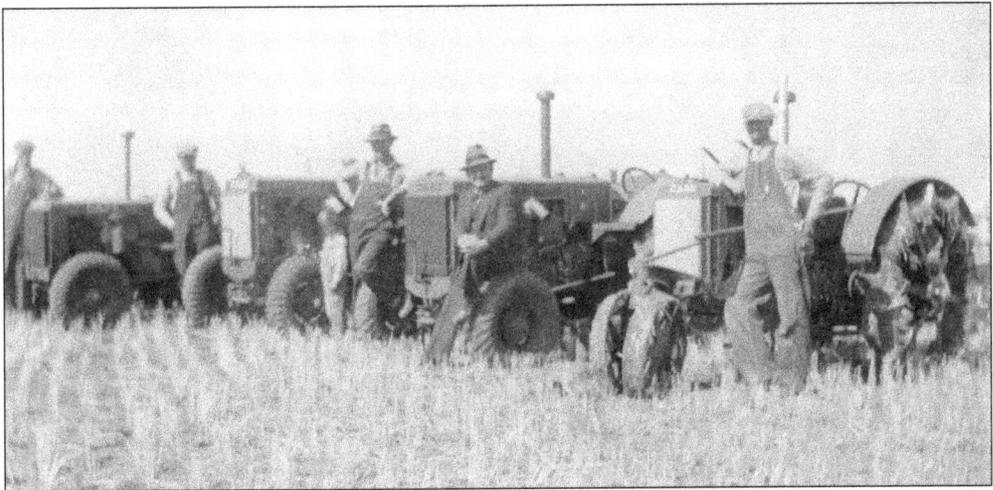

As America became involved in another world war, most of Lakewood was still invested in agricultural production. During this time, the Peterson family was among the community's most successful farmers. In this photograph taken in 1939, the four brothers pose with their tractors, which enabled them to cultivate more land than they could with horses or oxen. (Courtesy of Lakewood's Heritage Center.)

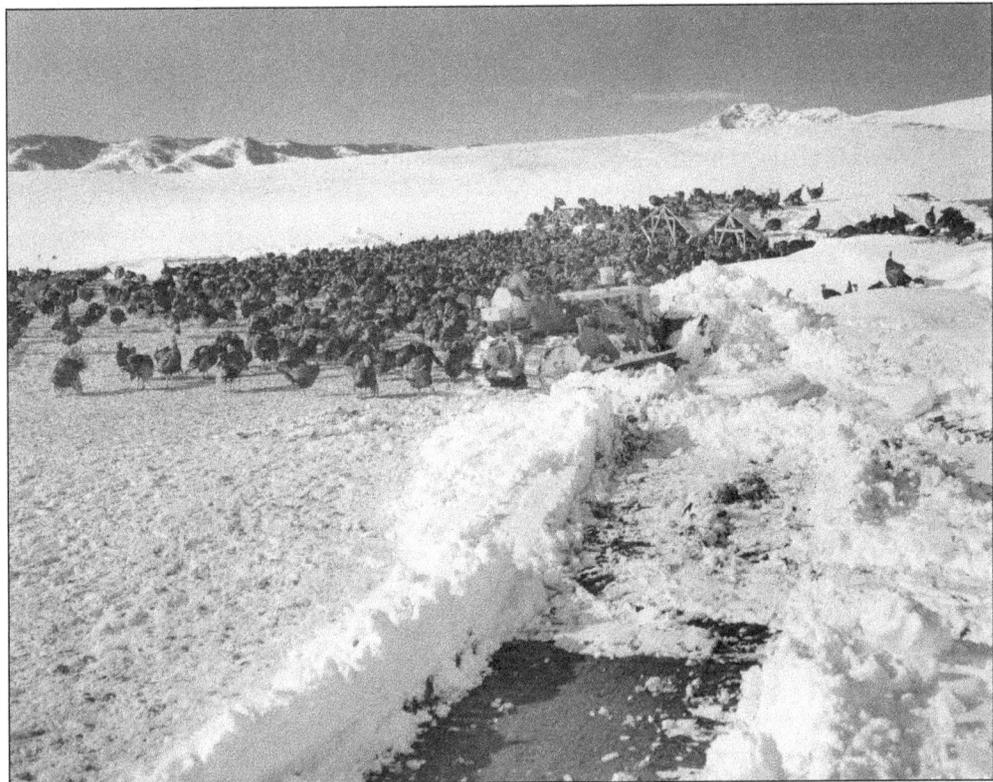

Frank and Amanda Peterson's sons, Victor, Harry, Albert, and Ted, managed several turkey farms across Lakewood. The largest turkey farms were on Green Mountain. Their flock grew to 26,000 birds by the mid-1940s. After a 1940s snowstorm, the Petersons bulldozed their way to feed a stranded flock. (Courtesy of Lakewood's Heritage Center.)

By the late 1920s, the families of established Lakewood farmers began to sell off sections of their homesteads to make way for new houses. In 1929, Sam Braden took possession of land cultivated by the Westfield family. The main house stood at the junction of West Mississippi Avenue and South Sheridan Boulevard. (Courtesy of Lakewood's Heritage Center.)

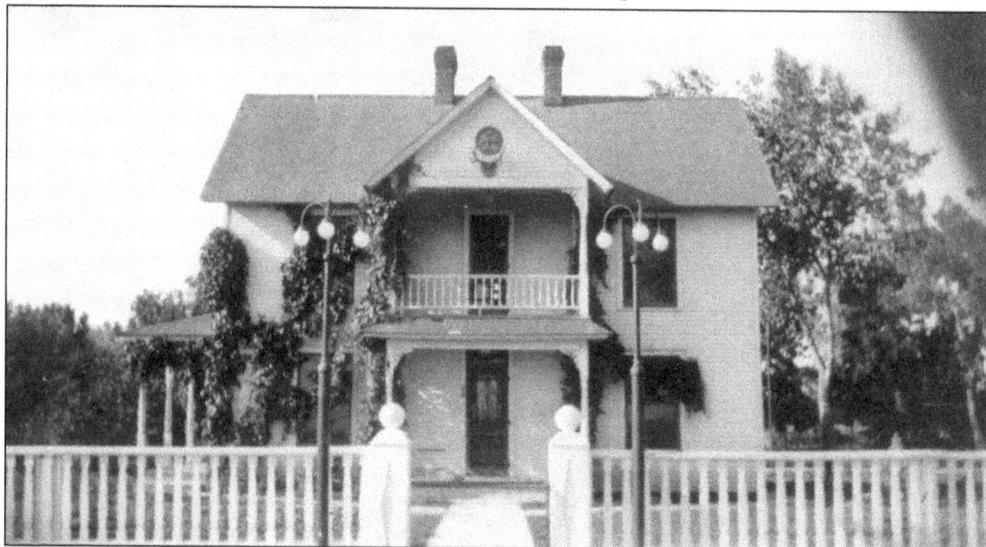

After a fire destroyed his original farmhouse in 1924, William Gorrell constructed a new home on West Mississippi Avenue within a year. The Gorrells saved their furniture by throwing it out the windows during the fire. Like most farm families, William and Anna Gorrell had their share of tragedy. Married in 1892, Anna Gorrell bore 13 children with five dying in infancy. (Courtesy of Lakewood's Heritage Center.)

Established in 1890, the Gorrell family's dairy farm boasted 320 acres and 30 milking cows. Their farm was a typical example of Lakewood's early-20th-century dairy industry. The Gorrells employed about two dozen men each spring. The second floor of their two-story bunkhouse provided living quarters for some of their hired men. The milk was stored in a tank building next to the bunkhouse. The Gorrells sold their milk to dairies for processing and retail sales. Alderfer Dairy, Windsor Dairy, and Carlson Frink Dairy all bought Gorrell milk. In the winter, the Gorrells supplemented their income by cutting and delivering ice from the two ponds on their property. (Both courtesy of Lakewood's Heritage Center.)

The Gorrells new brick house was built on the foundation of their original home. Most Lakewood dairies up until the 1920s, such as Green Mountain Dairy or Harp Dairy, were on five to 40 acres. Owners generally hired one to three men to help. The Gorrell family dairy encompassed 320 acres—an area equal to a rectangle one mile long and half a mile wide. In the 1920s and 1930s, the Gorrells used a generator and batteries to power their lights and radio. A new owner wired the house for electricity in the 1940s. (Both courtesy of Lakewood's Heritage Center.)

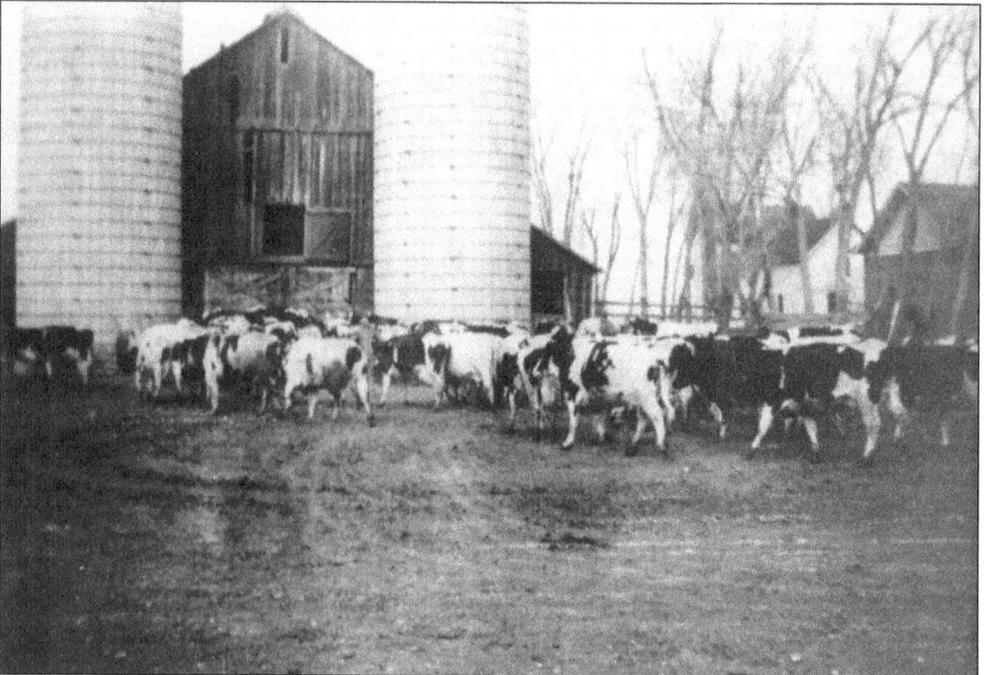

In April 1881, William
Thomas Gorrell left Ohio
to settle in Colorado.
In 1906, Gorrell bought
land north of West Jewell
Avenue and west of South
Wadsworth Boulevard,
expanding his farm to
320 acres. The Gorrells'
two-story smokehouse
was used to cure hams
and whole sides of beef.
(Courtesy of Lakewood's
Heritage Center.)

In 1865, Joseph Rist
obtained several parcels
of land near Bear Creek.
In the mid-19th century,
the Pennsylvania House
stage stop stood south
of Morrison Road and
west of South Kipling
Street. George Allen
subsequently ran the
Kendalvue Dairy at this
site during the first half
of the 20th century.
(Courtesy of Lakewood's
Heritage Center.)

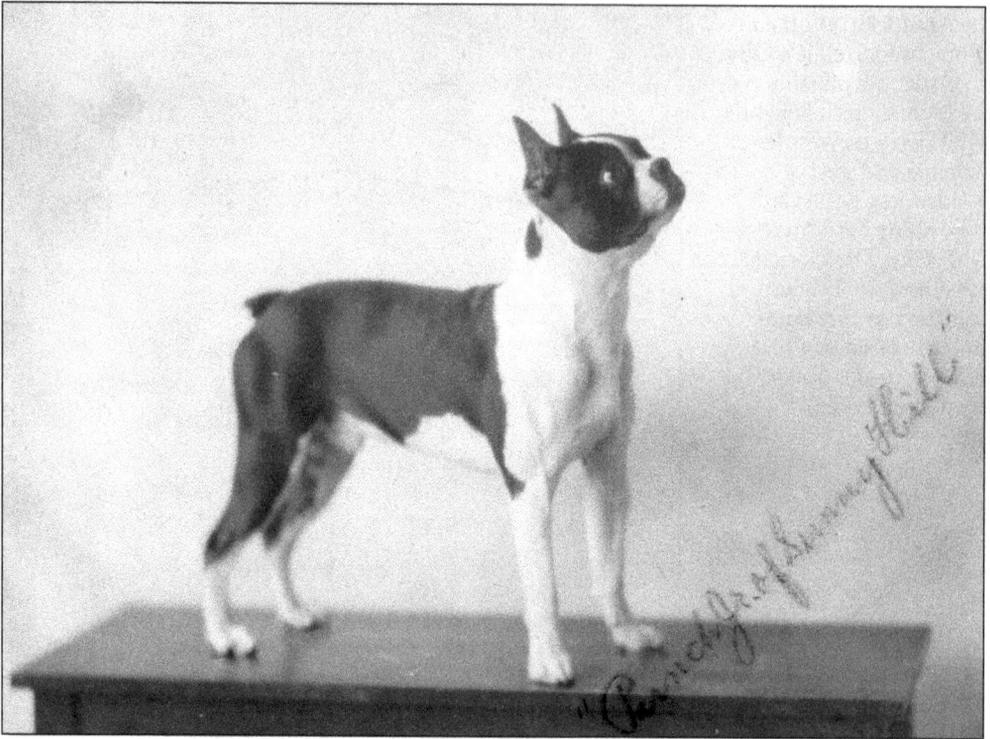

"Punch Jr. of Sunny Hill"

Lakewood's animal husbandry was not limited to dairies, ranches, and poultry farms. In the 1930s and 1940s, farms like Mountain View Rabbitry and the Axford Fox Farm were among the community's nontraditional agribusinesses. Anscot Kennels, Edgewood Kennels, and Even So Kennels (West Colfax Avenue), Bull-Haven Kennels and Bonnie and Joe's Canine Beauty Salon (Teller Street), and Lakewood Kennels (Reed Street) also offered boarding, grooming, and training services. Lakewood's kennels bred Boston terriers, English bulldogs, collies, and miniature schnauzers. Punch Jr. of Sunny Hill was a champion Boston terrier raised at the Lakewood Kennels and owned by Ray and Daisy Carver. Below, the back of a trade card traces four generations of the pedigree of the Carvers' champion Peter's All Clear Signal. (Both courtesy of Daisy Koffman Masoner.)

CHAMPION PETER'S ALL CLEAR SIGNAL
A-560504

	Personality Clean Sweep 4-Points	Personality Personality King 11-Points	Ch. Personality Kid Ch. Brayman's Miss Leading Lady
Personality Peter Hagerty A-369559 9-Points		Kingway Donlinna	Ch. Captain Hagerty Kingway Clean Cut
	The New Yorker 4-Points	Monte Carlo Captain	Monte Carlo Handsome Fangmann's Little Vamp
		Gypsy Chica	D.V.M.'s Expectation Gypsy Brindy
	Kingway Personality King 11-Points	Ch. Personality Kid	Ch. Ravenroyd Rockefeller Ch. Sunny Girl
Personality King's Moody Girl A-512873		Ch. Brayman's Miss Leading Lady	Ch. Garry's King Brayman's Rare Charm
	Moody's Tomboy	Ch. Moody's Yankee Boy	Ch. Captain Moody Motor City Memory
		Dazzling Lady	Captain Hagerty II Buttered Toast

48

Daisy Masoner described her great-aunt Daisy Carver as her "sweet little lady aunt." Ray and Daisy Carver built their house and kennel to breed Boston terriers at 1450 Reed Street between 1931 and 1935. In the late 1940s, the Carvers divorced and closed the kennel. Daisy later moved to Denver, and she is remembered for her fondness for gentle, well-mannered, and somewhat enthusiastic little dogs. (Courtesy of Daisy Koffman Masoner.)

Ray and Daisy Carver's house is on the left, and the Lakewood Kennel is on the right. The kennel featured an apartment in the front, and the dogs lodged at the back of the building. The Carvers hired Signe Carlson to breed, train, and show their dogs. Carlson presented the dogs in events at the Colorado Kennel Club and American Kennel Club. She also showed the dogs as entertainment for the patients at Fitzsimmons Army Hospital in August 1945. (Courtesy of Daisy Koffman Masoner.)

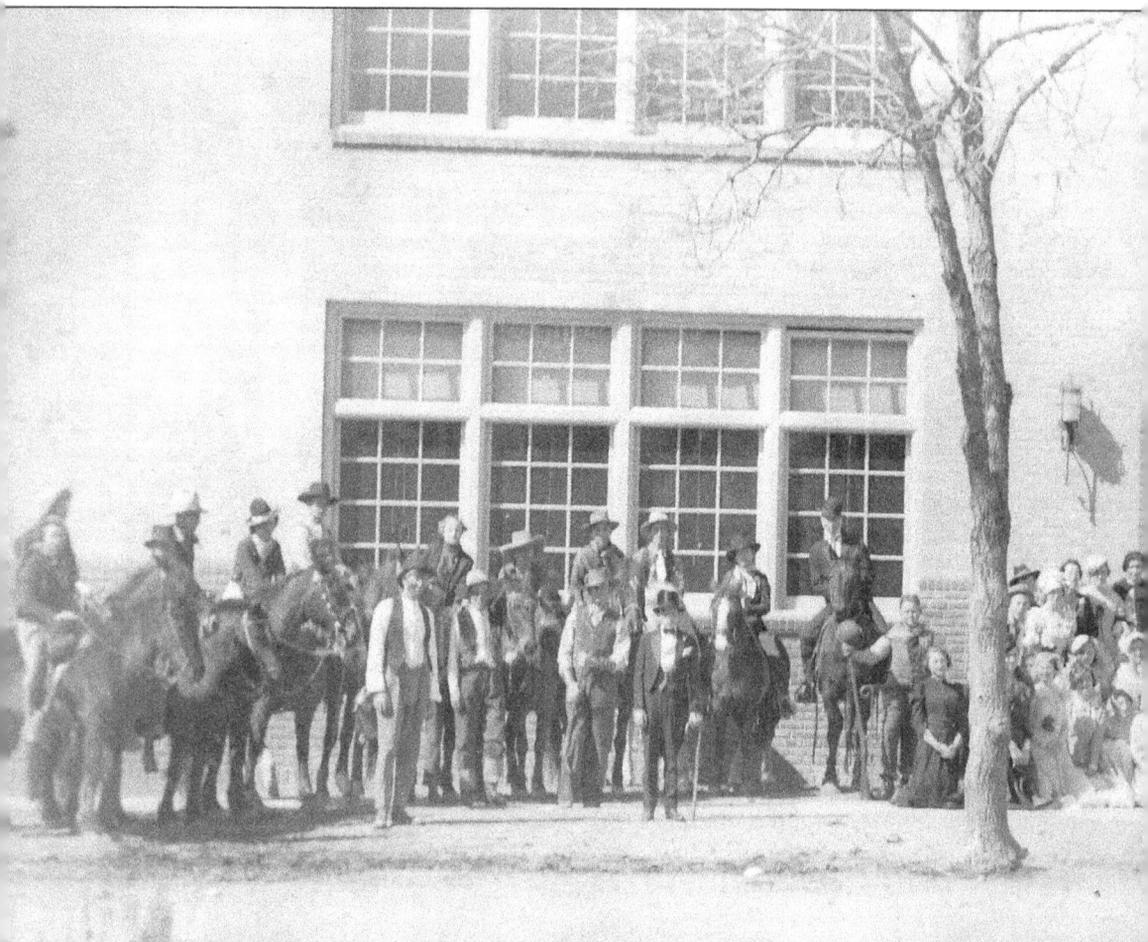

Although there were many hardships during the Great Depression, students from Lakewood High School still programmed Pioneer Day for the community's first residents. Throughout the 1930s, Pioneer Day was a reoccurring tribute to Lakewood's earliest settlers. Teachers and the principal were involved. Lakewood's earliest settlers predate this photograph by about 70 years. Many first

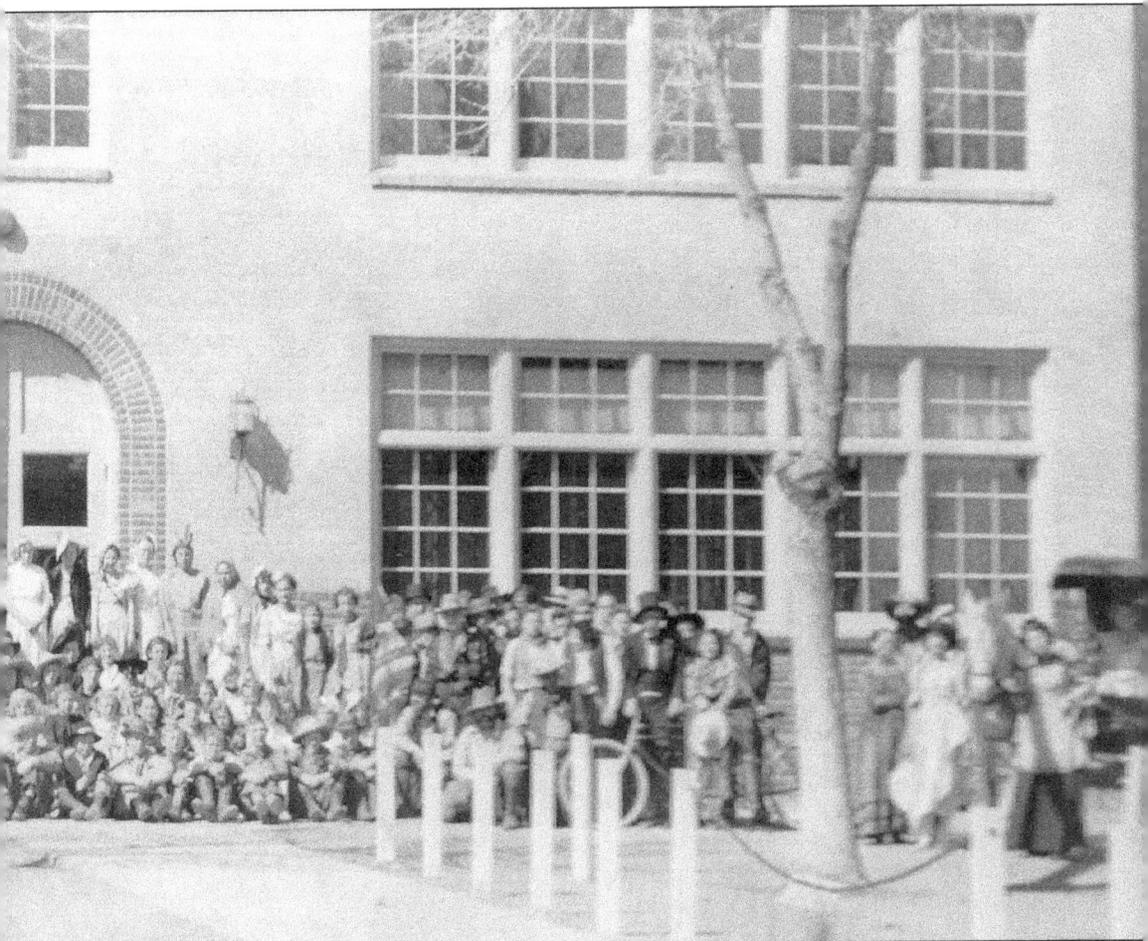

residents left after a few years, and they sold improved farmsteads with equipment. Due to the influx of new residents between 1890 and 1910, it is likely that only a few of these children were descendants of Lakewood's first residents. (Courtesy of the O'Kane family.)

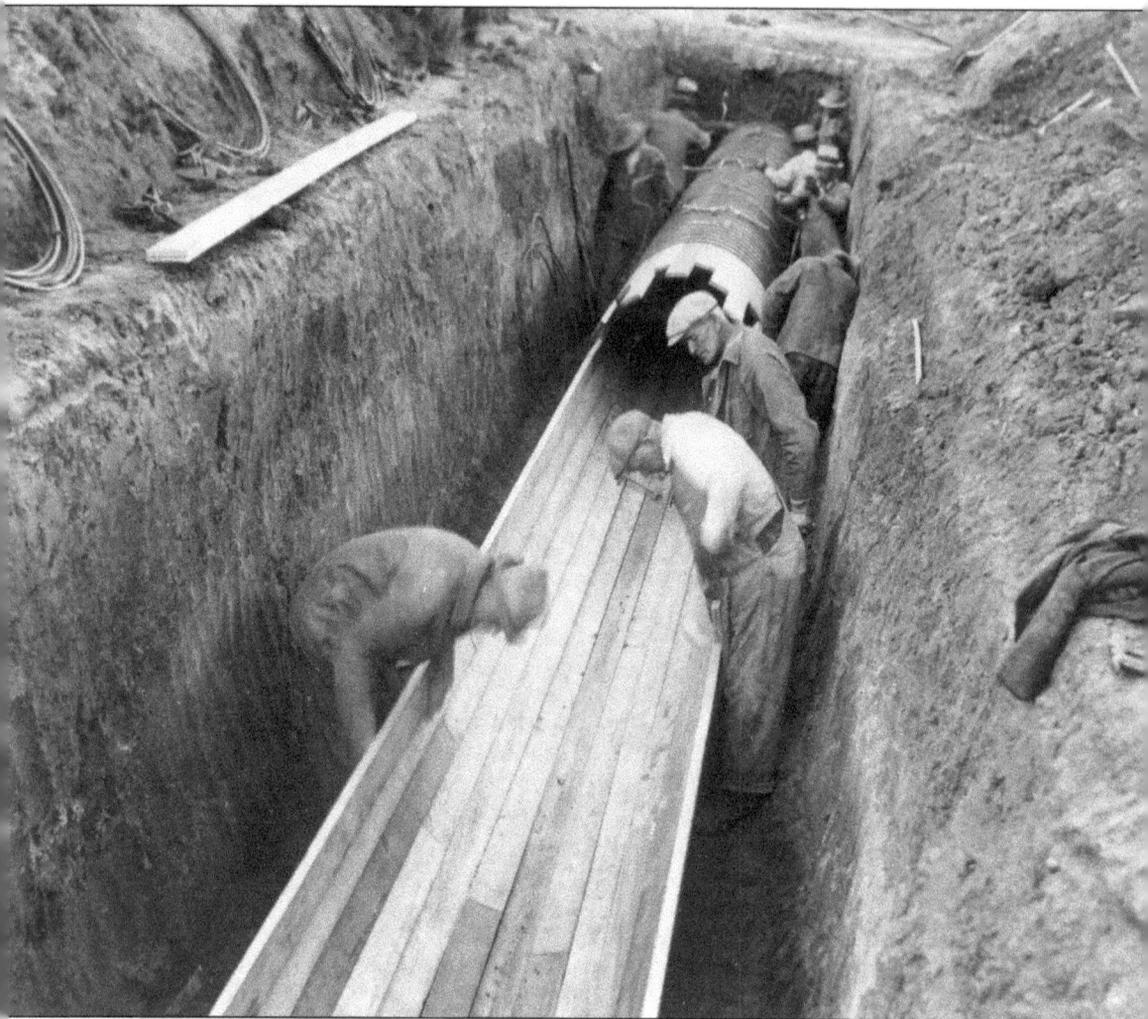

As the population grew and became less agrarian, the community needed infrastructure like water and sewage pipes. Above, workers construct a wooden stave pipe under an unidentified Lakewood street. This method of building wooden stave pipes for sewer or potable water was unchanged in the West between 1900 and the 1940s. After the staves were set, metal bands were placed around the finished pipe to ensure that it would not come apart under pressure. Wooden stave pipes have the longest life in applications where the pipe is continually and entirely wet. Decay begins when part, such as the top staves, begins to dry out. During World War II, wood was used as an alternative, nonessential material for sewage pipes. (Courtesy of Lakewood's Heritage Center.)

Three

TRANSCONTINENTAL AND INTERURBAN

LAKEWOOD'S TRAINS AND TROLLEYS

Agriculture was Lakewood's economic base at the end of the 19th century. However, the collection of ranches and farms was not completely isolated from the growing city to the east and the immovable mountains to the west. Horses and stagecoaches brought Lakewood's first settlers and remained an important aspect of farm living for many years thereafter, but the railroad was the next step in the evolution of transportation. The locomotive made it possible for one of the community's founding fathers, William A.H. Loveland, to achieve his ambition to plat a community where his Denver, Lakewood & Golden Railway (DL&G) could stop and take on passengers. The January 2, 1892, issue of the *Rocky Mountain News* described the DL&G as "a humble affair" with 15 miles of track and eight stations. A century after Loveland platted Lakewood, Associated Railways abandoned its route to the Denver Federal Center. As a result, Lakewood was the first city in late-20th-century America to lose its rail service despite having more than 100,000 citizens.

Few mourned the loss of freight traffic in Lakewood by the end of the 20th century, but there were still many residents who fondly recalled the Denver & Intermountain Railroad (D&IM). The D&IM trolleys carried Lakewood's residents from downtown Denver out to Golden for nearly five decades. The D&IM made the rural community of Lakewood seem a little more sophisticated. As the automobile reshaped Lakewood and the nation, it was no longer important to remember a timetable for trains and trolleys. As gravel roads expanded into four-lane highways, segments of the D&IM track rusted from abandonment and exposure. The trolley's linear rails are about to carry Lakewood back full circle. In 2013, Denver's Regional Transportation District will launch a new light rail route that closely follows the D&IM's original alignment.

The 1889 Beecove Cottage was a welcome sight for 19th-century travelers between Morrison and Denver. Riders on the Wall and Witter stagecoach line would stop and purchase honey, which was sold by the comb and jar. David K. Wall also farmed and sold farm implements, and Daniel Witter ran a title abstract business. Both men oversaw the construction of the earliest irrigation ditches in Lakewood and nearby Wheat Ridge. (Courtesy of Lakewood's Heritage Center.)

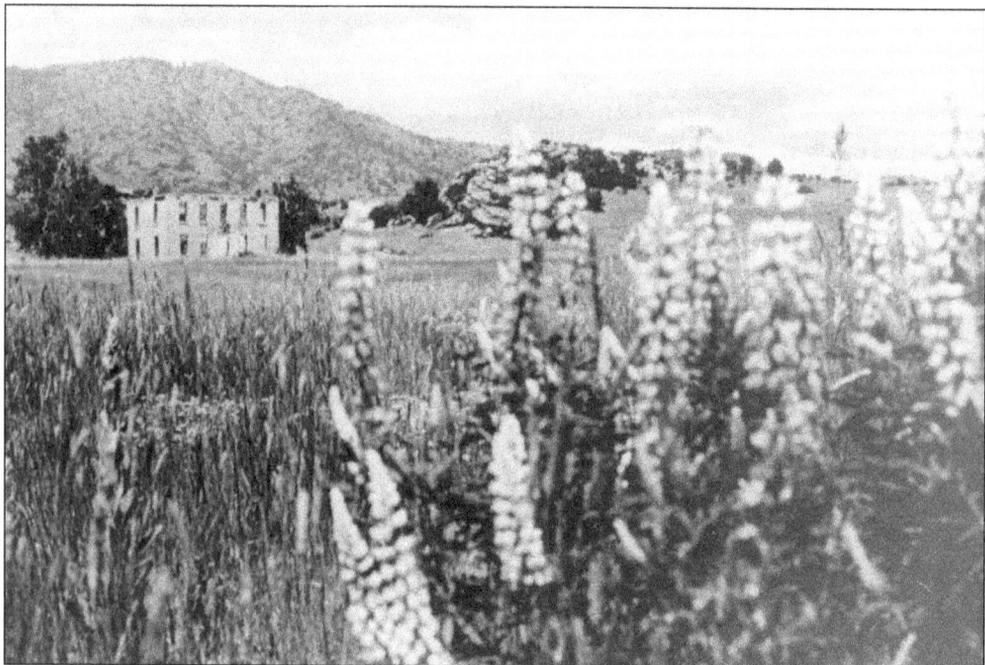

In the 1860s, Robert Bradford built this stonewall mansion for his family before constructing a toll road across his property. Bradford hoped to earn $500 a week from his private thoroughfare. His toll road was not profitable, because there were a number of other routes that led fortune-seekers to the mining camps in South Park. Later visitors to his estate observed that his "city of a house" looked "solitary and bereaved." (Courtesy of Lakewood's Heritage Center.)

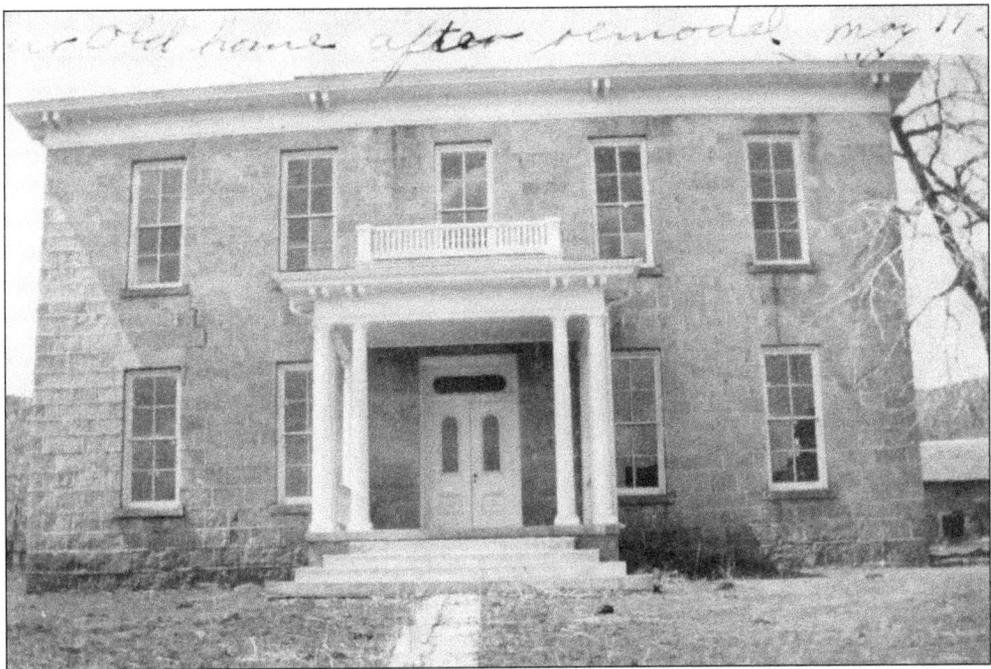

old home after remodel. may 11

In 1862, Bradford Road entered Lakewood at what is now Hart's Corner on South Sheridan Boulevard, then it veered south and west over Carmody Hill on South Kipling Street. It crossed Bear Creek and went into Robert Bradford's unrealized dream of a town. James Adams Perley purchased the 229-acre site in 1895 and set about renovating the house. (Courtesy of Lakewood's Heritage Center.)

Perley's daughters, Josephine and Charlotte, pose in front of the old Bradford house in 1919. Less than 10 years later, the Perleys sold their land to *Rocky Mountain News* publisher John Shaffer. Shaffer acquired adjoining lands and expanded Bradford's original 226 acres. The area is known today by the first names of Shaffer's two sons, Ken and Caryl. With the renaming of streets and roads, Ken-Caryl Ranch has lost its association with modern Lakewood. (Courtesy of Lakewood's Heritage Center.)

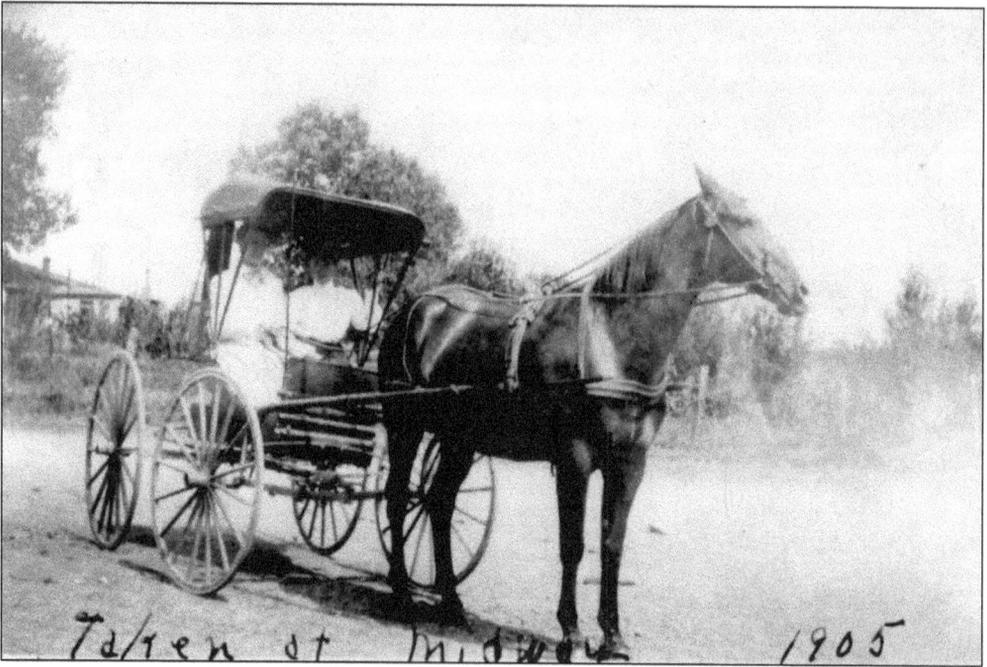

Taken at Midway 1905

Leah Bancroft takes the horse and buggy out for a spin in 1905. As one of Lakewood's first prominent families, the rig was necessary for the duties of her father, Dr. Frederick Bancroft, a physician. This photograph was taken near the Midway School, which was built on lands donated by the Bancrofts. (Courtesy of Lakewood's Heritage Center.)

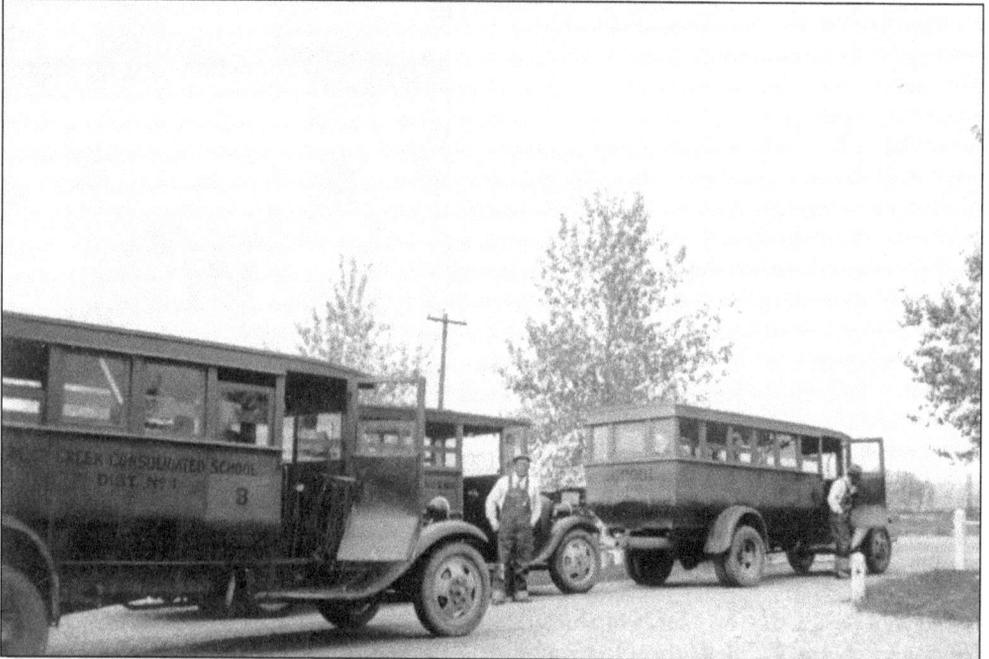

During the late 19th and early 20th centuries, Lakewood's school districts covered a lot of territory. In the 1920s, schools in the Bear Valley neighborhood began to use buses to transport students to the community's only school in southern Lakewood. (Courtesy of Lakewood's Heritage Center.)

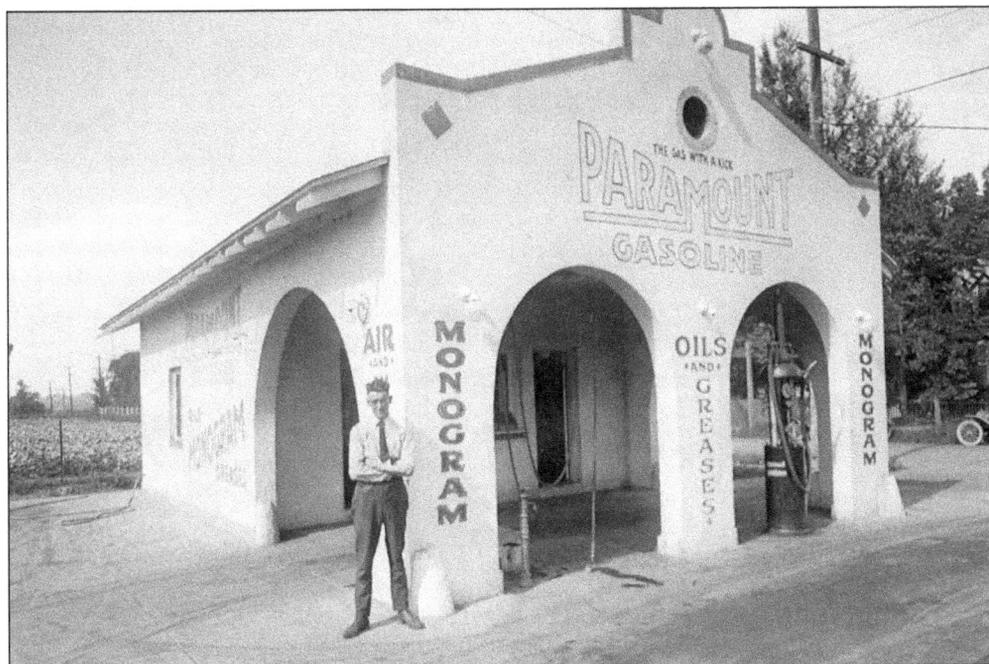

West Colfax Avenue, or US Highway 40, was the primary route to reach the Rockies from Denver dating back to the appearance of the first cars in Colorado. During the 1920s, the Paramount gas station serviced many of those automobiles at 5201 West Colfax Avenue. From the 1920s to the 1940s, West Colfax Avenue saw an increasing number of motels, restaurants, and roadhouses. (Courtesy of Kenneth and Faye Milne.)

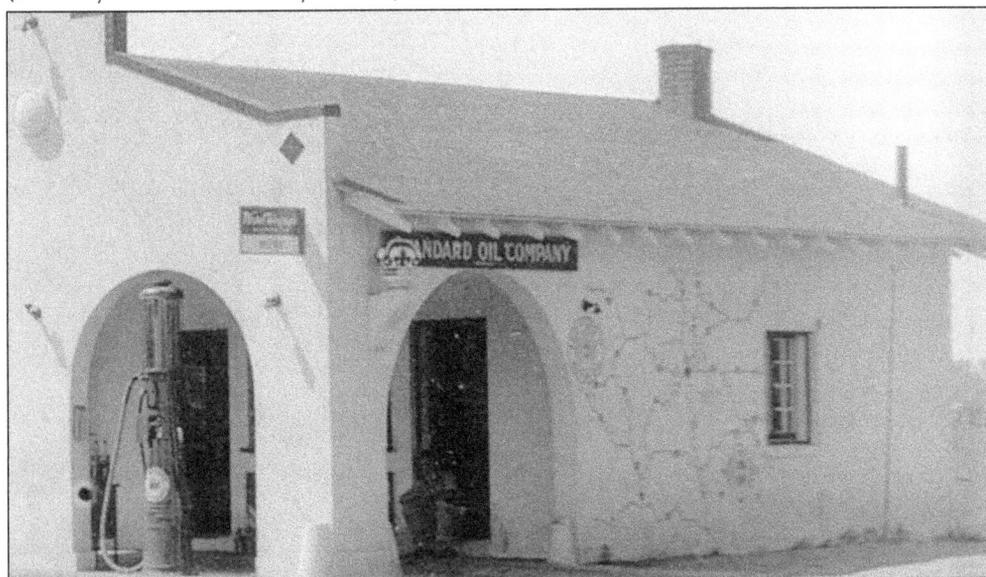

Bigger than any road guide but difficult to store in the glove box, the eastern exterior of the former Paramount gas station featured a map of the Denver Mountain Park System. The administration of Denver mayor Robert W. Speer designed a series of parks later managed by the City and County of Denver to invite motorists to the mountains west of the city. (Courtesy of Kenneth and Faye Milne.)

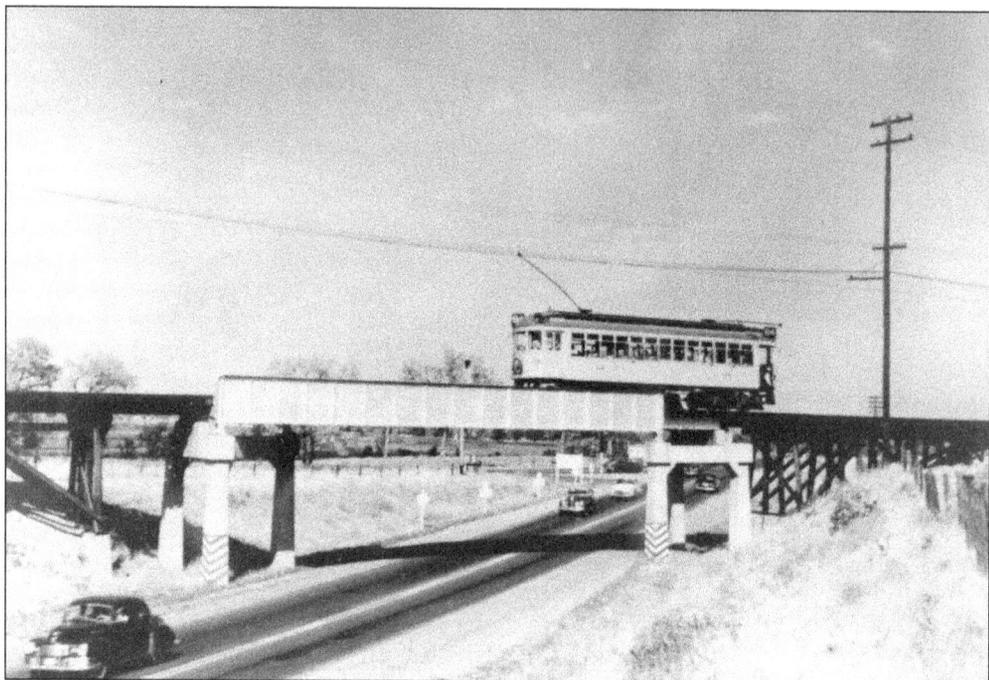

A Denver Tramway Company trolley crosses Sheridan Boulevard westbound in 1949. The site of the sunshine colored cars whizzing past at 50-to-60 miles per hour caused some wags to refer to the trolley as "the Yellow Peril." By June 1950, the Denver Tramway Company went to an all-bus service and put the trolleys out of commission. (Courtesy of Lakewood's Heritage Center.)

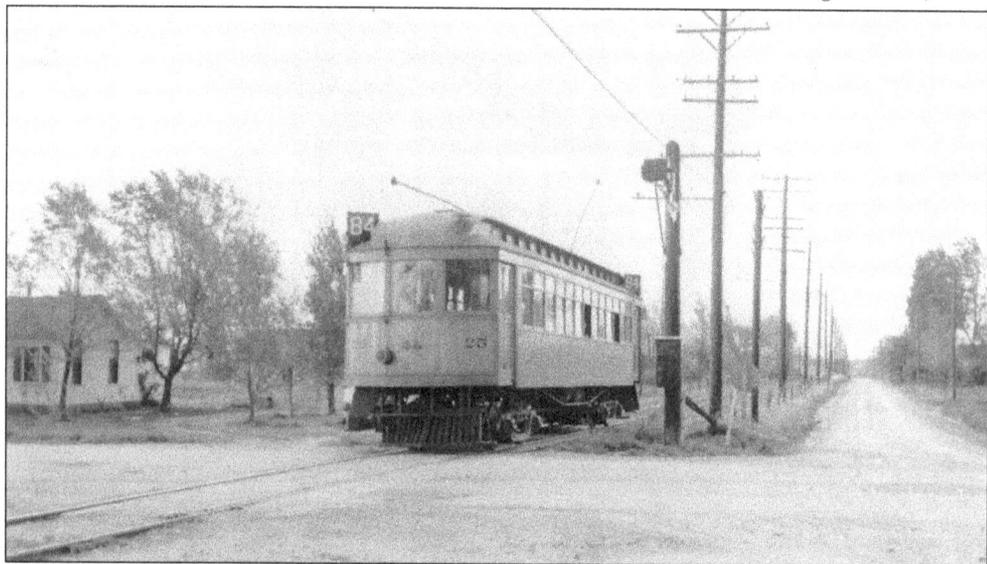

The Denver and Interurban Mountain (D&IM) 84 trolley makes a stop at Pierce Street and West Thirteenth Avenue. Route maps identified stations by locally familiar names or landmarks, such as Devinny Station (Wadsworth Boulevard) and Beehive (Kipling Street). According to a timetable from the 1920s, the 84 trolley ran from downtown Denver's interurban loop to its terminus at West Thirteenth Street and Washington Avenue in Golden in 38 minutes. (Courtesy of Lakewood's Heritage Center.)

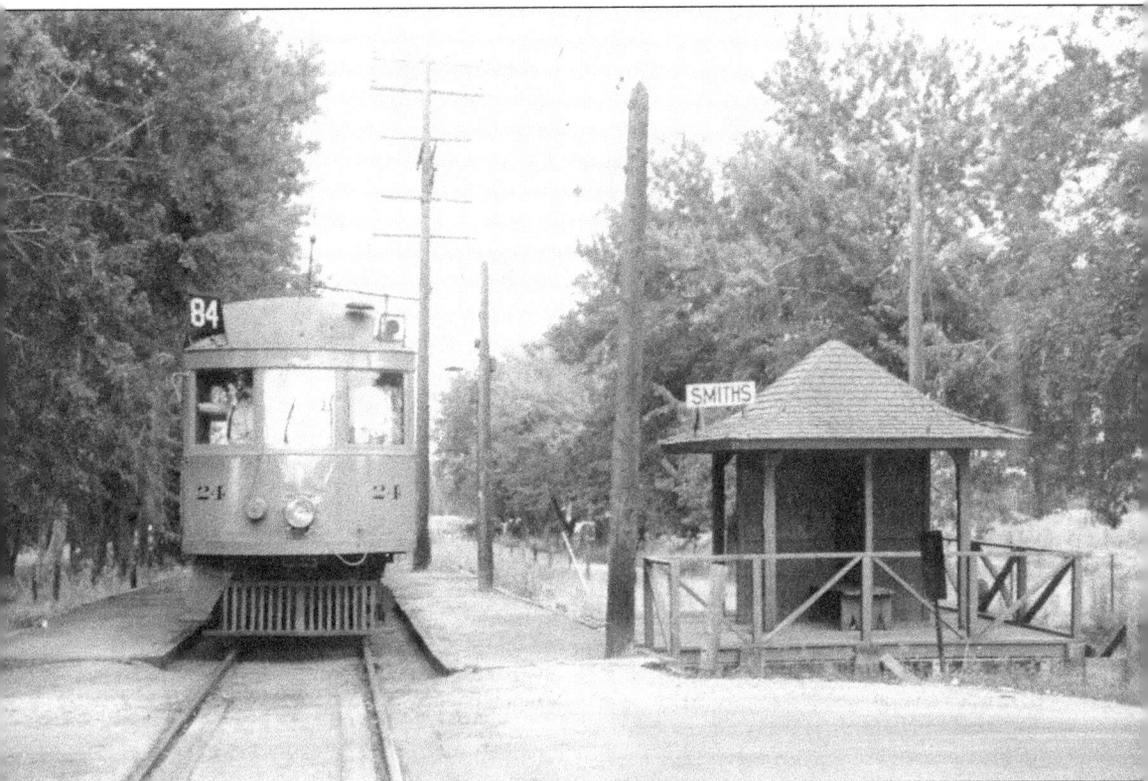

The 84 trolley makes a stop at the Smiths station near West Thirteenth Avenue and Garrison Street one afternoon during the 1930s. The Smiths stop was named after an early ranching family, and Garrison Street was originally called Smith Road. The D&IM also ran a freight service, and many local sugar beet growers would ship from Smiths station to sugar beet refineries outside of Denver. During the years when most of Lakewood's residents made their living off the land, there was a sugar beet dump adjacent to the tracks. Not all stops along the 84 trolley route could boast covered stations. The Smiths station had a lot of traffic because there was a modest structure protecting waiting passengers from the elements. (Courtesy of Lakewood's Heritage Center.)

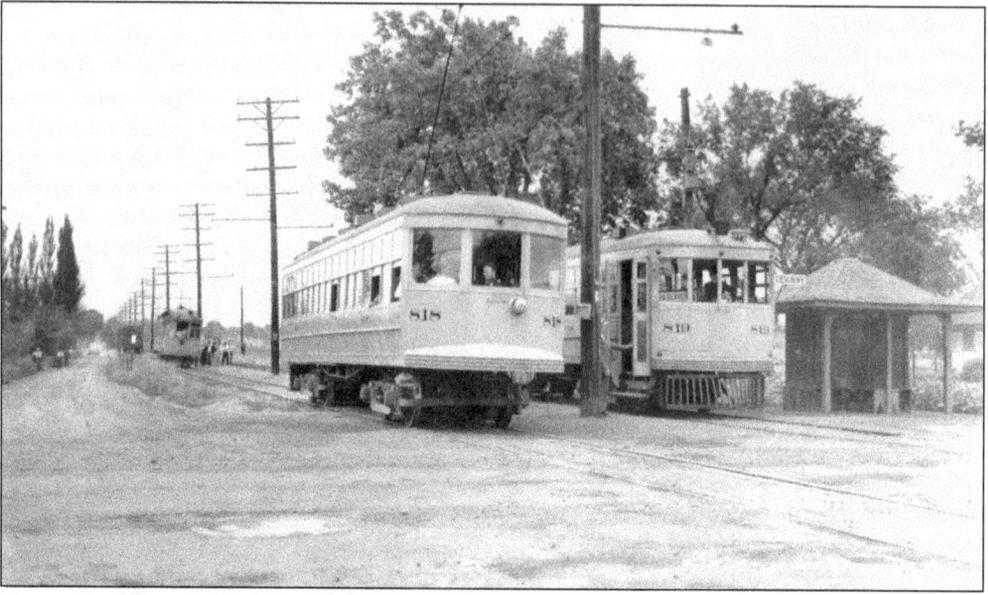

Two trolleys pass each other at the Devinny station at Wadsworth Boulevard. At this point, the operators would switch the trolley car from the main track to a side track. One of the operators would contact a dispatcher in Golden to confirm if any freight or trolleys were headed down the line. Once given the "all clear," the westbound journey would resume into Golden. (Courtesy of Lakewood's Heritage Center.)

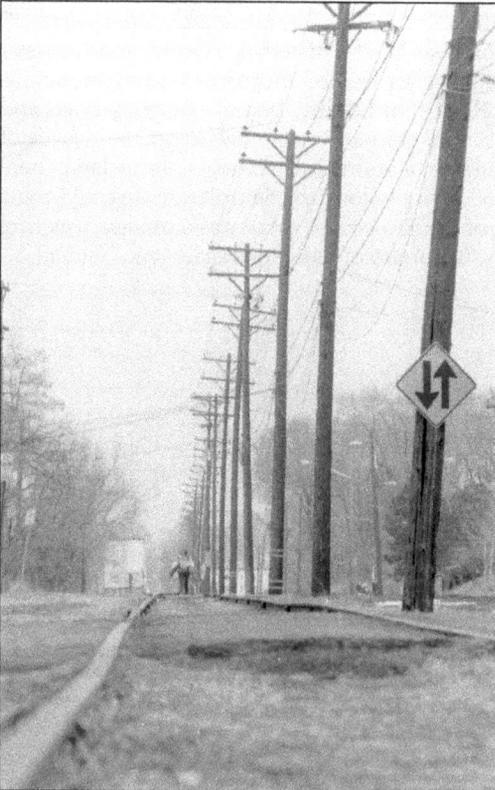

The 84 trolley paralleled West Thirteenth Avenue through Lakewood during the first half of the 20th century. Segments of track remained haphazardly untouched near West Thirteenth Avenue from 1950 to the end of the century. The Regional Transportation District (RTD) will follow much of the same alignment for its light rail service. The RTD's Gold Line is scheduled for completion in 2013. (Courtesy of Lakewood's Heritage Center.)

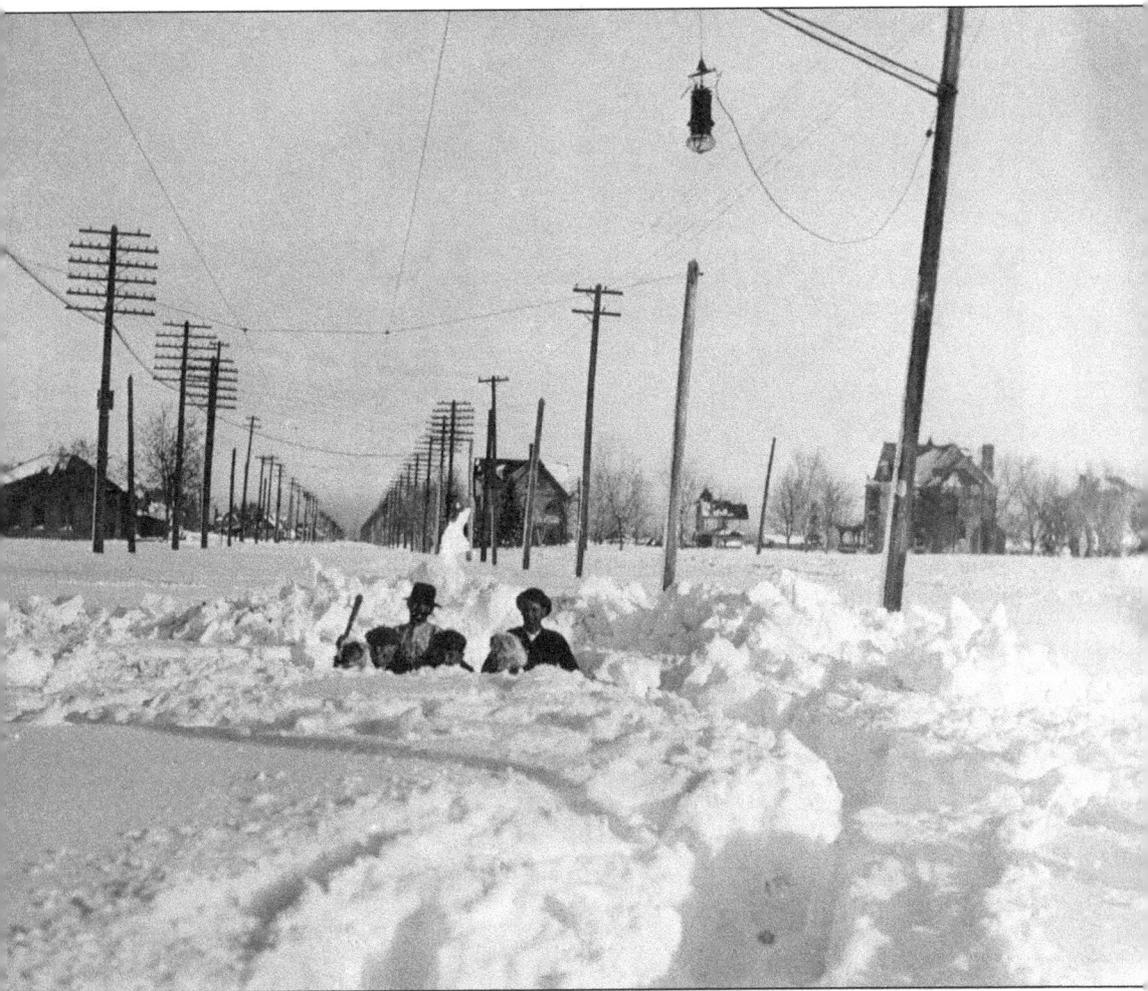

The greatest snowstorm in metropolitan Denver's recorded history shut down all travel in Lakewood and the rest of the Front Range on December 4, 1913. The More family on Garrison Street, along with their neighbors, dealt with drifts as high as 12 feet into the spring of 1914. Six decades later, Marsh and Evelyn Nottingham recalled that the storm had buried Lakewood's man-made infrastructure. They remembered that "all the familiar landmarks were gone—fence, fence post, and small buried roadways erased. Most of all, long-timers remember the strange silence, for transportation, school, the usual business of daily life and its attendant sounds were halted and quieted by the great snows." During the snowstorm, an interurban train on its way to Golden found itself marooned west of Lakeside Amusement and to the north of Lakewood. Passengers spent several days trapped by drifts until a Denver Tramway plow came to their rescue. (Courtesy of Lakewood's Heritage Center.)

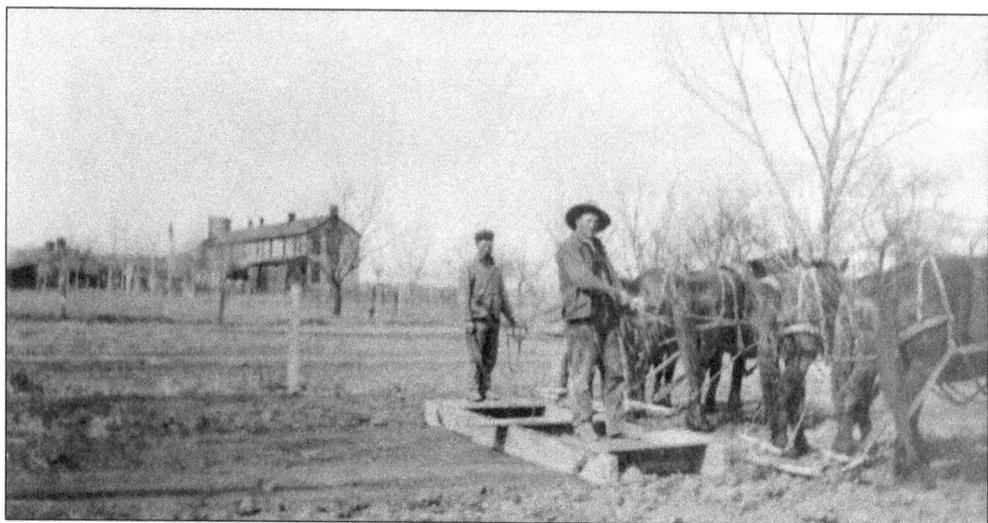

Work animal, companion, and family member, horses were more than just transportation before the coming of the automobile. The earliest brand books in Jefferson County indicate that ranchers and farmers branded their cattle and horses to protect them from theft and as easy identification if they went astray. This team is clearing the Westfield Farm around 1910. The Westfield Farm was south of West Mississippi Avenue at the junction of South Sheridan Boulevard. Westfield was also the first stage stop in Jefferson County on the old Bradford Road. (Courtesy of Lakewood's Heritage Center.)

Sam Licht ran the Curve Market during the 1920s. The stretch of Morrison Road (now West Mississippi Avenue) near the intersection with Pierce Street is still known by most Lakewood residents as "the Curve." The area got its name from the way the street bends to the right and then left in defiance of the rest of Lakewood's linear street grid. (Courtesy of Lakewood's Heritage Center.)

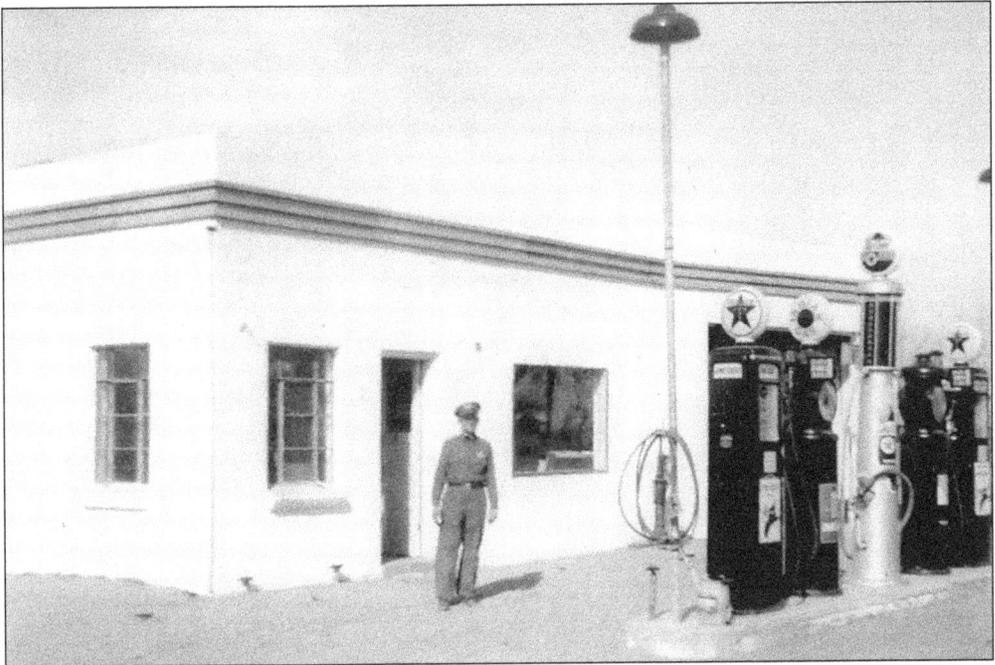

Most of Lakewood's earliest gas stations were often additions to a general store or a conversion of an outbuilding. By the 1920s, brand recognition through corporate design eliminated homegrown structural whimsy. The first streamlined, or igloo style, gas stations made of gleaming metal had their first appearance in Lakewood by the early 1940s. This station stood near the Curve on Morrison Road. (Courtesy of Lakewood's Heritage Center.)

First making their appearance after World War I, bungalow automobile courts eventually transitioned into motels as Americans hit the road in greater numbers. Sam Licht owned the Bungalow Court, located on the Curve along Morrison Road. The Bungalow Court offered a night's rest to those folks headed into or from the south central Rockies. (Courtesy of Lakewood's Heritage Center.)

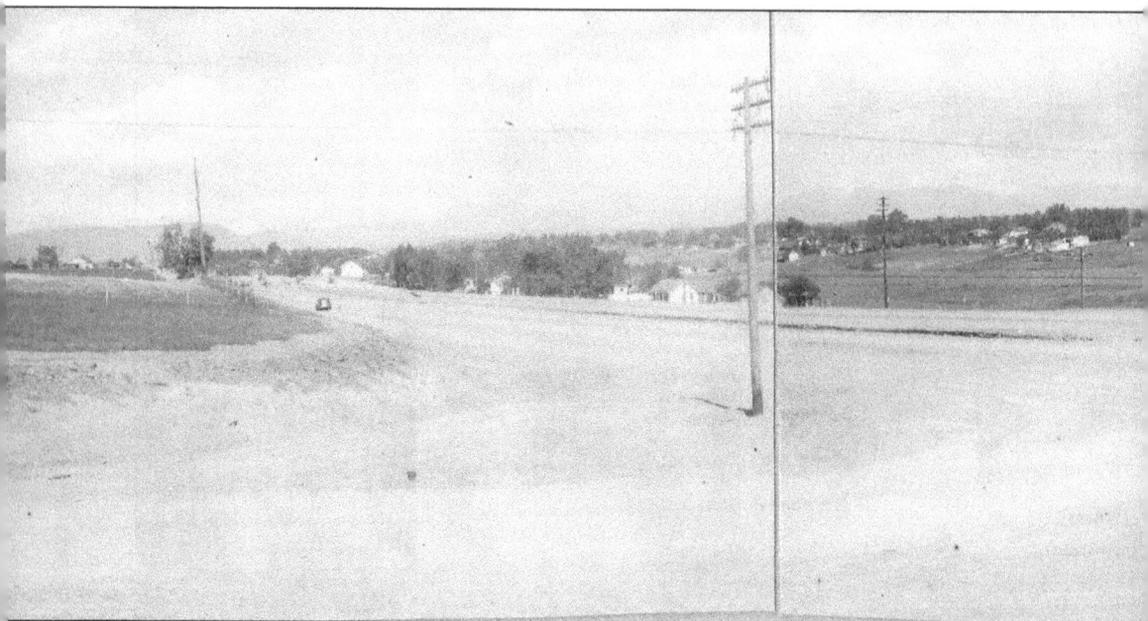

Poultry and cut flower farms were still found near West Sixth Avenue and Sheridan Boulevard by the early 1940s, but the area's bucolic character was about to change. The US War Department authorized the expansion of West Sixth Avenue from downtown Denver through Lakewood and on into Golden. The acquisition of the Hayden Ranch property for the construction of the Denver Ordnance Plant heralded the transformation of this sleepy country lane into

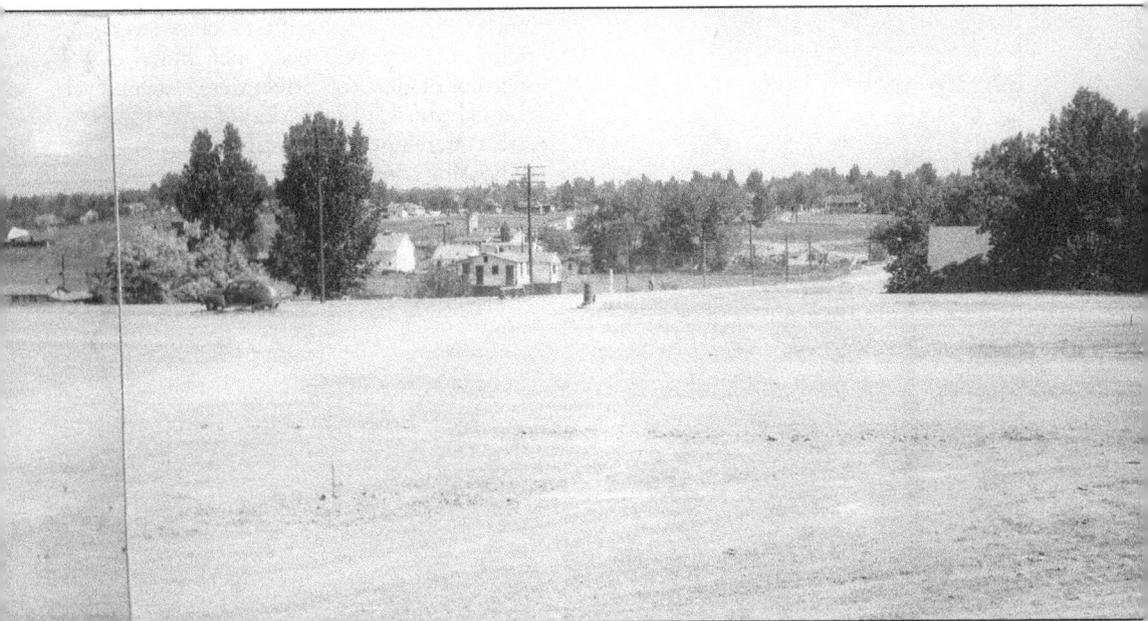

the fastest route from Denver to wartime jobs in Lakewood. The six-lane highway remains the primary route between downtown Denver and the Rockies to the west before merging with Interstate 70 west of Golden. Lakewood resident and amateur photographer Donald Rittenhouse created this panorama out of three separate pictures in May 1942. (Courtesy of Donald and D. Arter Rittenhouse.)

With the exception of West Colfax Avenue, many of Lakewood's roads, including this segment of Garrison Street were rough gravel through the war years. Most of Lakewood's streets were not paved until the first wave of housing construction in the late 1940s. Concrete has yet to reach some Lakewood neighborhoods, like the Glens and Daniels Gardens, as they remain without sidewalks. (Courtesy of Donald and D. Arter Rittenhouse.)

Old meets new in front of the Hart's Corner BBQ and Tavern on a summer's day during the 1940s. As the Tivoli Brewery of Denver beer wagon makes a promotional visit, a motorist stops to purchase gasoline that was priced at 12¢ per gallon. The horse teams that were important to Lakewood's early survival became a curiosity on the community's streets by the mid-20th century. (Courtesy of Lyle Miller.)

Four

WHERE WAS
DOWNTOWN LAKEWOOD?
A TOWN SEARCHES FOR ITS CENTER

For most of its history, Lakewood was a community in name only. If Lakewood had no municipal identity, looking for a downtown Lakewood would be a pointless exercise. Other suburbs and towns surrounding Denver recognized an economic or historical area in their respective communities. Lakewood did not officially become a city until a few weeks after Neil Armstrong took his first steps on the moon. However, Lakewood's attempt to create a commercial and residential heart within the town's boundaries occupied nearly the entire 20th century.

West Colfax Avenue was usually discussed as the potential city center. But Colfax's intersection with Lakewood's primary north-to-south route, Wadsworth Boulevard, remained the downtown in most residents' minds. Concurrent with the rise of West Colfax Avenue and Wadsworth Boulevard, other commercial districts grew around the intersection of West Colfax, Carr Street, Morrison Road, and Sheridan Boulevard. During the first 50 years of the 20th century, hardworking people who spent each day making their feed stores, groceries, and gas stations successful symbolized self-reliance along with mom-and-pop business sense. Contemporary phone books and newspapers from the 1920s to 1950s recorded that Lakewood did not have an abundance of milliners or Cadillac dealerships. In the 21st century, Lakewood has retained a handful of these potential downtowns. These areas have blossomed quietly and faded slowly while holding on to the character of their neighborhoods.

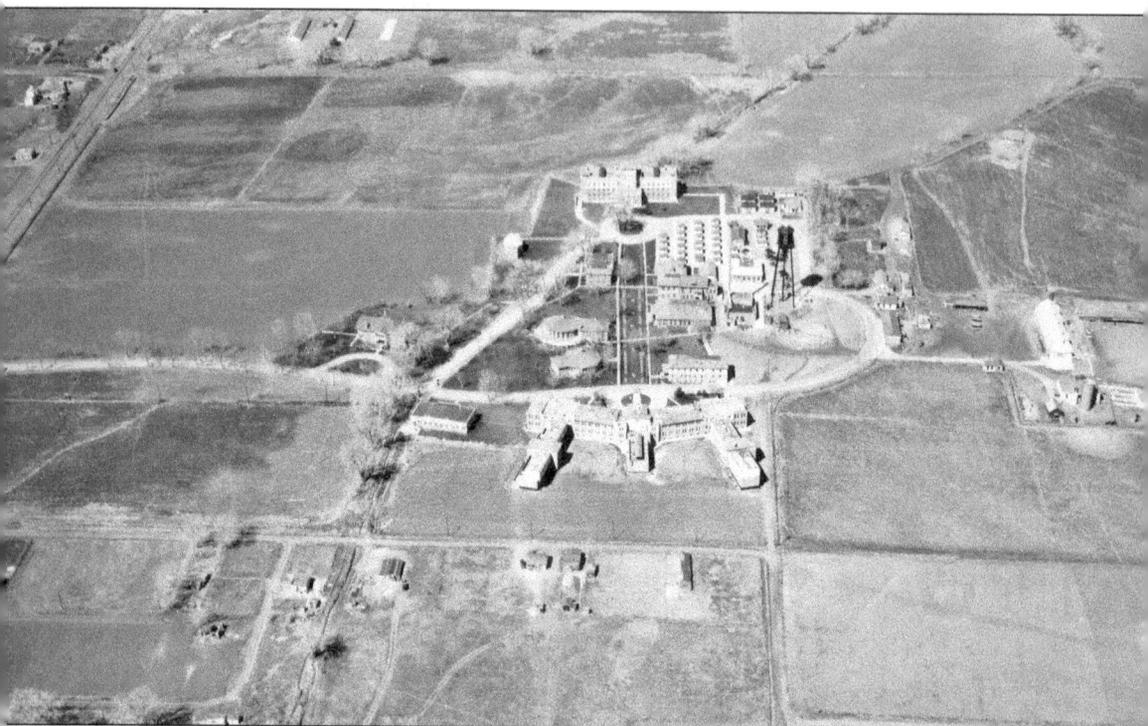

In 1903, a group of Denver Jewish working class immigrants formed the Jewish Consumptive Relief Society (JCRS). The society's goal was to treat patients in all stages of tuberculosis in "a more Jewish environment." Opening its doors the following year, patients at JCRS spent as much time as possible in the open air to cure them of the disease. The JCRS motto was: "He who saves one life saves the world." JCRS dominates the land north of West Colfax Avenue, which is visible crossing the upper left-hand corner of this 1930s aerial photograph. Commercial interests began to crowd the JCRS campus by the early 1950s, resulting in the completion of one of metropolitan Denver's earliest shopping malls directly to the south of the sanatorium. (Courtesy of the Arthur Lakes Library, Colorado School of Mines.)

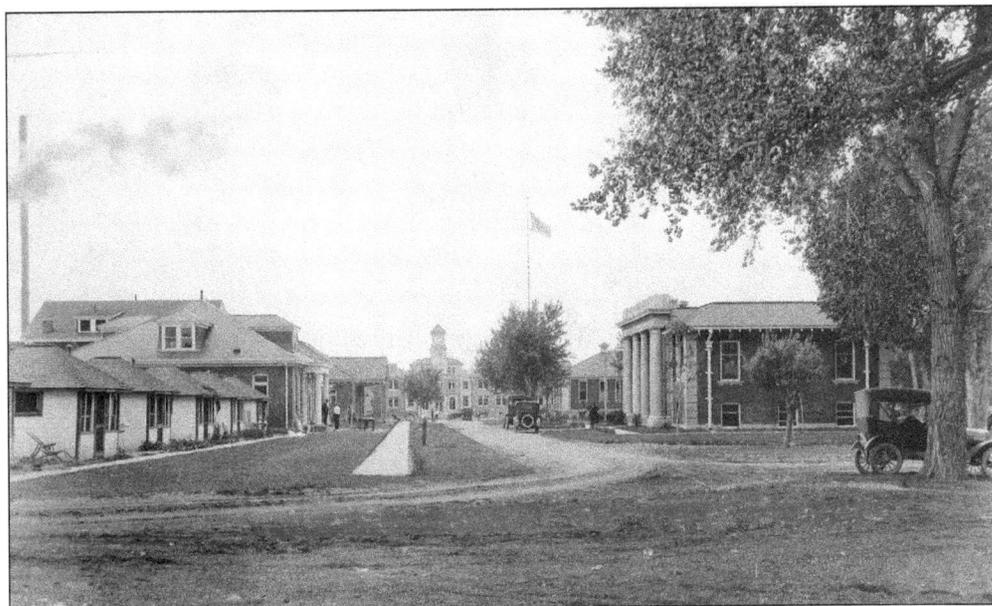

JCRS patients and staff referred to the sanatorium's Main Street as "Broadway." JCRS's guiding force, Dr. Charles Spivak, prescribed fresh air and maximum exposure to the sunshine (a practice called heliotherapy) as well as wholesome food to alleviate the symptoms of tuberculosis. In this image, the cottages are to the left, the Texas Building for Women is in the center background, and the Tri-Boro dining building is to the right. (Courtesy of the Rocky Mountain Jewish Historical Society.)

The cliché "physician heal thyself" barely encapsulates the life of Dr. Joseph Craighead. He started his medical education at Tulane University in New Orleans before contracting tuberculosis and coming west to JCRS for the cure. He finished his education at University of Colorado–Boulder and returned to JCRS as a doctor during the mid-1910s. The youngster is unidentified but likely a JCRS patient. (Courtesy of the Craighead family.)

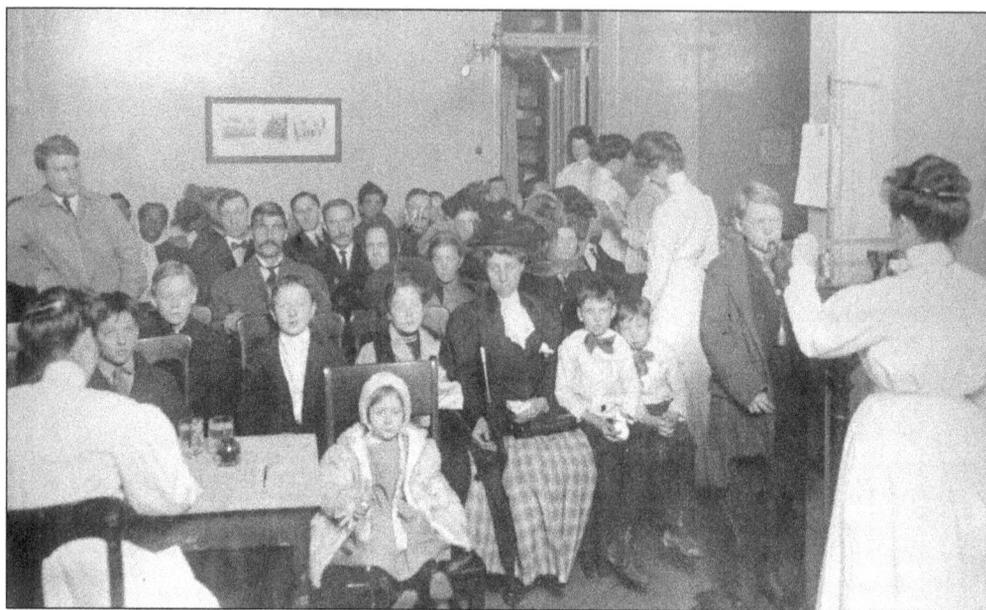

Six nurses attend to a crowd in the JCRS outpatient clinic in 1908. JCRS accepted tubercular patients free of charge and in all stages of the disease. The society's records indicate that no patients died of tuberculosis, but they occasionally succumbed to pneumonia and exposure, which resulted from the open-air cure prescribed by the doctors. Grateful patients affectionately referred to the doctor as "Papa Spivak." (Courtesy of the Rocky Mountain Jewish Historical Society.)

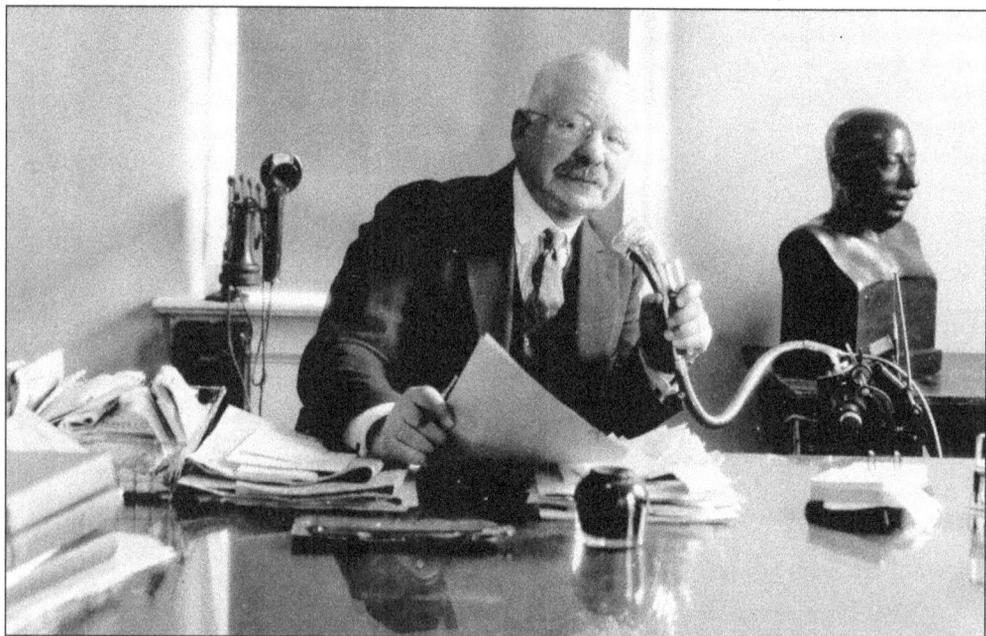

Dr. Charles Spivak speaks into his office Dictaphone at JCRS. Spivak fled Czarist Russia because of revolutionary activities in 1881. He earned his medical degree from Jefferson Medical College in Philadelphia in 1890. Six years later, Spivak and his family arrived in Denver. Supported by physicians, rabbis, and businessmen, Spivak established the sanatorium in 1904. JCRS's first fundraiser garnered $1.97. (Courtesy of the Rocky Mountain Jewish Historical Society.)

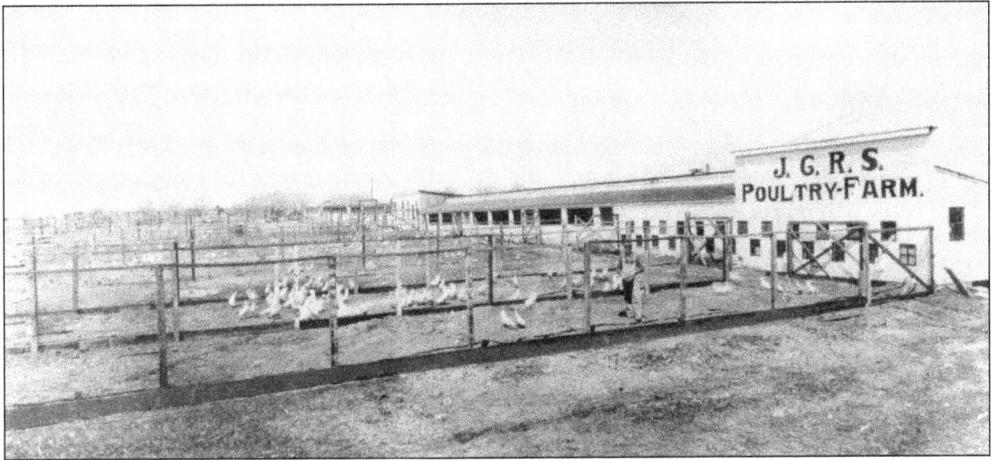

Every day for 45 years at JCRS, a steam whistle blasted at 6:30 a.m., 7:30 a.m., noon, and 5 p.m. One JCRS staffer recalled why the steam whistle tradition ended in 1968: "I guess we stopped it because we didn't know it was blowing in the first place. And it disturbed the patients." (Courtesy of Lakewood's Heritage Center.)

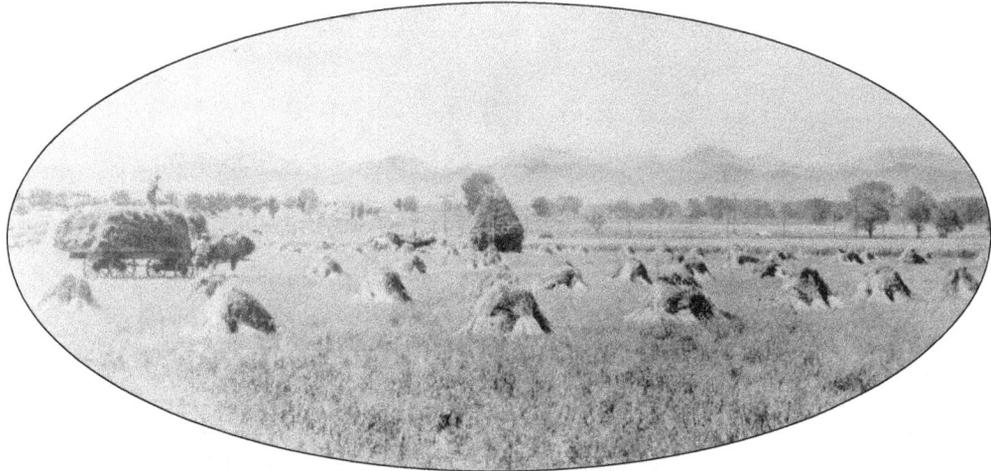

Poverty, overcrowding, and malnutrition led to the prevalence of tuberculosis among Eastern European Jewish emigrants. Spread across 105 acres, JCRS for many years boasted its own farm, dairy, and chicken coops. In addition to the farm, JCRS also ran a print shop and book bindery. (Courtesy of Lakewood's Heritage Center.)

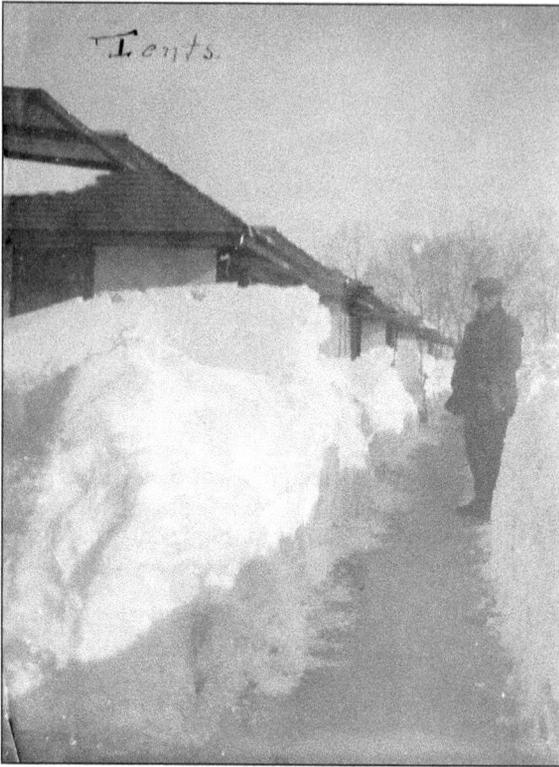

Dr. Charles Spivak's cure for tuberculosis involving as much outdoor exposure as possible was put to a serious test after the great blizzard of December 1913. There is no record of how much snow hit Lakewood from that storm. The aftermath resulted in snowdrifts as high as the roofs of patients' cabins. (Courtesy of the Craighead family.)

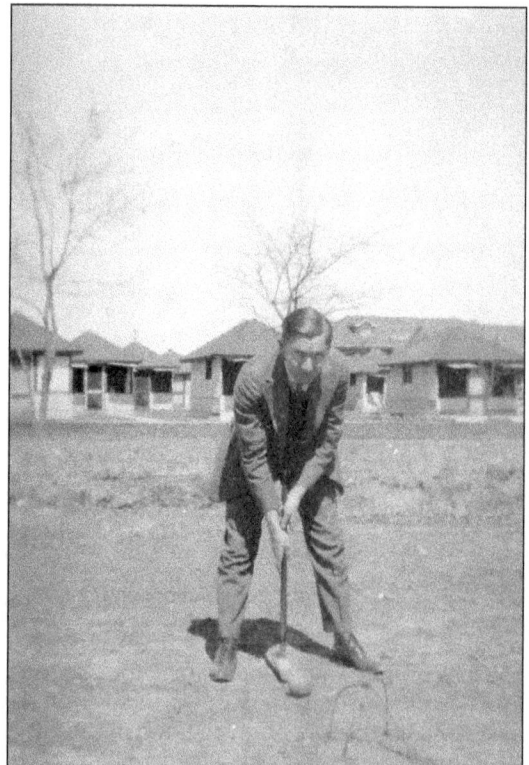

The ideals from Pres. Theodore Roosevelt's speech "The Strenuous Life" were part of the patients' daily routine at JCRS. Lakewood's dry air and 300 days of sunshine each year put emphasis on sports like running, Indian clubs, and tossing the medicine ball. One of JCRS's early doctors, Dr. Joseph Craighead, demonstrates his abilities with a croquet mallet. (Courtesy of the Craighead family.)

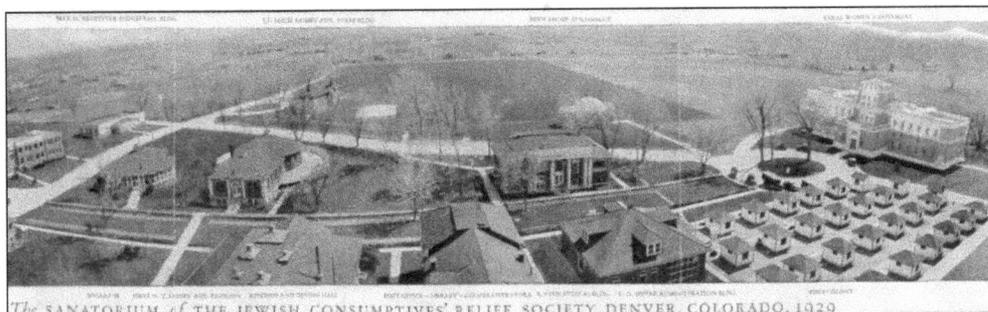

The SANATORIUM of THE JEWISH CONSUMPTIVES' RELIEF SOCIETY, DENVER, COLORADO, 1929

This panorama, taken two years after Dr. Charles Spivak's death in 1927, indicates the main structures he helped establish during his 23 years as JCRS's executive secretary. After his death, the JCRS post office of Sanatorium, Colorado, was renamed Spivak in the doctor's honor. JCRS is listed as a National Register of Historic Places Historic District. (Courtesy of Rocky Mountain Jewish Historical Society.)

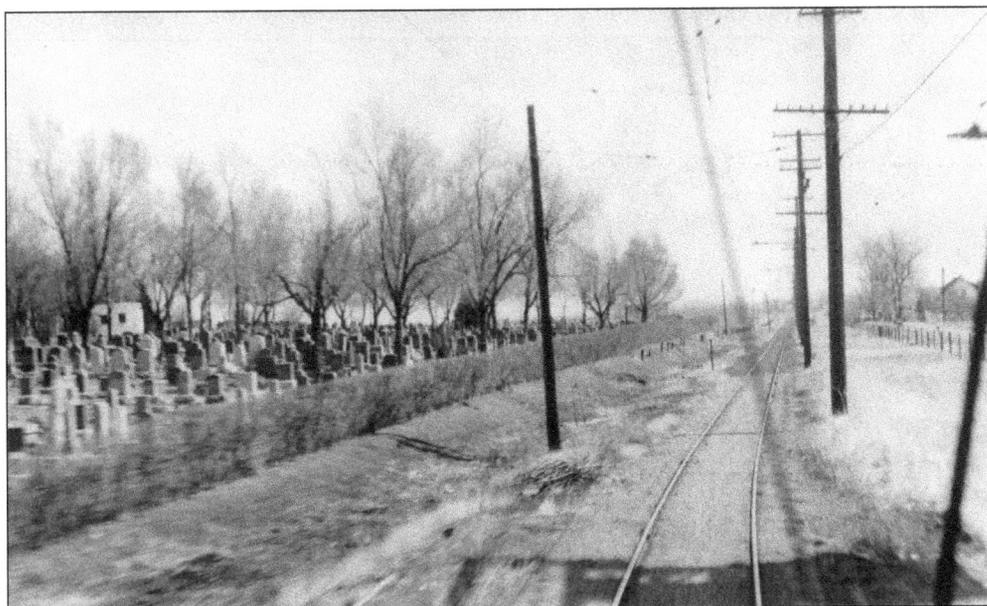

The Golden Hill Cemetery is a nearly forgotten part of Lakewood's history, located by the junction of West Colfax Avenue and Wide Acres Road. The West Side Benevolent Society established the Jewish cemetery in 1906. Many former JCRS patients are buried at the site. This photograph from the 1930s was taken as the 84 trolley raced past the Golden Hill Cemetery. (Courtesy of the Colorado Railroad Museum Collection.)

William A.H. Loveland, his wife, Miranda, and business partner Charles Welch platted Lakewood in 1889. During his life, Loveland was a Jefferson County commissioner and the publisher of the *Rocky Mountain News*. He had been nominated for president at the 1880 Democratic Convention. This area is now part of the Mountair neighborhood near South Sheridan Boulevard. Despite its conversion into apartments, Loveland's home at 1435 Harlan Street still stands. (Courtesy of Lakewood's Heritage Center.)

One of Lakewood's earliest subdivisions, Glen Creighton, was advertised in the 1920s as a place that was "away from the smoke and dirt of the city." Cyrus Creighton developed the neighborhood after his $32,000 purchase of 80 acres along West Colfax Avenue. Creighton claimed the neighborhood's artesian wells provided "the best water in the world . . . [and] people in Denver pay five cents a bottle for it." (Courtesy of Lakewood's Heritage Center.)

The staff of Lakewood's first telephone exchange takes a break from handling calls and stands near the intersection of West Colfax Avenue and Carr Street. Mary Bruce (left), Eva Williams (center), and Elza Bruce (right) comprised the switchboard team for Lakewood in 1917. There are no records available to confirm how many residents had a phone in their home during the century's early years. (Courtesy of Lakewood's Heritage Center.)

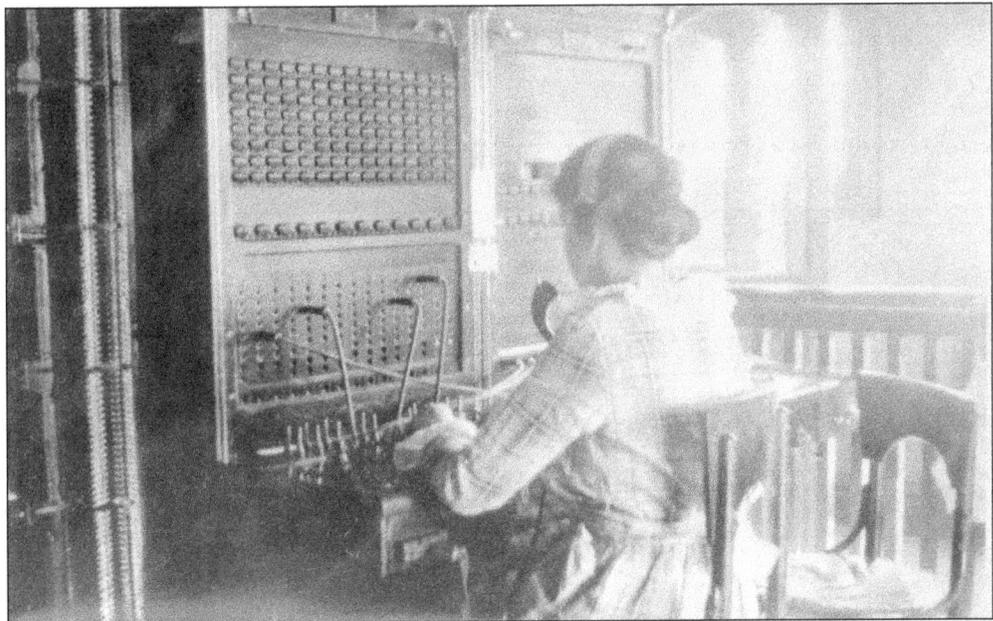

Three-digit dialing was the height of telephone technology in 1917. Mary Bruce inputs the calls on the town's first switchboard in the Kummer Store, which was located at West Colfax and Carr Street. Lakewood kept its three-digit exchanges until the 1940s. (Courtesy of Lakewood's Heritage Center.)

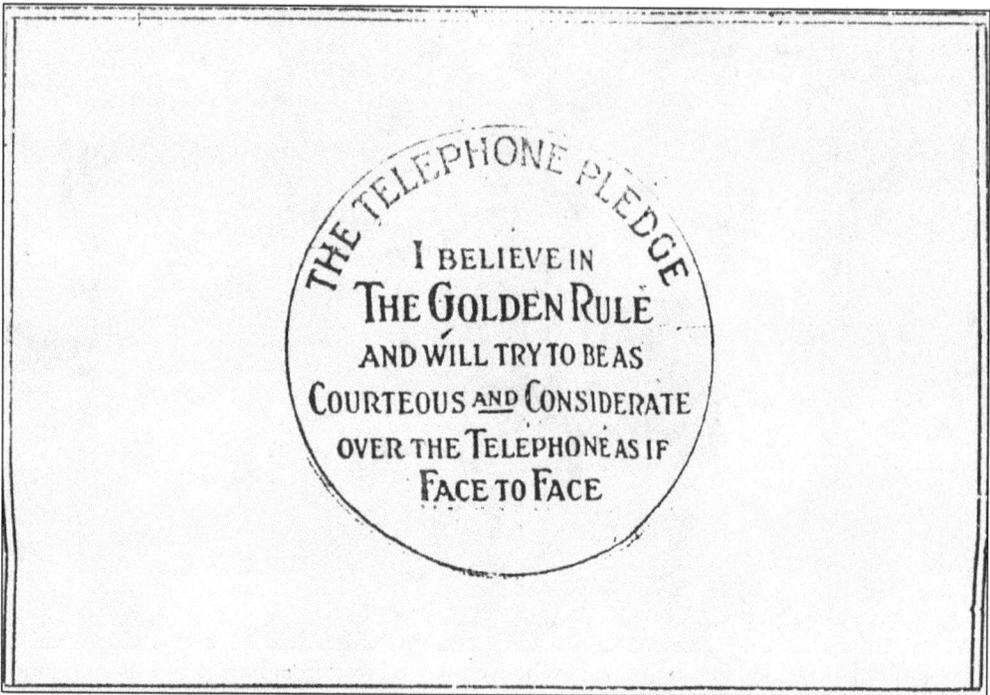

On September 23, 1910, the *Arvada Enterprise* reminded customers to follow "the Telephone Pledge." There is no record of a separate pledge for party-line customers who engaged in eavesdropping and gossiping about their neighbors. (Courtesy of the *Arvada Enterprise*.)

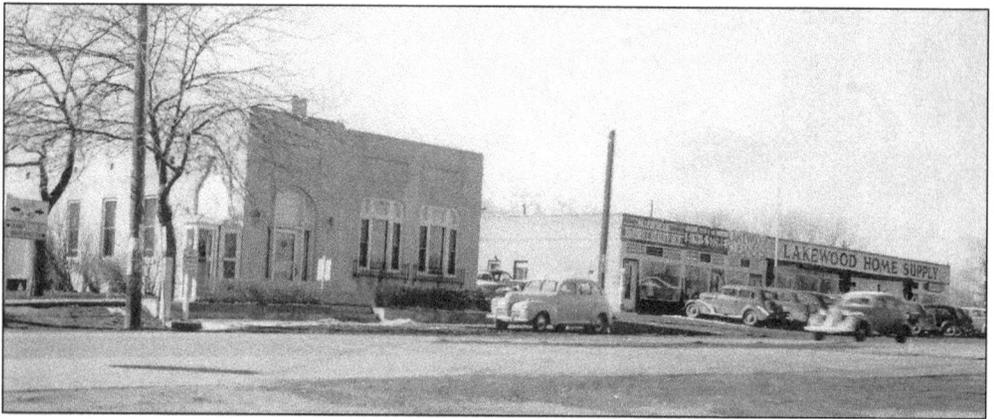

Most Lakewood residents recalled that their downtown has always been located at the intersection of West Colfax Avenue and Wadsworth Boulevard. On March 3, 1945, a hardware store and the telephone exchange stood at the intersection's southwest corner. (Courtesy of Donald and D. Arter Rittenhouse.)

West Colfax Fuel & Feed Co. was located at the corner of West Colfax Avenue and Wadsworth Boulevard during the early 1920s. It was demolished in the mid-1990s. Before becoming a victim of surrounding commercial development, the Fuel & Feed symbolized the community's agrarian character for years. (Courtesy of Lakewood's Heritage Center.)

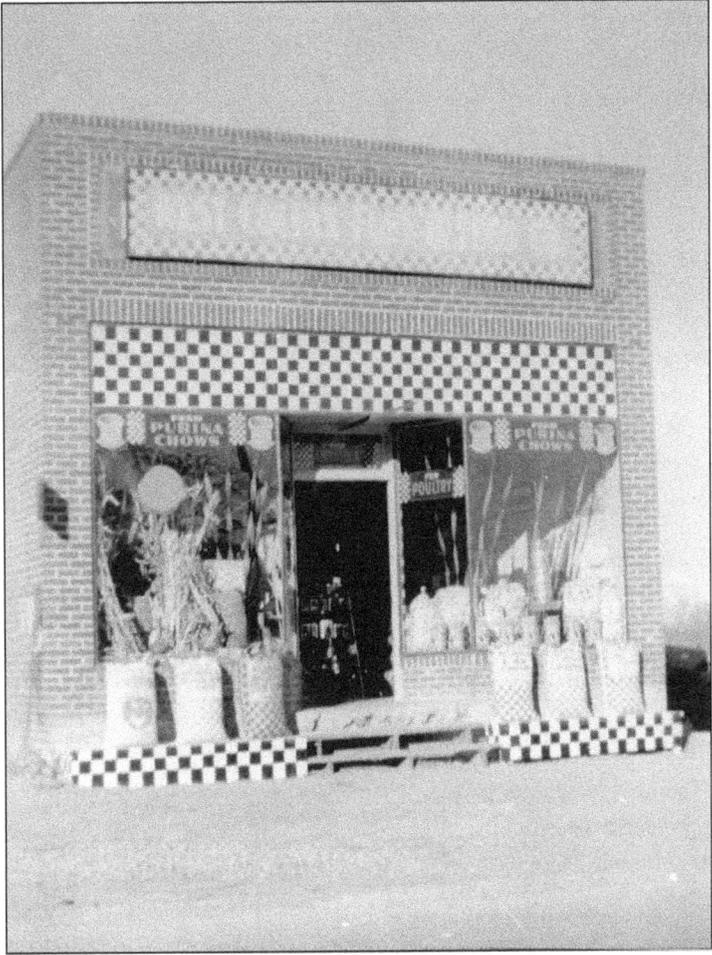

Despite the lack of visible activity, Jefferson County's newspapers referred to the intersection of West Colfax Avenue and South Wadsworth Boulevard as the city's "Busy Corner." In 1938, the Red Cross opened a highway emergency station on the intersection, and in 1942, the intersection's new traffic light was somewhat of a novelty. By the early 21st century, none of the buildings or utility poles—even the street's original width and surface—had survived. (Courtesy of Donald and D. Arter Rittenhouse.)

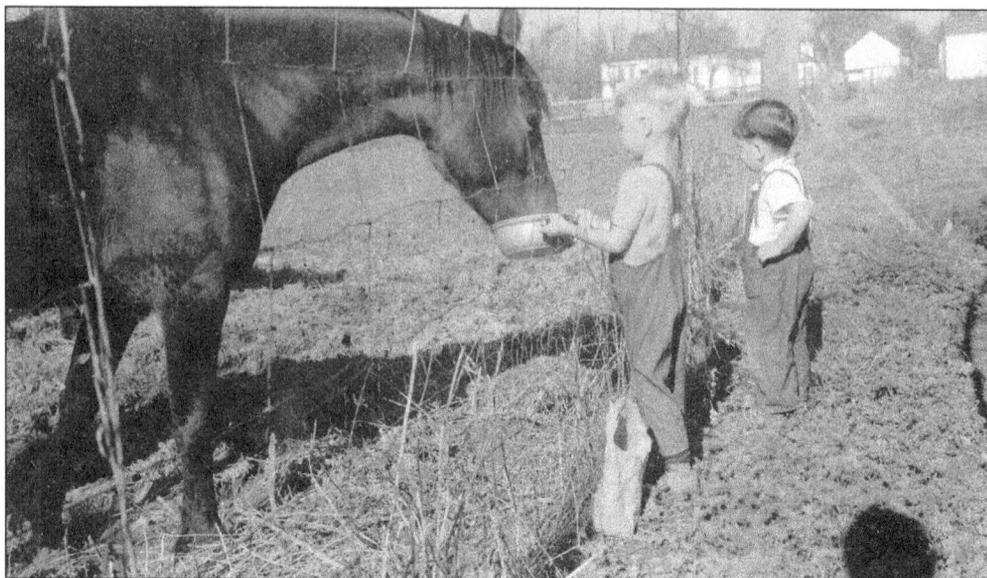

West Colfax Avenue was Lakewood's social and business center during the early 1940s, but much of the surrounding land remained open and rural. Four blocks north of West Colfax, the Rittenhouse children feed their mare Ginger. The Rittenhouse property was near West Sixteenth Avenue and Wadsworth Boulevard. (Courtesy of Donald and D. Arter Rittenhouse.)

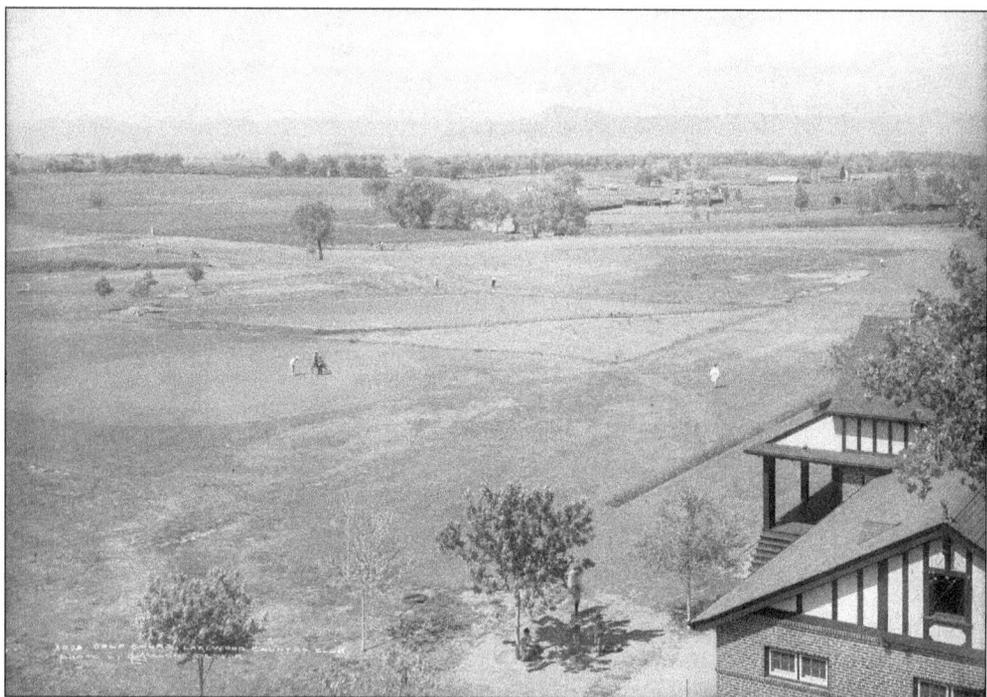

The following was written on the back of this photograph: "Almost every day is a golfing day in Denver. The city abounds in fine courses, public, and private." Frederick Bonfils, publisher of the *Denver Post*, opened the Colorado Golf Club in 1907 after he was denied membership to the Denver Country Club. Within a decade, the Colorado Golf Club became Lakewood Country Club. (Courtesy of the Denver Public Library, Western History Collection, L.C. McClure, Call No. DPL M55 3075.)

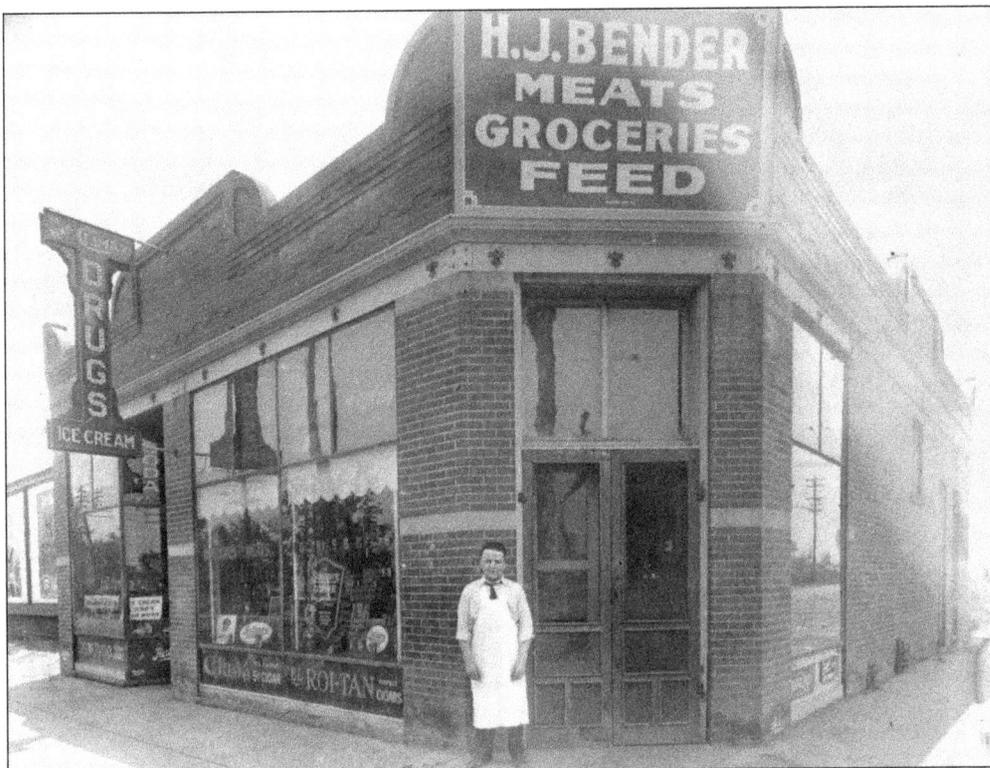

Henry J. Bender was the postmaster in Edgewater, ran a grocery store in Denver, and lived in Lakewood. One of Lakewood's pioneer grocers, his father A.W. Bender, established the Red and White store in 1904 and boasted, "For meat that is tender, go to Bender." For many years, the store was a Jefferson County polling place even though the building was in Denver. (Courtesy of Lakewood's Heritage Center.)

HI!

LAKEWOOD MARKET

8400 WEST COLFAX

THE WEST'S BEST FOOD VALUES EVERYDAY PLUS THESE SUPER SAVINGS FOR THURSDAY, FRIDAY AND SATURDAY

Kremel
PUDDINGS Assorted Flavors, Box **5¢**

Fancy
TOMATO JUICE Big No. 5 Tin **19½¢**

Parkay
OLEO Lb. **27¢**

Armour's
TREET **39¢**

In the 1940s, Conrad Becker moved his grocery store from 7600 to 8400 West Colfax Avenue. Becker's Lakewood Market was one of many locally owned and operated stores. The Lakewood Market lasted until major chains made their presence felt in the 1950s. (Courtesy of the *Denver Post*.)

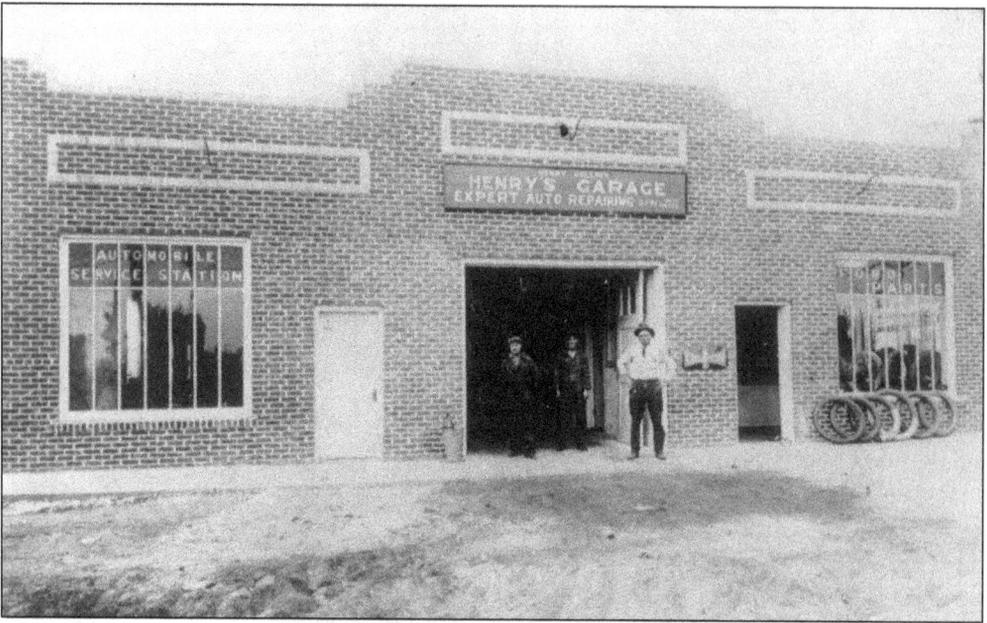

Henry Gollner established a garage on 5246 West Colfax Avenue in the Mountair neighborhood in 1921. Gollner ran the only tow truck company in Lakewood, and he often went into the mountains to rescue disabled cars and trucks. Henry's Garage remained in business until the late 1950s. (Courtesy of Lakewood's Heritage Center.)

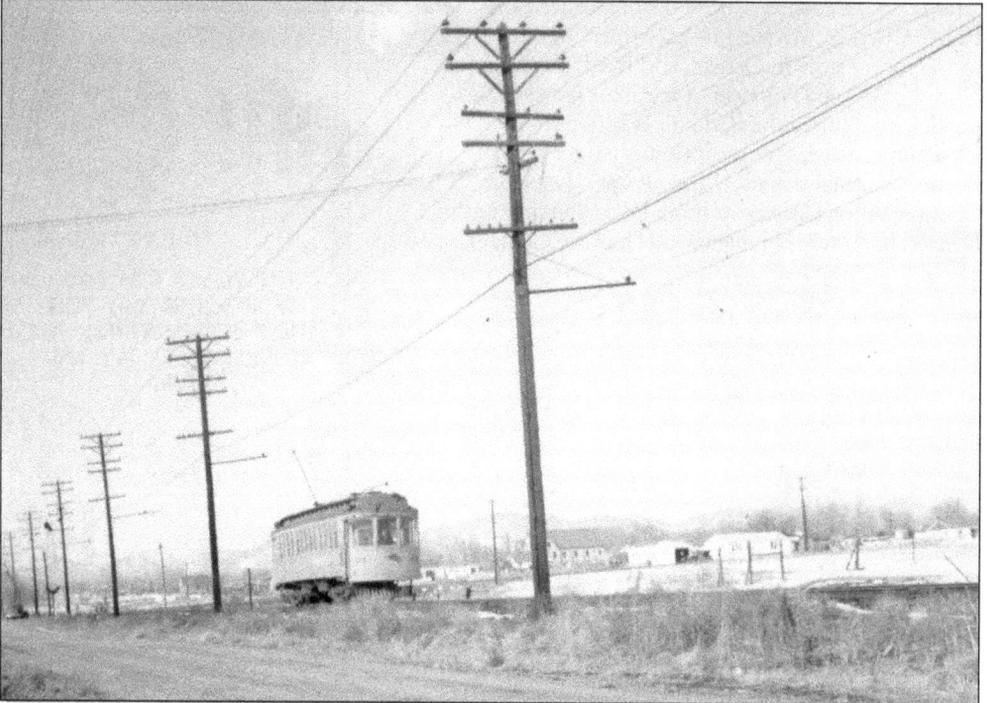

The D&IM 84 trolley's route from Denver to Golden was one block south of West Colfax Avenue. This 1920s photograph shows the trolley approaching the Smiths station on West Thirteenth Avenue and Garrison Street. (Courtesy of the Colorado Railroad Museum Collection.)

The Mountair neighborhood was the gateway into Lakewood for those heading west out of Denver. One of the first stops west of Sheridan Boulevard was Verne's Grill at 5215 West Colfax Avenue. Verne's relaxed atmosphere offered diners a chance to bring "your wife, mother or sweetheart and they will feel at home." (*East Jefferson Sentinel*, c. 1940s.)

One of the first—and last—roadhouses on West Colfax Avenue was Lane's Tavern. Many Lakewood residents recall sampling their first "3.2 beer" at Lane's. The "3.2" refers to the alcohol content of beer that Lane's could legally sell. The old bar was held together by smoke and stale beer and without the convenience of indoor plumbing. (*East Jefferson Sentinel*, February 22, 1945.)

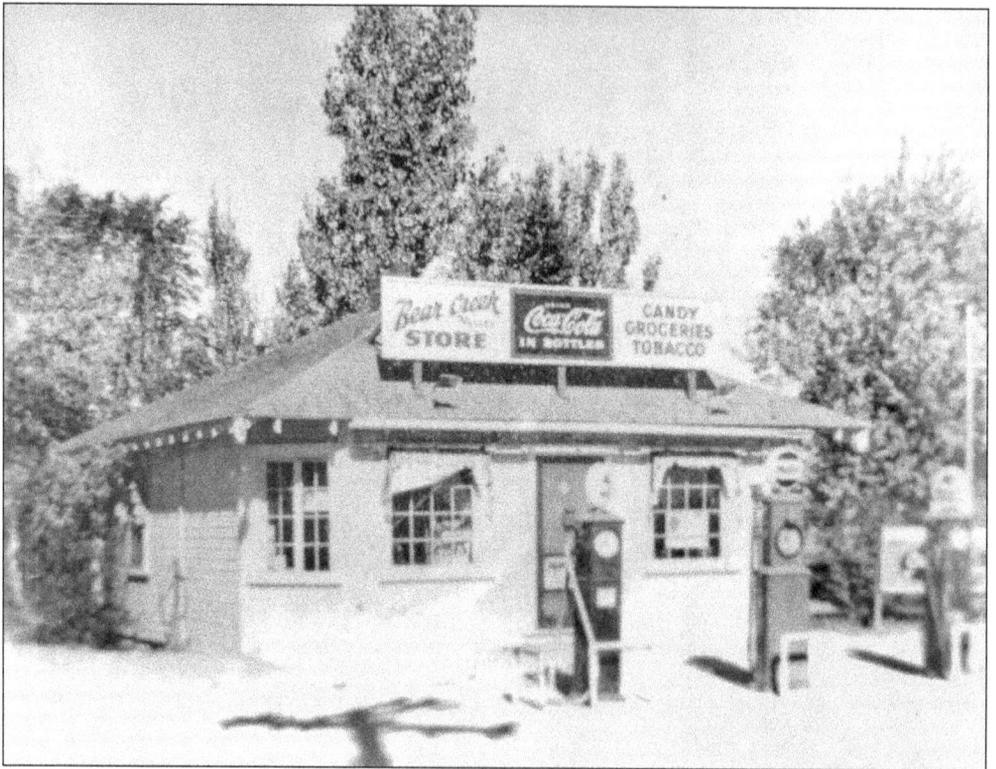

In 1908, Francis and Permelia Annis Bevans came to Colorado from Iowa with two children afflicted with consumption. The family reported that Francis exclaimed, "This is the valley of paradise!" By the 1920s, Bear Valley had its own general store that serviced the surrounding farms. (Courtesy of Lakewood's Heritage Center.)

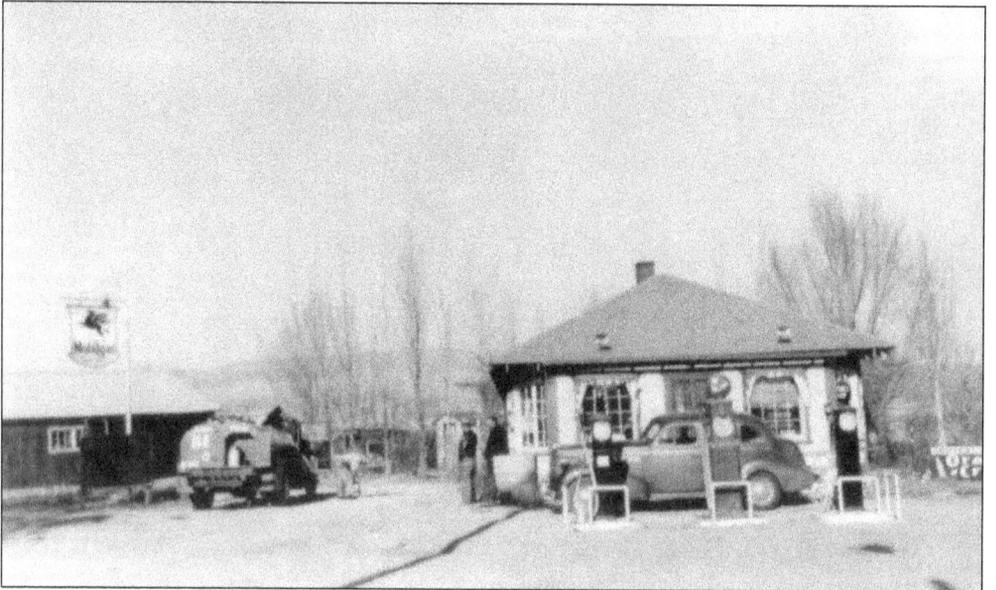

In the 1930s, the Bear Creek Store was considered one of the few "last chance" outposts for motorists on Lakewood's southern end. (Courtesy of Lakewood's Heritage Center.)

HARRIS GROCERY AND MEAT MARKET

QUALITY TELLS
555 GARRISON — **PRICE SELLS**
LAKEWOOD

COFFEE Solitaire 1 Lb. 33c		**CRACKERS** Salted Sodas 2 Lbs. for 25c		
3 Lb. 95c		**WESSON OIL** Pint 30c		
POSTS BRAN	**10c**	**VEGETOLE SHORTENING** Lb. 20c		
GRAPE NUT FLAKES		**CAMAY SOAP** LIMIT 3 for 20c		
PEP PKG.		**PEANUT BUTTER** Pint 34c		
WAX PAPER 125 Ft. Roll 19c		**SOLITAIRE TEA** 16 Bags Pkg 15c		
SUGAR 5 Lbs. 35c		**FLOUR** GOLD 5 Lb. 27c		
10 Lb. 68c		MEDAL 10 Lb.51c		

FRESH FRUITS and VEGETABLES

COMPLETE LINE OF LUNCH MEATS

FRESH POTATO SALAD FRESH FISH

TOMATO JUICE NOW POINT FREE

47-ounce Can 24c

Open 7 A. M. to 9 P. M. Daily—Sunday 7 A. M. to Noon

Reported by the *East Jefferson Sentinel* on August 9, 1945, the opening of Harris Grocery took place in an area where Lakewood was growing considerably. Anticipating a postwar influx of potential customers, Harris opened his store at 555 Garrison Street during the last week of World War II. According to the *East Jefferson Sentinel*, Harris planned on "expanding after the war." (Courtesy of the *East Jefferson Sentinel*.)

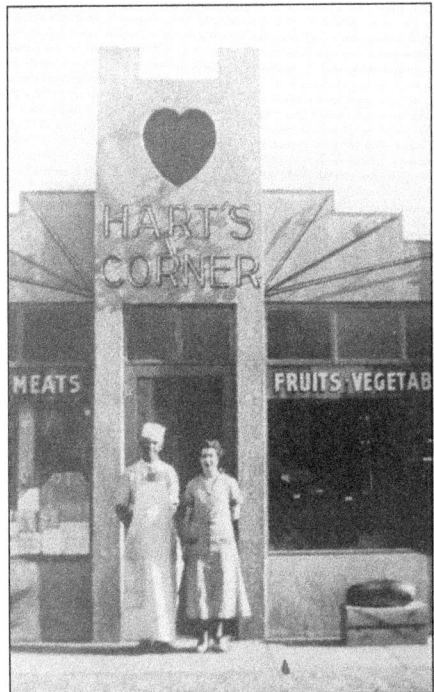

Established by Leo Hart in the 1920s, Hart's Corner was a celebration of the automobile; it had a restaurant, gas station, and motel court. In 1935, Hart added a grocery store to his commercial empire, bounded by Morrison Road and South Sheridan Boulevard. (Courtesy of Lakewood's Heritage Center.)

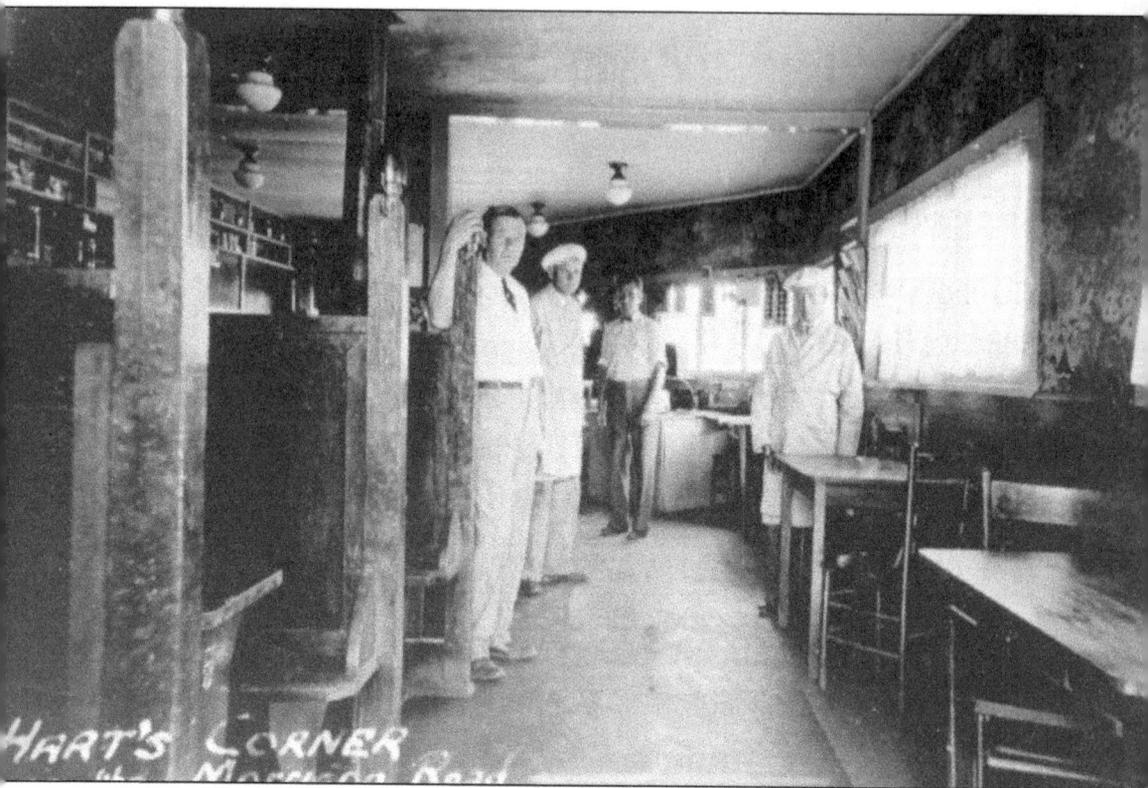

HART'S CORNER

Originally, Hart's Corner restaurant served hot dogs, hamburgers, and soft drinks. In the days before stringent building codes, Leo Hart gradually added on to the original restaurant to include living space. By 1929, the Harts were doing so well that Leo purchased 90 adjacent acres and built a brick house from which he could oversee his commercial interests. Unidentified employees pose in this 1933 photograph. (Courtesy of Lakewood's Heritage Center.)

In the early 1920s, Leo Hart began his commercial empire on a $50 poker bet he won from Colorado boxing commissioner (and fellow restaurateur) Eddie Bohn. In this photograph, Verle Miller, an employee and future owner of the Hart's Corner hardware store, poses with his wife, Alice, and son Veryln. In the summer of 1939, the Millers moved from Missouri to Lakewood. The family settled near Sheridan Boulevard. (Courtesy of Lyle Miller.)

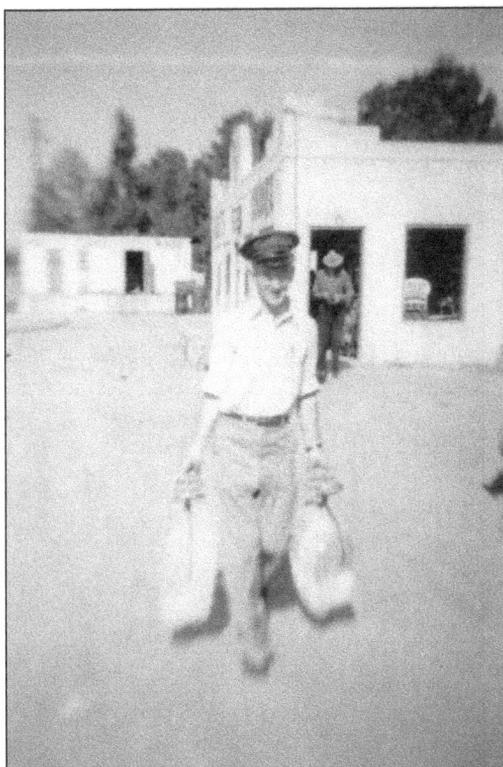

The iceman was the subject of many ribald blues or swing number during the first half of the 20th century. Hart's Corner employee Verle Miller wore many hats, including carrying blocks from the icehouse. Keeping cool was a good idea at Hart's Corner as a sign in the grocery store sign read, "We don't know where Mom is, but we have Pop on ice." (Courtesy of Lyle Miller.)

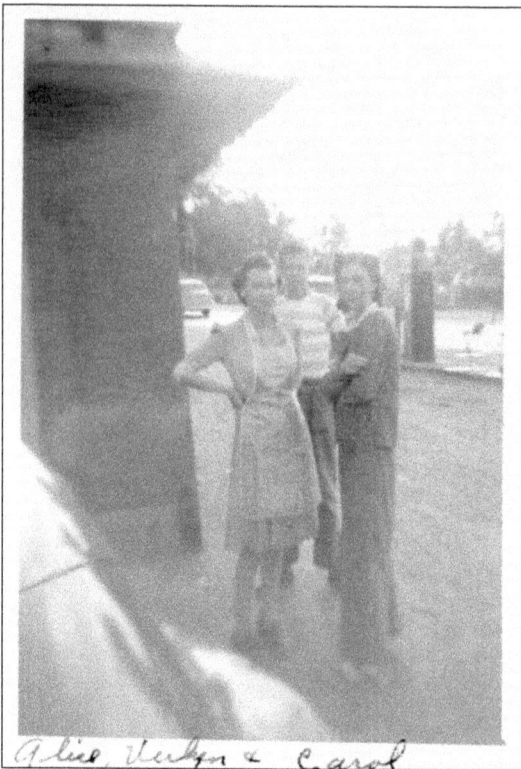

Alice, Verlyn & Carol

Alice Miller (left) poses with son Veryln (center) and sister-in-law Carol Miller in August 1945. The Millers worked at Hart's Corner before, during, and after the war years. The Harts operated the business with 50 employees from the 1940s into the 1970s. Tommy Hart oversaw operations until his death in 1978. Subsequent owners, the Moutsos renamed Hart's Corner "Tommy's Corner." (Courtesy of Lyle Miller.)

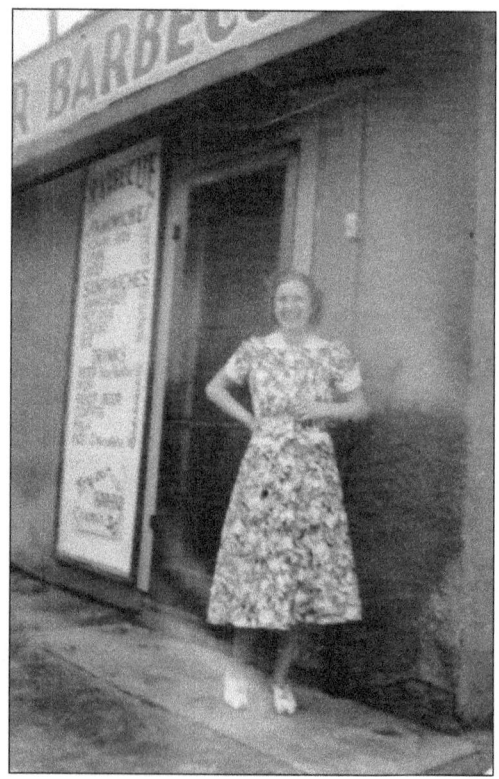

Beginning in the 1920s, the Hart family established a small business empire dedicated to the automobile at the intersection of Morrison Road (now West Mississippi Avenue) and Sheridan Boulevard. Hart's Corner started as a root beer stand and gradually added businesses and services catered to the motorist and tourist. Employee Alice Miller takes a break from her duties at Hart's Corner on a busy day during the early 1940s. (Courtesy of Lyle Miller.)

Hart Corner Cabin Camp 1942

The homey nature of Hart's Corner culminated in the construction of a cozy motel court on West Mississippi Avenue. The cottage court originally featured eight (eventually expanding to 16) cabins with garages. Opened in the mid-1930s, a guest could spend "$1.50 and up" per night for a room. Contemporary promotion literature praised the court's "spacious grounds," private showers and bathrooms, and "ice cream fountain services." (Courtesy of Lyle Miller.)

The weather, wartime travel restrictions, and snow had little effect on business at the Hart's Corner Cabins. The "Cabin City" was noticeable because it had a certain shade of yellow that covered the building's exteriors. An apocryphal story is told that a local paint supplier coined "Hart's Corner Yellow" as one of its shades. The dominance of the chain motels meant the end of stops like Hart's Corner Cabins by the 1960s. (Courtesy of Lyle Miller.)

May 9th 1943

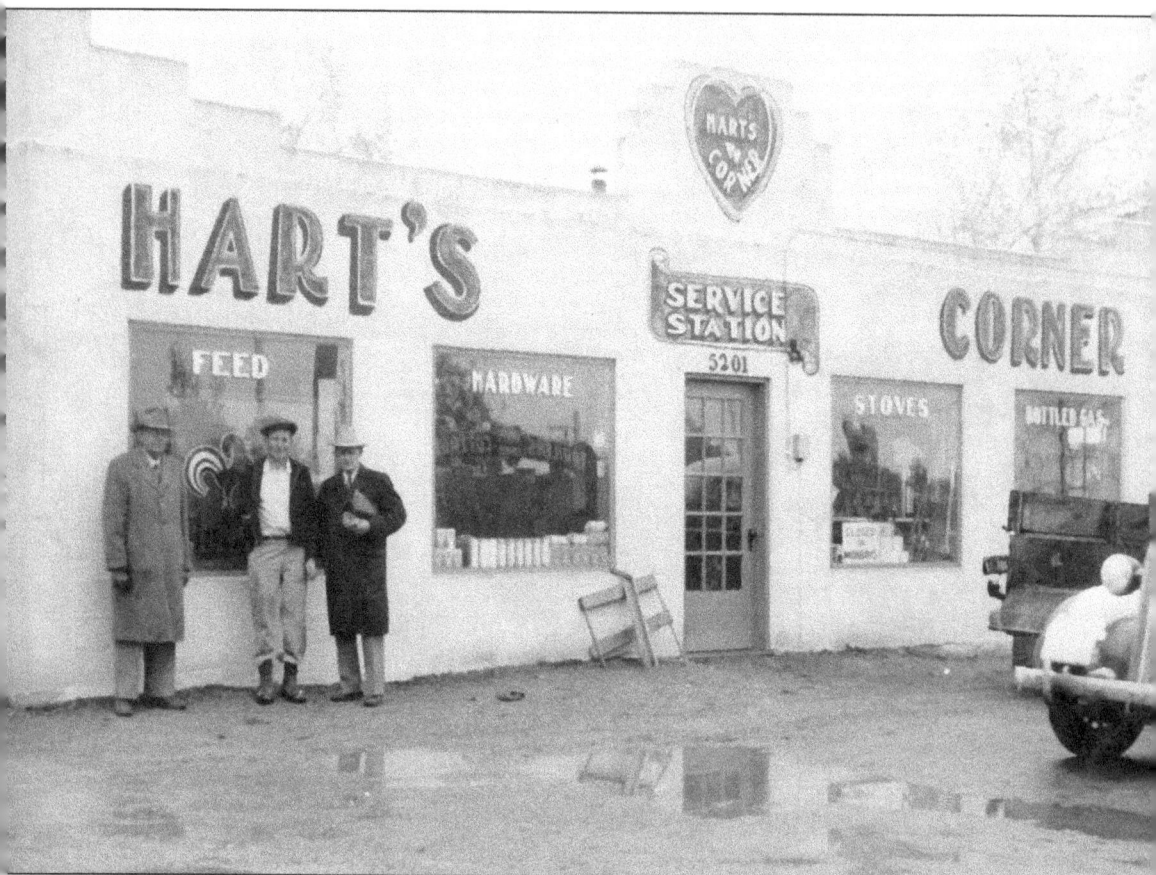

In the years leading to World War II, service stations had become the successors to general stores. Hart's controlled the north and south sides of the Morrison Road and South Sheridan Boulevard intersection. The concrete paving of Morrison Road during the early 1930s boosted the visibility and significance of Hart's Corner. During Prohibition, Leo Hart sold nonalcoholic "near beer" with the come-on, "Near Beer Sold Here, No Beer Sold Near Here." The complex offered motorists during the late 1930s and early 1940s a variety of diversions beyond a fill-up. Hart also introduced curb service at his restaurant, put up a screen in the parking lot to show movies, and built a stage for hula dancers and Western musicians. Hart died in 1939, leaving the operation to son Tommy. Tommy is in the center of the trio near the building; the other men are unidentified. (Courtesy of Lyle Miller.)

Five

THE PAVED ROAD

THE AUTOMOBILE AND COLFAX AVENUE

Colfax Avenue cuts across Eastern Colorado from the plains to the foot of the Rockies. Colfax Avenue is the nation's longest main street, and it was characterized as one of the most gaudy and commercial thoroughfares in the 20th century. The avenue is composed of motels, bars, liquor stores, restaurants, car dealerships, and, recently, big box stores.

West Colfax Avenue is the artery that brought Lakewood to life nearly 100 years ago. In 1918, the Colorado Department of Highways laid the first concrete along the avenue. The smooth road was an immediate sensation with motorists. Sunday traffic made the front page. In June 1920, the *Jefferson County Republican* offered the following: "In time the cement road between Golden and Denver will likely resemble the famous old Santa Fe trail, the only difference being that instead of the white bones of man and beast that will bleach in the sun along the way will be the remains of autos, mute tributes to reckless driving instead of to thirst and savage Indians."

By the mid-1920s, Colfax Avenue's visibility was further elevated after the road received the national designation of US Highway 40. The businesses and shops bordering Colfax Avenue represented the worst and best of human nature. Roadhouses offered illicit temptations like cheap beer and "dime-a-dance" girls. But the highway also provided the path for those diagnosed with tuberculosis to seek a cure at the Jewish Consumptive Relief Society (JCRS), near the corner of West Colfax and Pierce Street. Under the direction of Dr. Charles Spivak, JCRS stressed that a cure to tuberculosis was fresh air and healthy living.

During the 1930s, Lakewood's first franchises tied to national distributors set up shop along West Colfax Avenue. By the mid-1930s, Safeway established a base at West Colfax Avenue and Ames Street. Its location was close to Ford and Chevrolet car dealerships as well as Standard and Conoco gas stations. Also, locally owned and operated motels offered a place for drivers to stay. Today, the chain stores did not completely erase West Colfax Avenue's past, as many businesses kept their neon signs, brick facades, and comfortable accessibility.

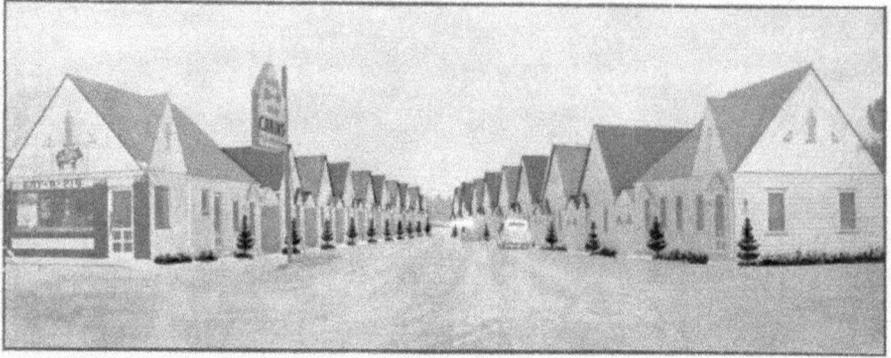

BLUE BOW MODERN CABINS

Steam Heat
Insulated
Hardwood Floors
Spring Filled Sealy
Mattresses
Bridge Lamps
Draperies and Rugs

CAFE ADJOINING Phone Lakewood 435 MODERATE RATES
7343 WEST COLFAX—On U. S. 40 West, 5 Miles from Downtown Denver, Colo.
NO ADJOINING CABINS ✠ PRIVATE GARAGES
ABSOLUTELY ONE OF COLORADO'S BEST

The 1920s to the 1960s was the golden age of the motor court along West Colfax Avenue. Owned by T.B. Buchanan, the Blue Row stressed privacy as no cabins stood side-by-side but were separated by private garages. Once inside, a weary visitor could enjoy insulated hardwood floors and steam heat. (Courtesy of Lyle Miller.)

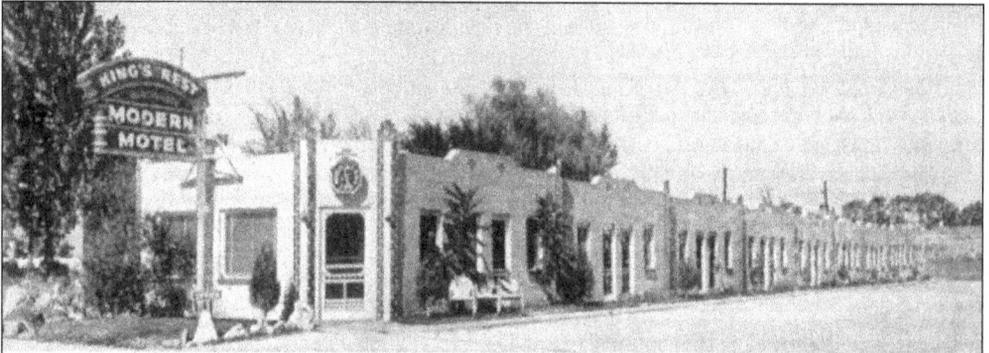

Phone Lakewood 459

Everything New, Cozy
and Comfortable

Springfilled Mattresses
Private Showers

Stop at

KING'S REST MODERN MOTEL

RALPH MURRAY

7011 W. COLFAX — ON NEW HIGHWAY 40
DENVER, COLO.

The King's Rest Motor Court was located at 7011 West Colfax Avenue. Hoping to garner more business, the motor court advertised that it was on "New Highway 40" in Denver. Lakewood thrived despite the identity crisis that some of its merchants and motel owners fostered. (Courtesy of Lyle Miller.)

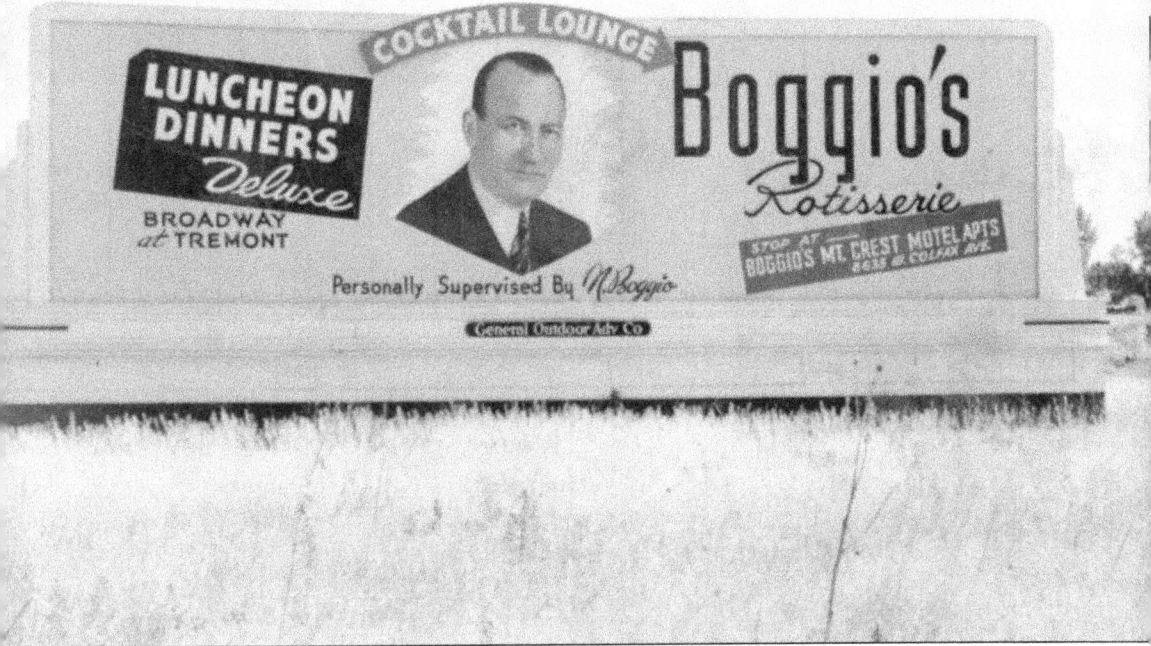

Natale "Nate" Boggio's billboard on West Colfax Avenue advertised "Luncheon Dinners Deluxe" during the 1940s. Boggio's was located on Broadway and Tremont Streets across from the Brown Palace in downtown Denver. Boggio left Denver by the early 1950s, but he continued to operate the Mount Crest Hotel Apartments at 8635 West Colfax Avenue. Boggio returned to the restaurant business in Lakewood during the mid-1960s. (Denver Public Library, Western History Collection, Mark Oatis, Call No. DPL Z15338.)

This matchbook cover shows Kelly's Camp, which was located at 5637 West Colfax Avenue. It offered room to set up a trailer. (Courtesy of Lyle Miller.)

Established in the late 1930s, the White Swan Motel was located at 6060 West Colfax Avenue. The White Swan is still in business today and has kept its mid-century neon signage. (Courtesy of Lyle Miller.)

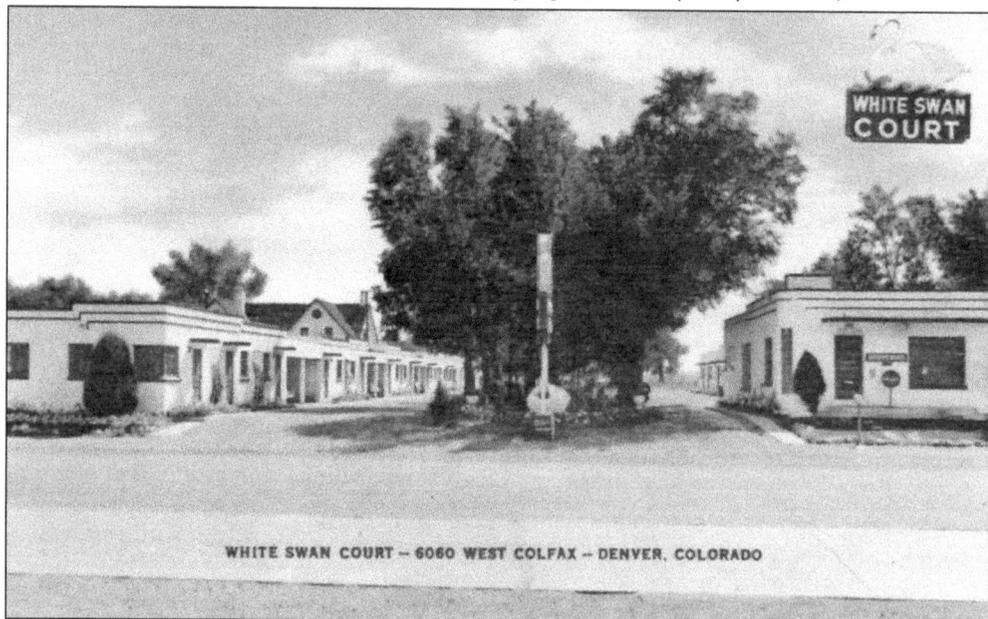

Lakewood's main thoroughfare is named after Vice Pres. Schuyler Colfax, one of the 19th century's shadiest politicians. Established as the Old Golden Road during the Gold Rush Era of the 1860s, Colfax has always been the link between Denver, Lakewood, Golden, and the foothills beyond. In the late 19th century, the construction of the first wooden sidewalks made it a little safer to walk from Sheridan Boulevard to Depew Street and indicated the importance of the new road. When Charles Spivak opened the Jewish Consumptive Relief Society (JCRS) in 1904, West Colfax Avenue was a dirt road. In 1918, the Colorado Department of Highways paved West Colfax Avenue with cement from Lakewood to Golden. The state's first traffic jams came soon after West Colfax Avenue became a two-lane highway. Because it was only two lanes, it took four hours to travel from Denver to Golden on Sundays during the 1920s. In 1926, the federal government designated Colfax Avenue as US Highway 40. (Courtesy of the Colorado Department of Transportation.)

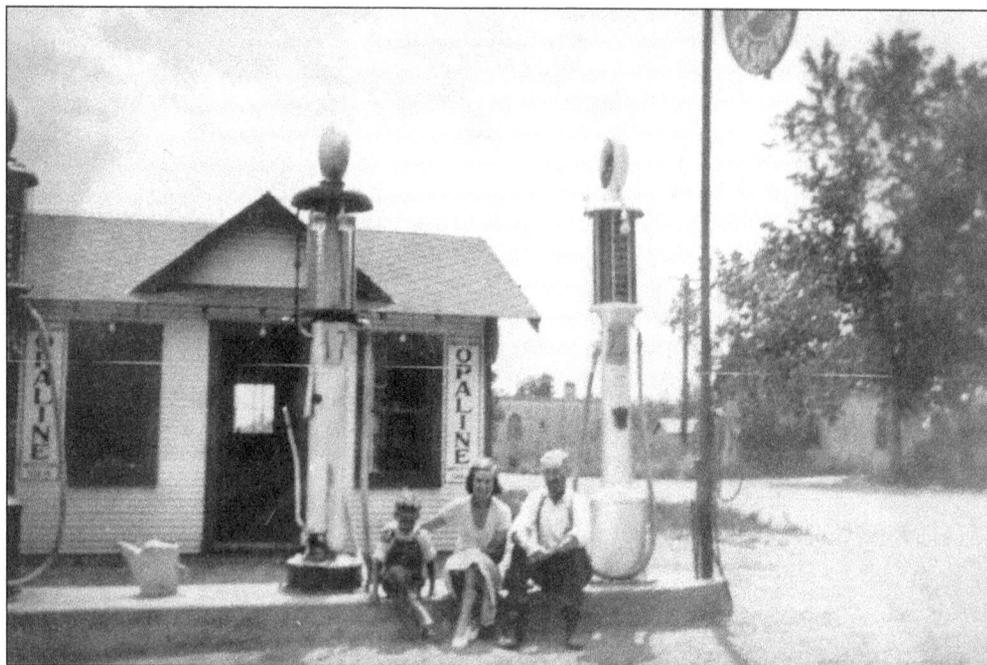

During a summer in the 1920s, Alexander and Mary Bruce sit with one of their seven children between the pumps at their gas station, located on West Colfax Avenue. (Courtesy of Lakewood's Heritage Center.)

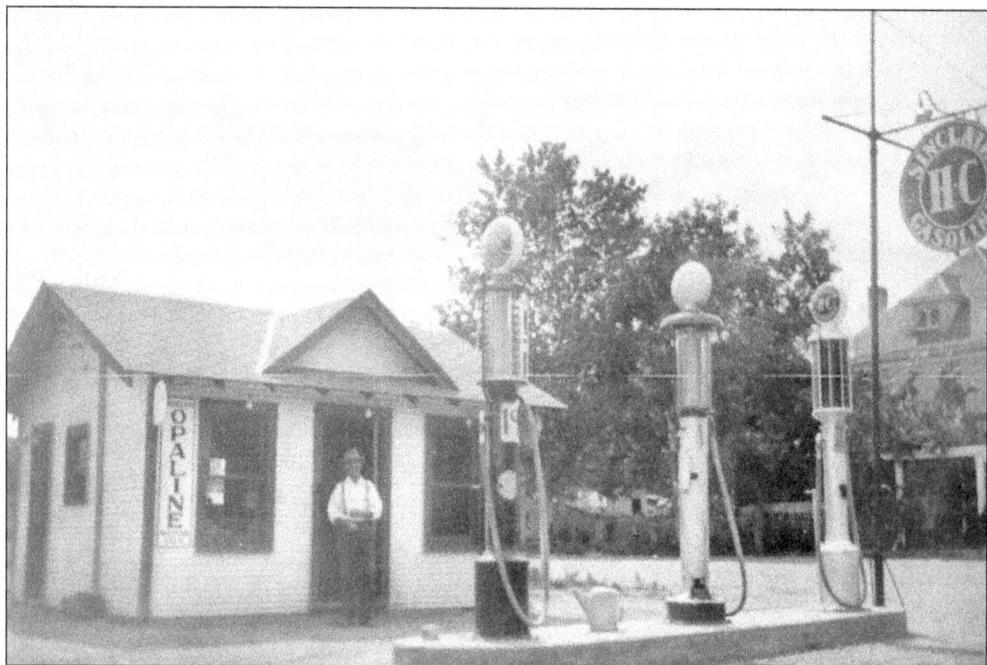

The Bruce family witnessed the transition of West Colfax Avenue from a quiet residential street to Lakewood's commercial strip during the early 20th century. In the 1920s, Alexander Bruce built this gas station at West Colfax Avenue and Brentwood Street. The Bruces also were in the tourist trade, as they had a few cabins on their property. (Courtesy of Lakewood's Heritage Center.)

LAKEWOOD COTTAGE COURT

W. Colfax and Carr Streets - Route 40 and 6 - DENVER 15, COLORADO

Telephone LA. 824 ● *Reservations Accepted* ● 48 Modern Units

This postcard of the Lakewood Cottage Court at West Colfax Avenue and Carr Street is from the 1940s. Many mid-20th-century motor courts remain along West Colfax Avenue between Sheridan Boulevard and Simms Street. The motor court portrays the automobile's importance and also shows the automobile's connection with the nation's growing tourism industry. (Courtesy of Lyle Miller.)

Visitors were always welcome at Kelly's Camp, located at 5637 West Colfax Avenue. By utilizing the inside of a matchbook cover, small businesses like Kelly's stretched their advertising dollar. (Courtesy of Lyle Miller.)

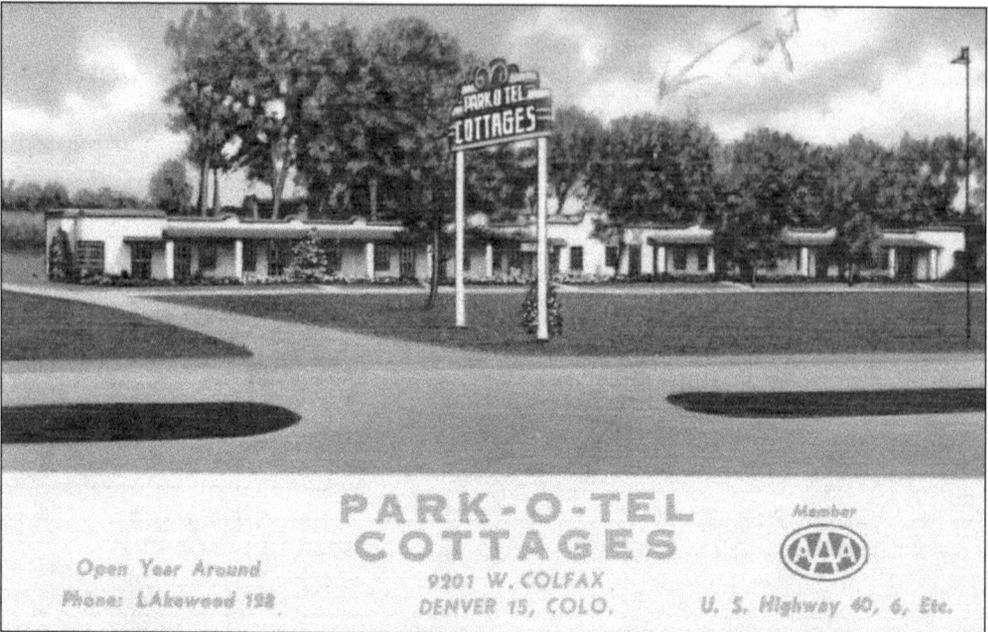

PARK-O-TEL
COTTAGES

Open Year Around
Phone: LAkewood 128

9201 W. COLFAX
DENVER 15, COLO.

Member
AAA

U. S. Highway 40, 6, Etc.

Because of the automobile, Lakewood's economic identity evolved from agriculture to tourist-related. One of the tourist businesses was the Park-O-Tel Cottages on West Colfax Avenue. In 1940, a *Business Week* examination of the national trend of motels and motor courts reported that these businesses were "a new way of life in tourism—a way that combines convenience, inexpensiveness, and informality in a formula that is definitely clicking." (Courtesy of Lyle Miller.)

Chicago M___h Co. Ca

— ★ —
FOR TOURISTS
ONE STOP
— ★ —
TOBACCO
SOFT DRINKS
GROCERIES
— ☆ —
ED'S
SERVICE STATION
PH. LAKEWOOD 620

4
MILE CAMP
.MODERN CABINS
CONOCO PRODUCTS
GAS, OIL, GREASING.
6900 W. COLFAX
DENVER, COLO.
CLOSE COVER BEFORE STRIKING

As West Colfax Avenue headed west toward Golden and the Rockies beyond, the number of motels and motor courts grew. Here is another example of Lakewood's lack of identity: the matchbook for Four Mile Camp at 6900 West Colfax Avenue advertised its address as Denver. (Courtesy of Lyle Miller.)

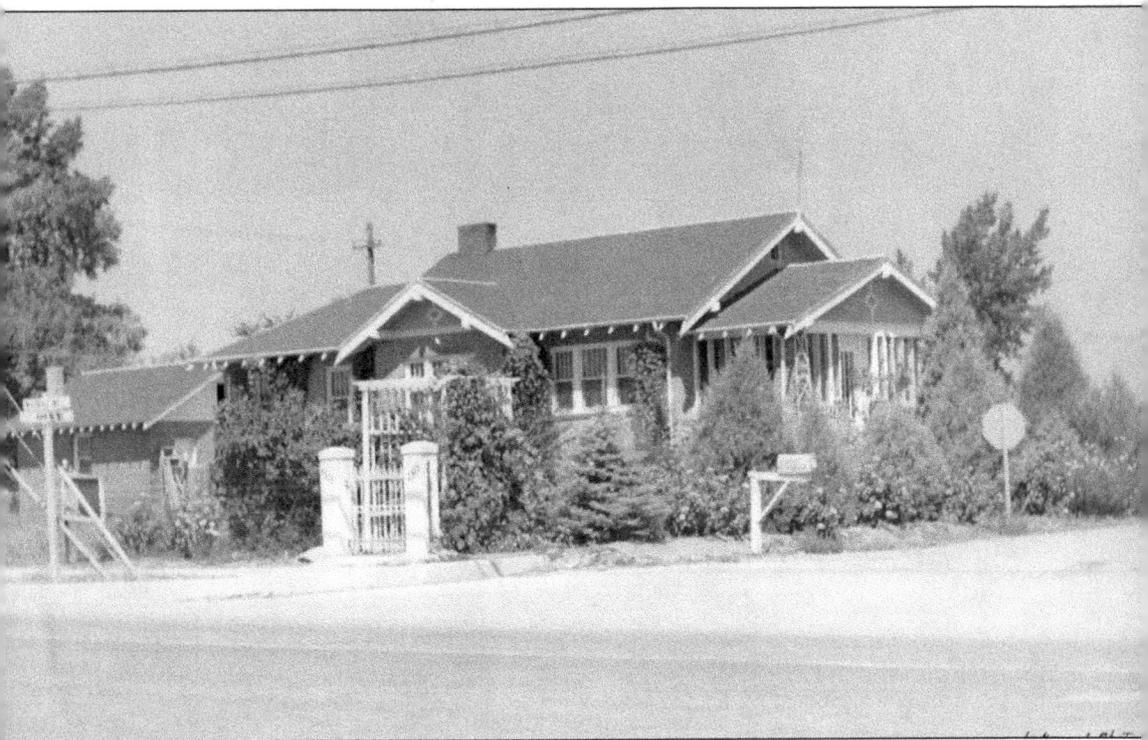

The Jonke family lived at 1515 Ames Street, a few steps from the intersection with West Colfax Avenue. The Jonkes were originally owners of a dairy farm. As automobile traffic along West Colfax Avenue increased and more people built homes, the Austrian immigrants diversified their business interests and leased their farmland. The family home is now an office for a used car dealership. (Courtesy of Kenneth and Faye Milne.)

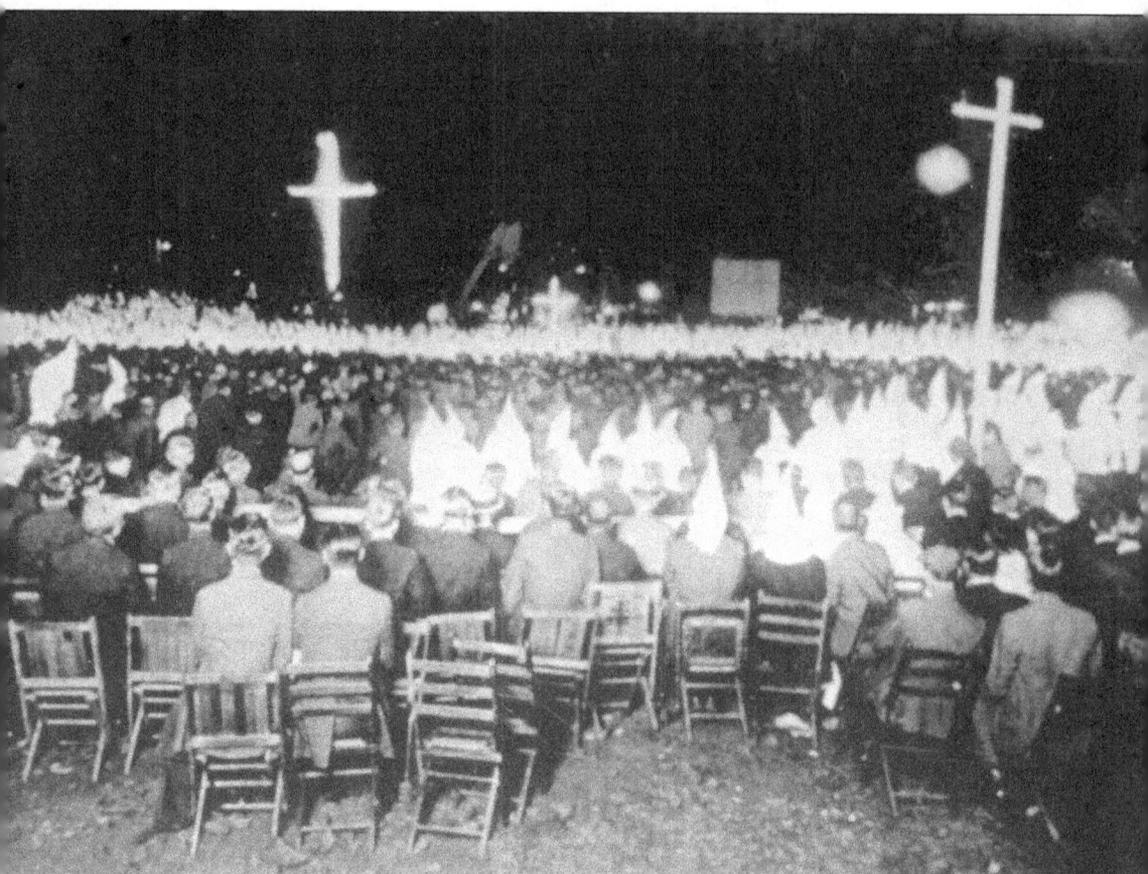

Dr. John G. Locke was Colorado's first and only Grand Dragon of the Ku Klux Klan. He established the Klan in 1920. Within two years, some 50,000 Coloradoans had paid the $10 initiation fee and the $6 annual dues to join. West Colfax Avenue, with its Jewish neighborhoods in east Denver and JCRS in Lakewood, was constantly a target of the Ku Klux Klan's hate. After World War I, a line of cars loaded with Klansmen drove along West Colfax Avenue forcing east-bound traffic to the side as they raced west to South Table Mountain in Golden. Members also marched or rode horses down West Colfax Avenue to Klan rallies, like the one pictured above, on top of Table Mountain near Golden. In 1925, Locke was charged with income tax evasion and other frauds and was jailed briefly on a contempt of court charge. Once Locke landed in jail, the Klan's influence in Colorado dissipated. (Courtesy of Lakewood's Heritage Center.)

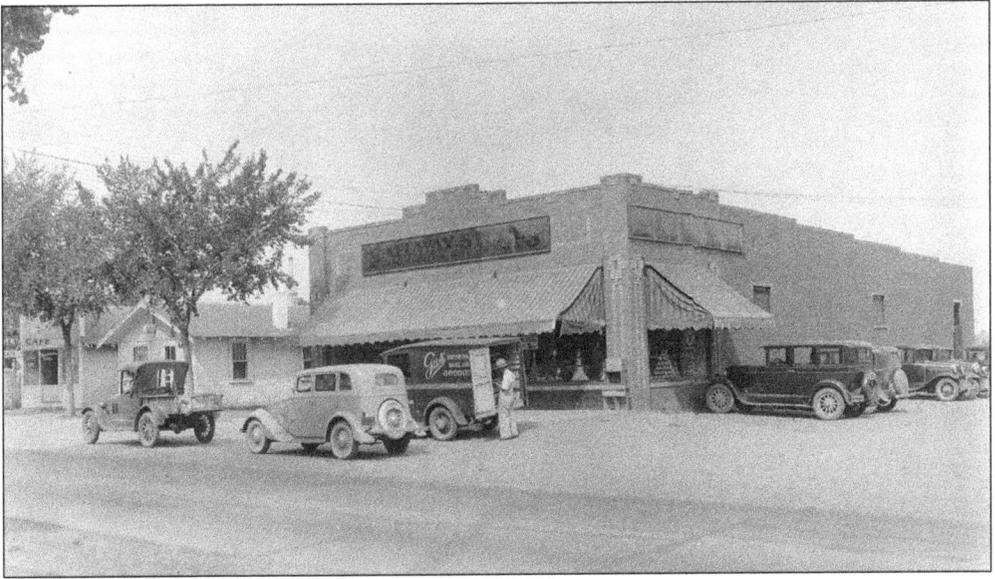

The Safeway supermarket chain built its first store (No. 461) in Lakewood at 5219 West Colfax Avenue during the early 1930s. The Safeway remained at this site until the late 1940s. To the east of the supermarket was the Standard service station at 5201 West Colfax Avenue. Originally known as the Paramount station (for more information, please see Chapter 2), Standard Oil took ownership of the location by the mid-1930s. By the early 1940s, the Lynd Tingley Taxi shared the site with the gas pumps and grease bays. The trolley tracks in the foreground go south on Sheridan Boulevard. The trolley never followed West Colfax Avenue into Lakewood. (Both courtesy of Kenneth and Faye Milne.).

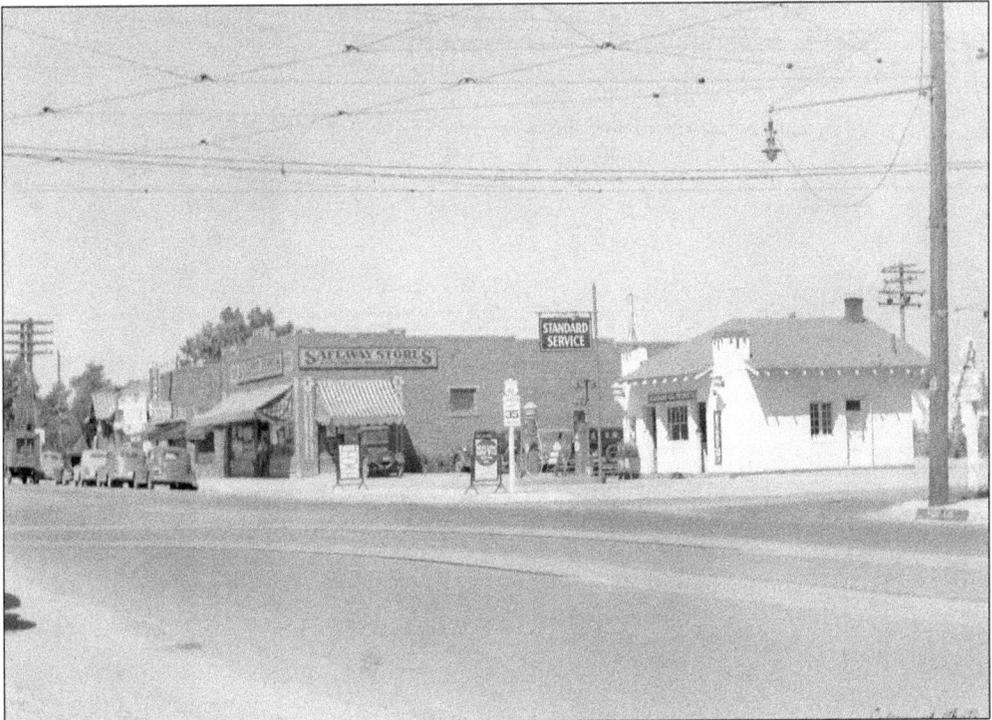

In the late 1880s, Joseph Jonke homesteaded what would become the 5200 block of West Colfax Avenue. Jonke had established a dairy, but by the 1920s he began to lease portions of his acreage. In the depths of the Great Depression, B.J. Bloyed opened the Eagle Café at 5225 West Colfax in 1934 on land owned by the Jonkes. In October 1945, Katherine Beck and Hattie Dambach reopened the Eagle as Vern's Café. (Courtesy of Kenneth and Faye Milne.)

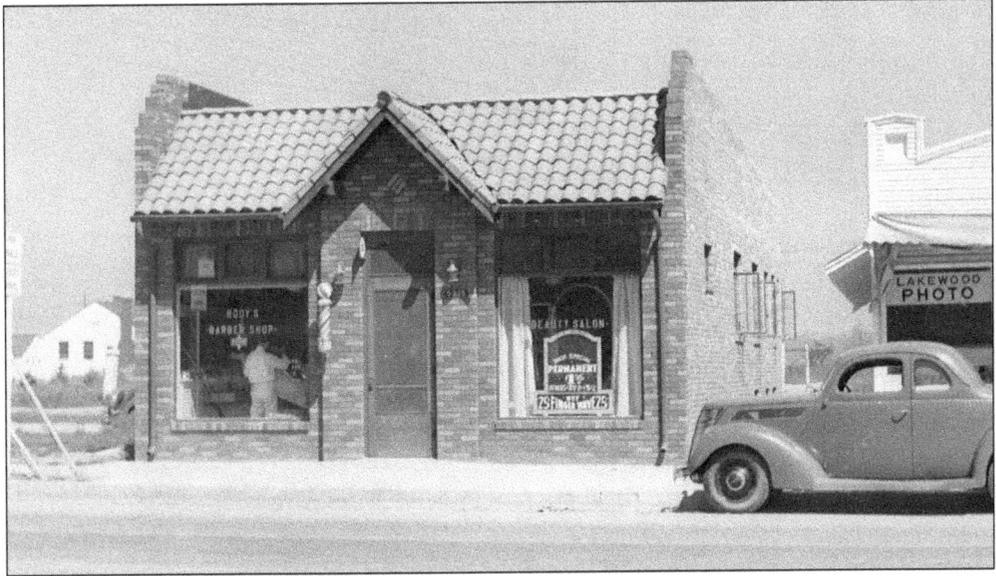

Rody's Barber and Beauty Salon opened during the 1930s and remained at 5229 West Colfax Avenue until 1943. At the time, the entrance to many beauty salons was at the rear of the barbershop and not visible from traffic passing by the front of the building. (Courtesy of Kenneth and Faye Milne.)

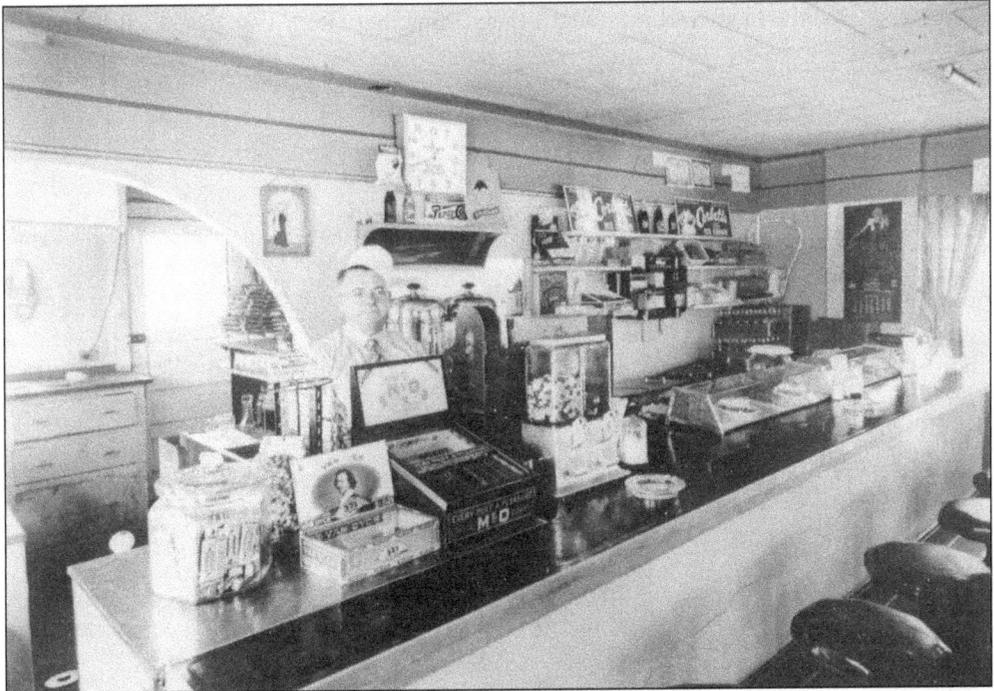

Jesse Duncan moved to the Mountair neighborhood from Texas in 1924. Once he established his barbecue restaurant, he became involved in local politics and was one of the leaders of Lakewood's first attempt at incorporation as a city in 1947. The restaurant Jess & Lil's was a favorite of the Colorado State Patrol, and a *Rocky Mountain News* cartoonist satirized the rib shack in a drawing by surrounding it with squad cars. (Courtesy of Lakewood's Heritage Center.)

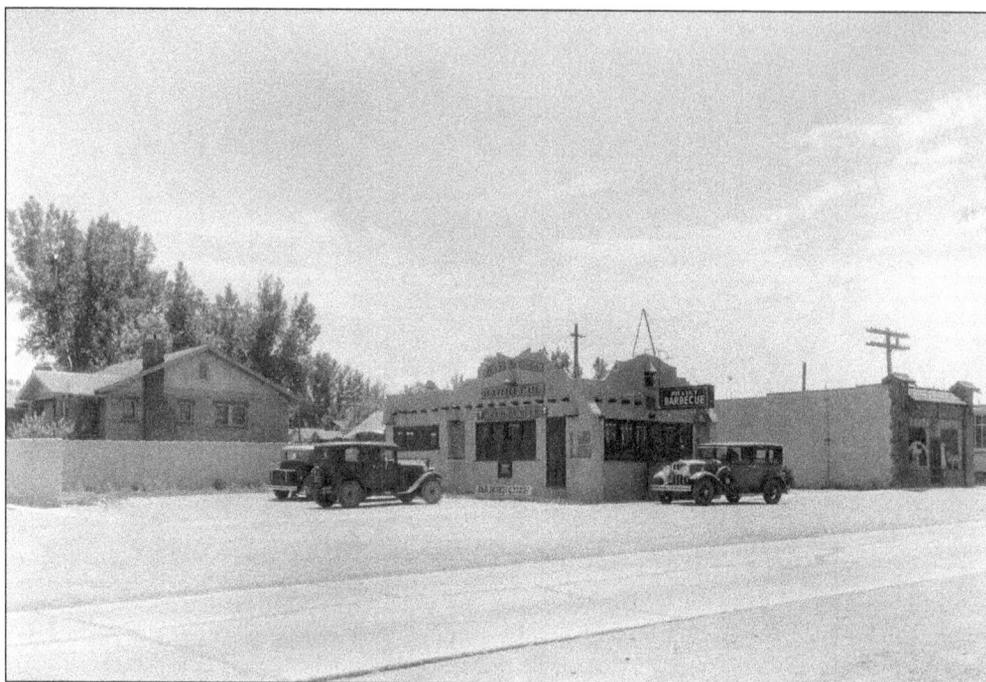

Parking was never a problem at Jess & Lil's, located at 5300 West Colfax Avenue. The barbecue restaurant shared the block with the West Colfax Farm Dairy from 1938 to 1945. (Courtesy of Lakewood's Heritage Center.)

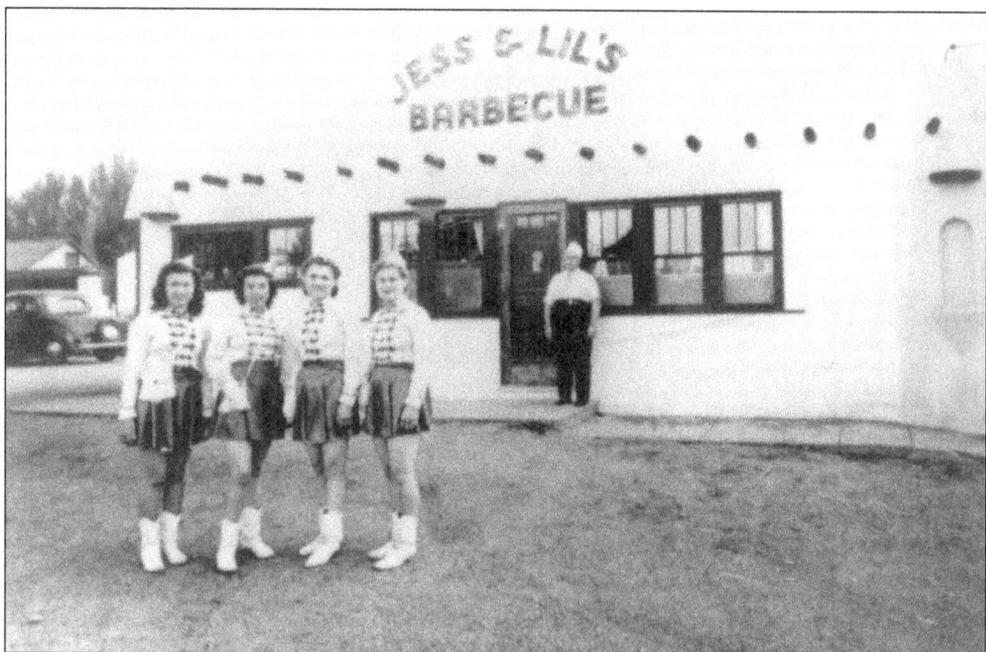

Carhops stand at attention in front of Jess & Lil's barbecue restaurant in the 1930s. Owner Jesse Duncan is in the background taking a break from his duties. Jess and Lil's served smoked meat in the Mountair neighborhood. It was located on Colfax Avenue between Ames and Benton Streets from the 1920s to the 1940s. (Courtesy of Lakewood's Heritage Center.)

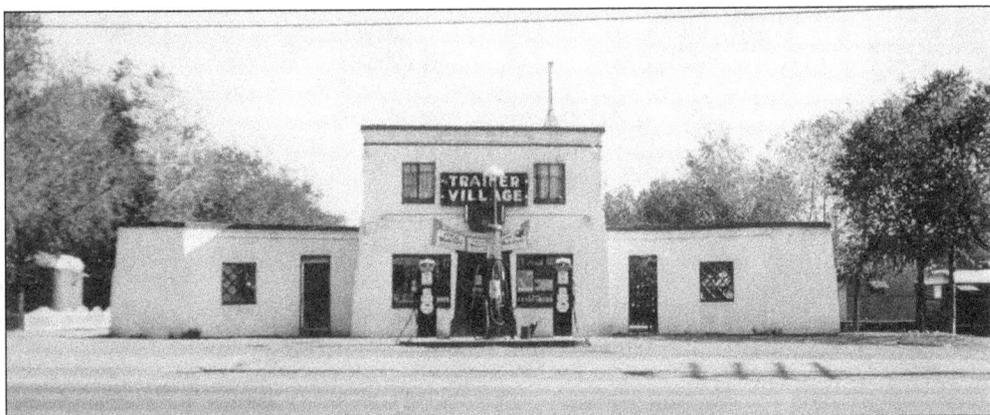

In the early 1930s, entrepreneur Jesse Duncan ran the Trailer Village at 5225 West Colfax Avenue. The business catered to Lakewood's residents in need of additional wheels in which to carry their possessions. Right on the dividing line between Denver and Lakewood, the building at 5225 West Colfax Avenue was built on land held by the Jonke family. The Eagle Café was later built on this site. (Courtesy of Lakewood's Heritage Center.)

The Jonkes were devout Catholics. Frances Jonke, seen here, entered a convent in Chicago in October 1923 after taking the name Sister Leolus. After Joseph Jonke died, daughter Josephine donated a portion of the family's estate to build Sts. Peter and Paul Catholic Church in the neighboring community of Wheat Ridge. After her death, Josephine left the titles to many business properties she owned along West Colfax Avenue to the church. (Courtesy of Kenneth and Faye Milne.)

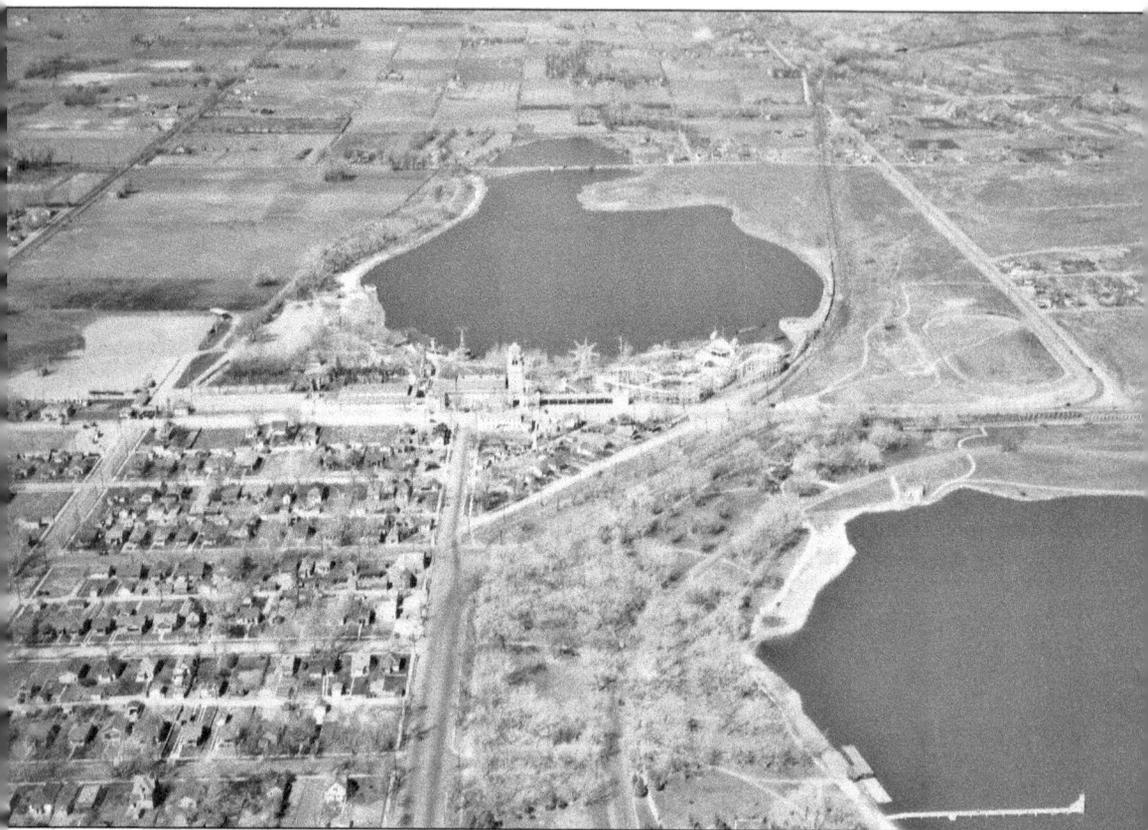

If other people came to Lakewood to vacation and take time off, where did Lakewood's residents go? There were local lakes and reservoirs where people could enjoy boating, swimming, and fishing. Both Alameda and West Colfax Avenues led to the Denver Mountain Parks system. In the 1890s, Manhattan Beach opened, located on Sloan's Lake in Edgewater. Manhattan Beach was composed of boat and amusement park rides and it also had a small menagerie that, for a short time, included an elephant. While Lakewood never had its own amusement park, Denver's Lakeside Amusement Park and Elitch Gardens were just north and east of Lakewood. For amusement, Lakewood children rode their ponies or drove pony carts to Elitch Gardens. Lakeside Amusement Park has carried away generations of children for a few hours of fun every summer since the 1890s. It is visible near the center in this 1931 aerial photograph. (Courtesy of the Arthur Lakes Library, Colorado School of Mines.)

Six

AN ARSENAL
IN THE FOOTHILLS

THE WAR COMES TO LAKEWOOD

World War II drastically changed the established political and social landscapes across the globe. The war also brought subtle shifts to people's livelihoods and their homes. One of those places was Lakewood, Colorado.

As early as 1937, the federal government considered the empty pastureland west of Denver a potential military and industrial location. That same year saw the completion of West Alameda Parkway from Denver through Lakewood into the foothills. In January 1941, anticipating an immediate entry into the global conflict, the US war department selected a portion of Hayden Ranch on Green Mountain as the site of a munitions manufacturing and testing facility.

The arrival of the Denver Ordnance Plant (DOP) is one of those hard-to-miss demarcations in the life of the community. Before the plant's arrival, dairies and orchards provided most Lakewood residents with an income. After December 7, 1941, the nation mobilized for battle. In Lakewood, West Sixth Avenue was transformed from a two-lane gravel road into a four-lane military highway. The demands of the military and industry brought workers to Lakewood, and many were from faraway places such as the Manhattan Project site in Tennessee. Both out-of-towners and local housewives worked to manufacture bullets, shells, and other instruments of war. In neighborhoods close to the DOP, like Daniels Gardens, renovated chicken coops became homes for war workers. The motels on West Colfax Avenue were always booked, and their motel registration ledgers carried the initials DOP after most renters' names. Rooms were never empty because the laborers, who were assigned to different time shifts at the plant, shared living quarters.

Like other places across the nation, most locals took pride in what they produced from their Victory Gardens. The war was the last hurrah for Lakewood's agricultural traditions. Soon after the war, the value of Lakewood's land was not in what it could produce but in its potential worth on the real estate market.

At the war's end in September 1945, the Denver Ordnance Plant cut its workforce and contracted less than 600 employees. This was only a temporary setback, as the presence of government agencies would expand the DOP in the years after the war. The war's impact on Lakewood meant that Washington had found a second home by the foot of the Rockies.

This memorial to the Works Progress Administration's (WPA) completion of the West Alameda Parkway in 1937 is currently located at the northwest corner of the intersection of West Alameda Avenue and Sheridan Boulevard. The federal works program built West Alameda Parkway as a direct route to Red Rocks Amphitheater. The project was initially the dream of George Cramner, who was chief of the Denver Improvements and Parks Department. He had hoped that the 200-foot-wide West Alameda Parkway would become Colorado's grandest roadway. (Courtesy of Lakewood's Heritage Center.)

Like the rest of the nation, the Great Depression hit Lakewood in the early 1930s. However, families like the Eibers still had much to celebrate. George and Lillian Eiber moved to Lakewood in 1920. George Eiber was a photo-engraver for the *Denver Post* and began a poultry business in 1943. Christmas meant a good deal to the Eibers, and on each holiday, they handed out cornucopias to students at the Daniels School in west Lakewood. (Courtesy of Lakewood's Heritage Center.)

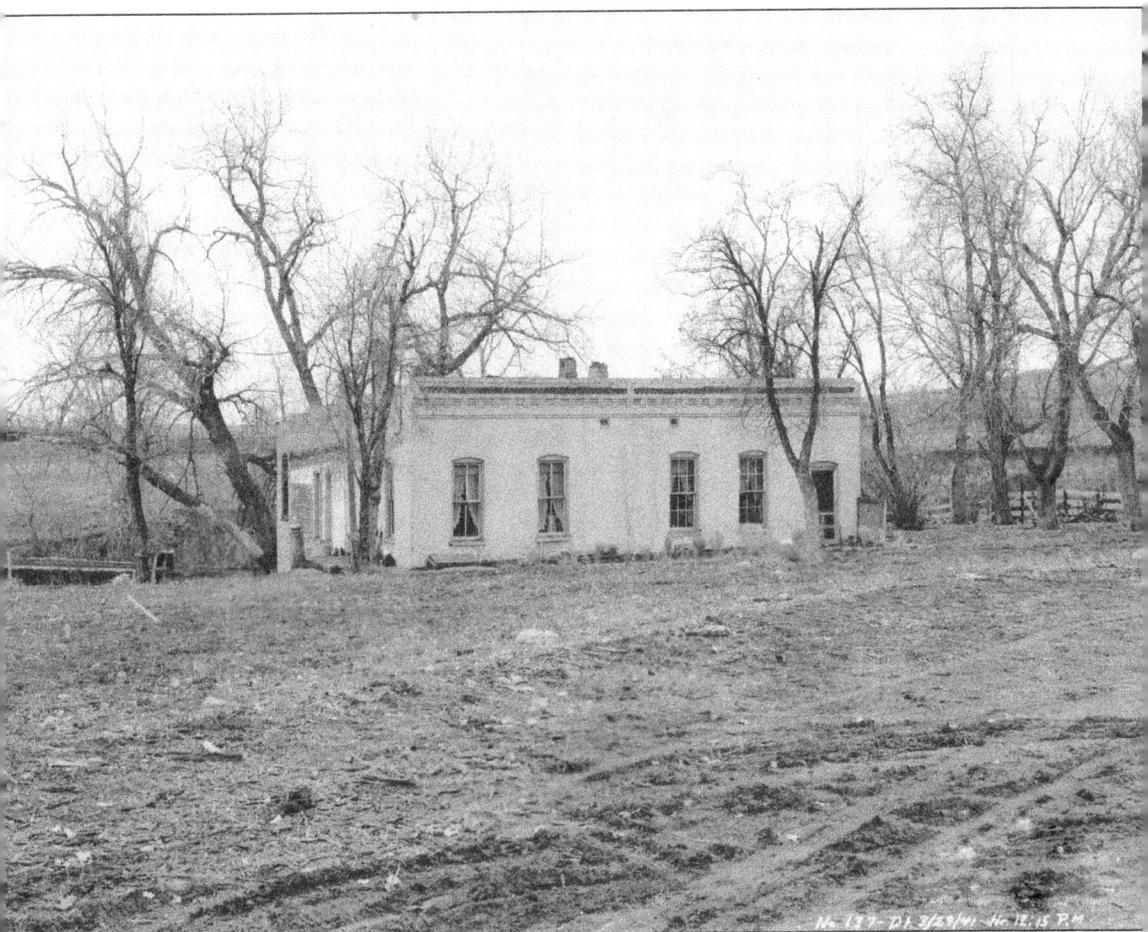

Maj. Jacob Downing's 2,000-acre farm on Green Mountain included a racetrack, a summer house, and various ranch buildings. In 1891, Downing announced his plans to build a town outside of Lakewood on Green Mountain. According to the March 9, 1891, issue of the *Denver Republican*, Downing's town would include "religious edifices, school and public halls." Downing is credited with introducing alfalfa to Colorado after obtaining seed during a visit to Mexico. He later grew 500 to 700 acres of alfalfa on Green Mountain. Downing's summer house burned after his death in 1907. There is no record of what purpose the building seen above served. The federal government purchased Downing's acreage from the Hayden family in 1941 and built the Denver Ordnance Plant in its place. (Courtesy of the National Archives and Record Administration, Rocky Mountain Region.)

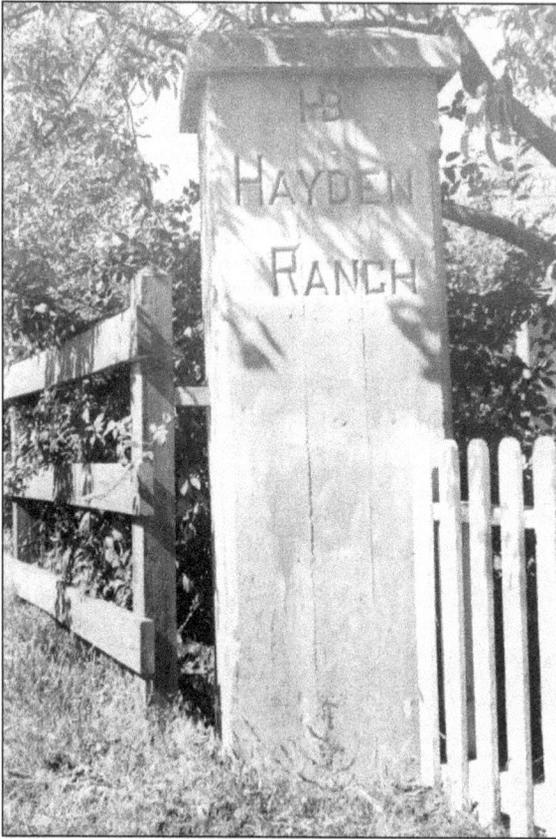

In 1875, Thomas and Flora Hayden purchased property across Denver and Lakewood. A year after he died, Thomas's realty company purchased 1,600 acres of Lakewood grazing land owned by the heirs of Jacob Downing. This transaction developed into the Hayden Ranch. One of the Haydens' sons, William, expanded the property to 6,300 acres during the 1920s. This Hayden Ranch gatepost still stands at West Fourth Avenue and Garrison Street. (Courtesy of Lakewood's Heritage Center.)

Lakewood farmers stubbornly hung on to the established ways of living during the war years. George and Lillian Eiber started a poultry business at 11555 West Seventeenth Avenue in 1943. In the image below, their son Gary is surrounded by a flock of turkeys. The Eibers, the Petersons, and other farm families briefly fostered a local turkey industry during the mid-20th century. (Courtesy of Lakewood's Heritage Center.)

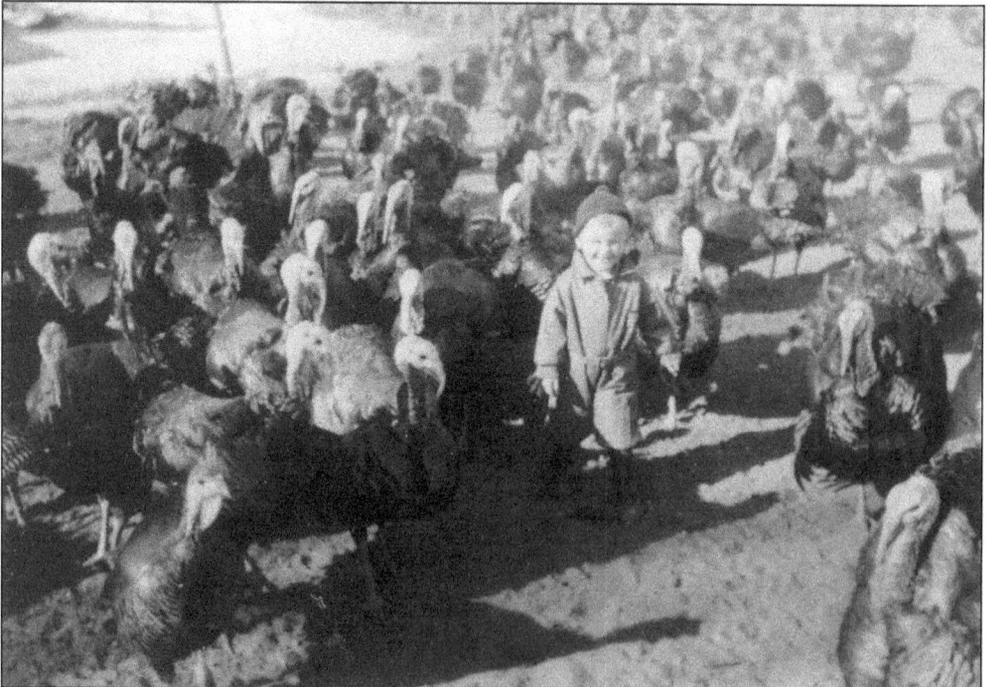

In early 1941, the federal government paid $181,077 for 1,422 acres of the Hayden Ranch on Green Mountain. At $122.2 million, the Denver Ordnance Plant was the largest contract ever awarded by a federal agency in Colorado up until that time. The government contracted with Remington Arms Company to operate the new plant that same year. These images capture the ranch just as the bulldozers, cranes, and trucks changed the landscape. The successor to the Denver Ordnance Plant, the Denver Federal Center, occupies 600 acres and is the largest compound of federal agencies outside Washington, DC, with more than 8,000 employees. Many of the agencies at the Denver Federal Center deal with the administration of Western lands and issues and include the US Geological Survey, the Bureau of Land Management, and the Bureau of Reclamation. (Both courtesy of the National Archives and Record Administration, Rocky Mountain Region.)

Three years after William Hayden's death in 1937, the war department began its acquisition of the Hayden Ranch. It eventually acquired 2,100 acres for construction of the Denver Ordnance Plant. The ranch's transition from grazing pasture to a munitions plant began in May 1941. By October of that year, phase one was complete, and the plant began production shortly thereafter. Construction was five months ahead of schedule and was finished only two months before the United States entered the conflict against Nazi Germany and Imperial Japan. (Courtesy of the National Archives and Record Administration, Rocky Mountain Region.)

The McIntire Ditch crossed the old Downing property. The ditch was established in the late 19th century, and many of Lakewood's most notable homesteaders were part of McIntire Ditch's initial construction and continued success. In 2010, open segments of the ditch remained visible across the Denver Federal Center. (Courtesy of the National Archives and Record Administration, Rocky Mountain Region.)

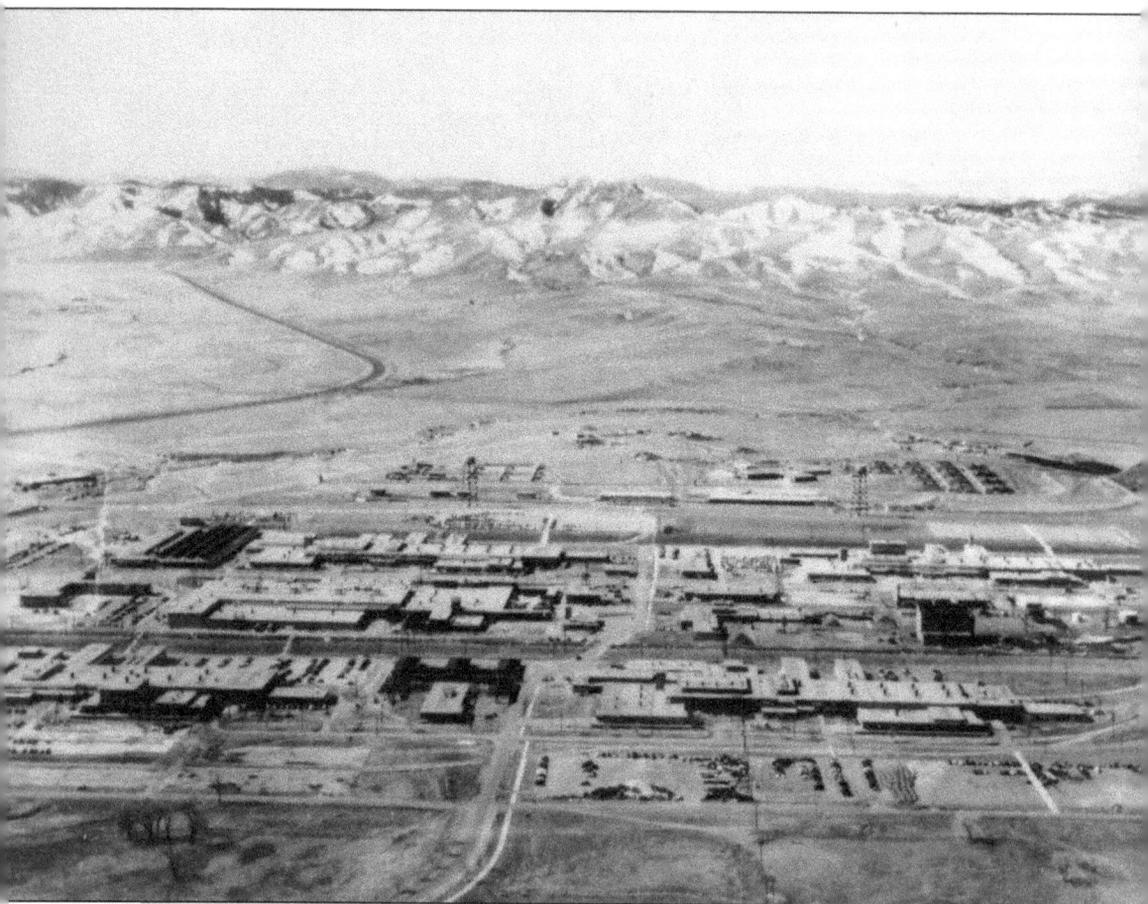

This aerial view of the Denver Ordnance Plant from the war years shows the immediate impact the plant had on Lakewood. The plant's main contractors during the war were Remington Arms Co., Kaiser Industries, Inc., and General Foods Corp. Within the complex were approximately 40 miles of road and 15 miles of high, woven fences topped with barbed wire. At night, tracers from the firing range along the plant's west side lit up the surrounding darkness. (Courtesy of Lakewood's Heritage Center.)

By the early 1940s, the vicinity of West Sixth Avenue and Wadsworth Boulevard was still rolling prairie. Visible to the left is one of the sand traps of the golf course at the Lakewood Country Club. Federal and state transportation agencies "fast tracked" the expansion of West Sixth Avenue in order to quickly carry workers to the Denver Ordnance Plant. (Courtesy of the Colorado Department of Transportation.)

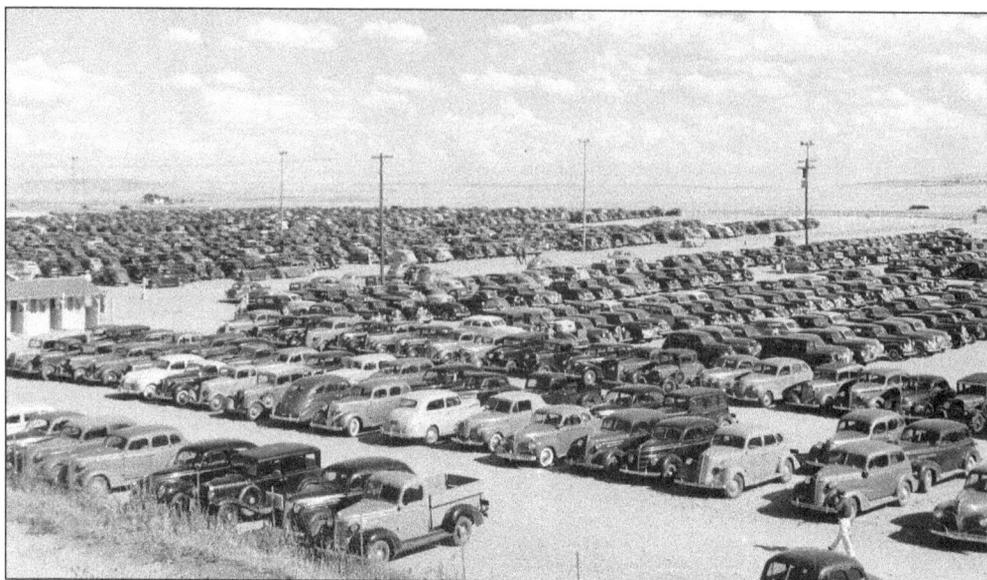

The partnership between the federal government and private industry led to an improvement in roads throughout Lakewood that led to the DOP. Prior to the war, WPA workers completed the West Alameda Parkway through Lakewood. During the war's early years, the federal government funded the widening of West Sixth Avenue from two to four lanes. (Courtesy of the National Archives and Record Administration, Rocky Mountain Region.)

A group of workers line up before their shift begins at the Denver Ordnance Plant (DOP). The plant ran three shifts per day, every day from 1942 to 1945. By 1943, the plant employed 20,000 men and women. The starting pay at Remington Arms was $4.50 per day. The graveyard shift was from 12 a.m. to 8 a.m., and the DOP paid $2 more to those on that shift. (Courtesy of the National Archives and Record Administration, Rocky Mountain Region.)

Lakewood had a long tradition of its men going to war. A memorial to Spanish-American War veterans is located in a special section of Crown Hill Cemetery. The 480-acre cemetery has a trail that leads to Golden and Central City. (Courtesy of Lakewood's Heritage Center.)

When the United States entered World War I, JCRS's executive board held a dinner to honor Dr. Philip Hillkowitz, seated in the center. Hillkowitz resigned in 1918 from JCRS to serve as a physician in the US Army in World War I. Hillkowitz served as JCRS's president for most of the years between 1904 and his death in 1948. (Courtesy of the Rocky Mountain Jewish Historical Society.)

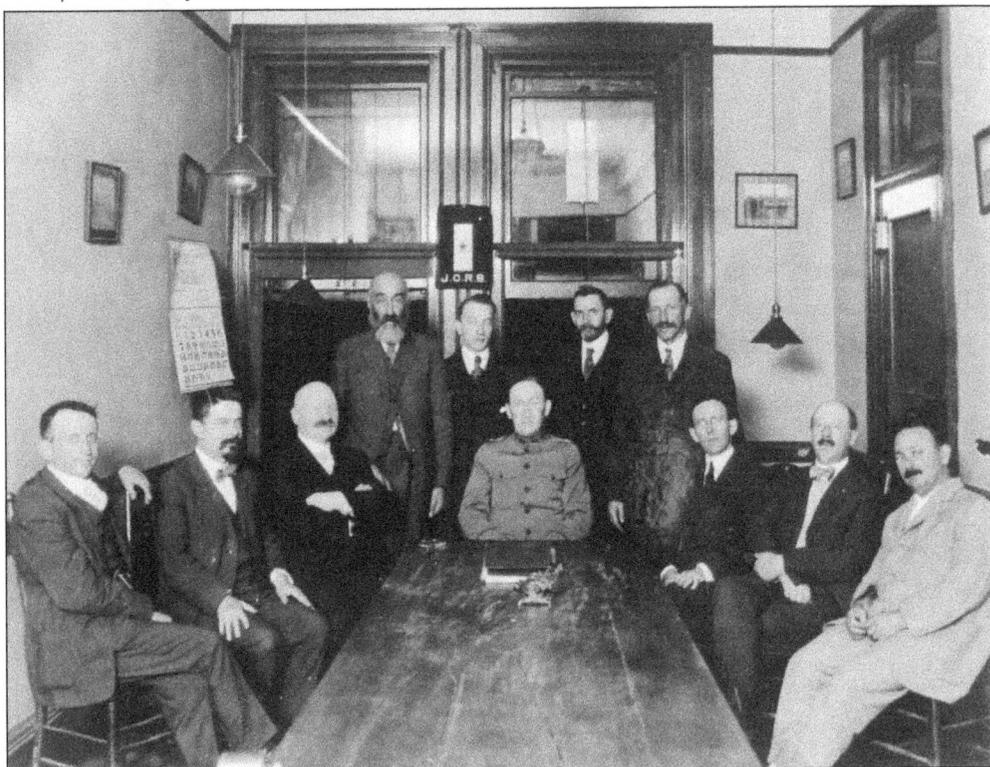

On May 8, 1945, Pres. Harry S. Truman told the nation, "Our victory is but half won." The federal government made the following appeal to potential employees in the *East Jefferson Sentinel* of May 10, 1945: "Right now production schedules are running far behind army and navy demands. There must be no let-up!" (Both courtesy of the *East Jefferson Sentinel*.)

Because of the flammable and dangerous aspects of wartime munitions production, the DOP had its own fire department. In 1947, a fire raged through Building 41, destroying a furniture warehouse. Beyond the DOP gates, Lakewood residents received their fire protection through the Lakewood-Mountair Fire Department. The DOP firefighters joined in the attempt to contain a pre-Christmas blaze at the Lakewood Country Club in 1948. The pressure at the only nearby water hydrant was low, forcing DOP, Denver, Lakewood-Mountair, and Wheat Ridge firefighters to string 3,000 feet of hose to the scene from Wadsworth Boulevard. The fire burned for 12 hours and destroyed the country club at a cost of $250,000. (Courtesy of the National Archives and Record Administration, Rocky Mountain Region.)

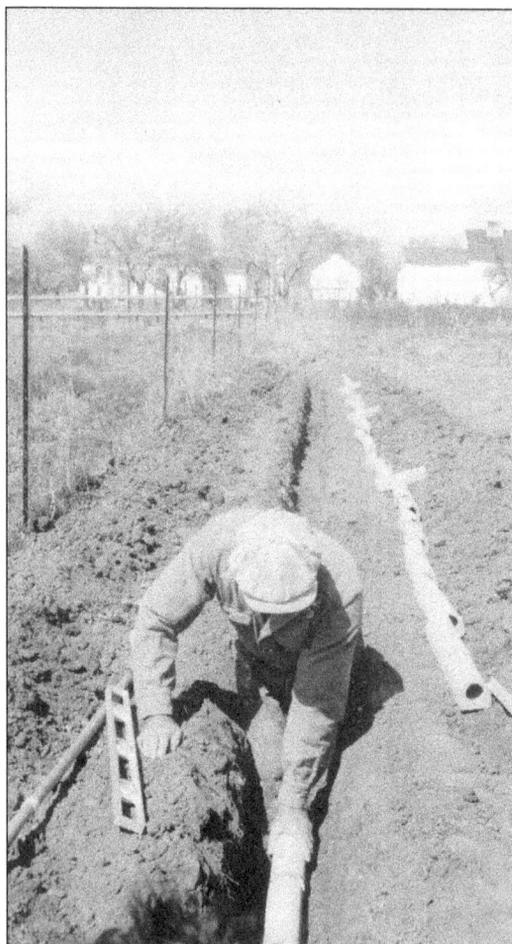

During the cold winter of 1942, Donald Rittenhouse would come home each night from his job as an engineer with the local telephone company, eat his dinner, then go down to the basement and fill a mold with cement to form one-foot sections of irrigation pipe. When spring came, Rittenhouse spent his vacation digging narrow furrows and depositing the pipe he crafted over the winter into them. The seepage method of irrigation brought bumper crops that year. (Courtesy of Donald and D. Arter Rittenhouse.)

Victory Gardens, or War Gardens were just a new name for an old way of survival for most Lakewood families. The Rittenhouse family examines the 1942 crop in the backyard of their house near Wadsworth Boulevard and Sixteenth Avenue. (Courtesy of Donald and D. Arter Rittenhouse.)

Don't Relax...

Until The Job Is Finished

When the corn is tall you can take it easy. But in the meantime, it's good to know that what you're doing is really helping the war effort. Your Victory Garden saves farm labor, containers, shipping space and those precious ration points. NOW is the time to plant.

Golden Council of Defense

Many families, like the Rittenhouses, were two steps ahead of the Golden Council of Defense when it came to management of Victory Gardens. The council of defense oversaw efforts toward winning the war in the home fronts of Golden and Lakewood. (*East Jefferson Sentinel*, May 3, 1945.)

The simple things in life took on greater meaning during the war. The Rittenhouse family celebrated Mother's Day with tulips on May 10, 1942. Florence Rittenhouse is flanked by her two sons, Art (left) and Bob (right). (Courtesy of Donald and D. Arter Rittenhouse.)

Members of the sixth-grade class of the Daniels School show off the puppets they made for a 1944 school Christmas pageant. "The youngest thespians put on a bang-up show," the *East Jefferson Sentinel* reported. Each child made and dressed his or her own puppet. Puppets were crafted from sawdust, then were modeled into characters. The school invited students from the Bear Creek School in Lakewood's south end to come and watch the show. The Daniels School opened in 1937. During the school's construction, classes were held in a chicken house, which made lessons a challenge. One student recalled, "We was [sic] in the lower half and the damned chickens was upstairs runnin' all over the place." (Courtesy of Lakewood's Heritage Center.)

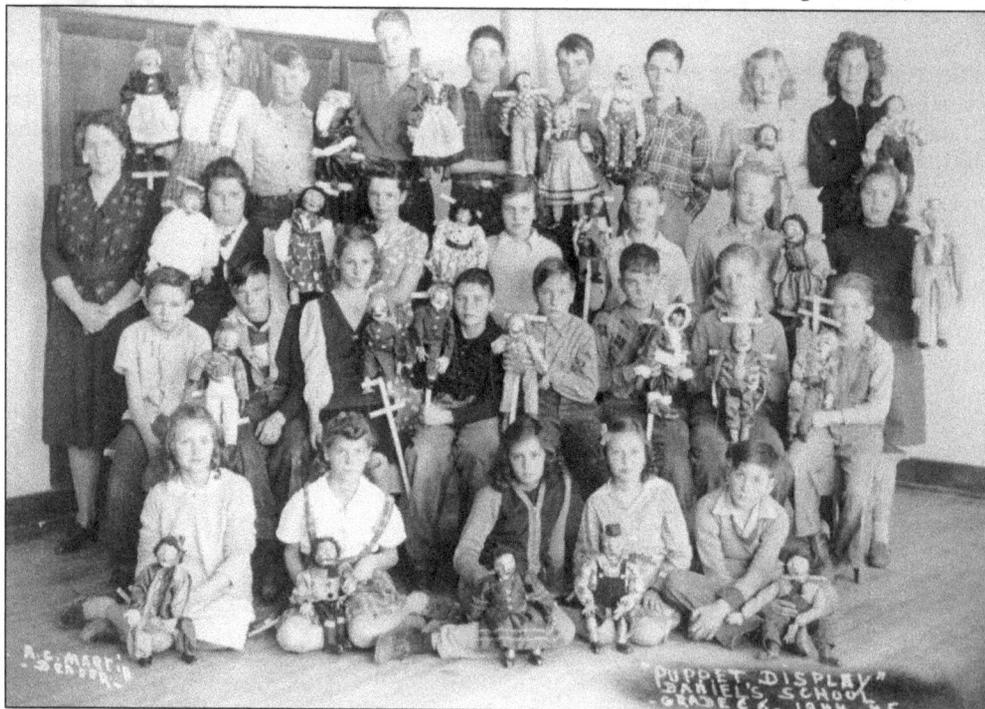

DANCE

That Others May Walk

Sponsored
By
Jefferson
County
Chapter of
The
National
Foundation
for
Infantile
Paralysis

Invest in
The Future
of
America
By
Helping
Some
Boy or Girl
Walk
Again

HOLLYWOOD
BARN

FRIDAY, FEB. 2

Howard Hosick and His Orchestra

9:00 to 12:30 Adm. $1.10 Per Couple

The Hollywood Barn dance hall on Morrison Road gave DOP workers, members of the armed forces, and other residents a chance to blow off some steam during the frantic war years. The barn, part of the Hall Dairy Farm, had room for 130 cows. During the war years, the dance hall brought in more revenue for the county than any other venue. A 1948 fire destroyed the site. (Courtesy of the *East Jefferson Sentinel*.)

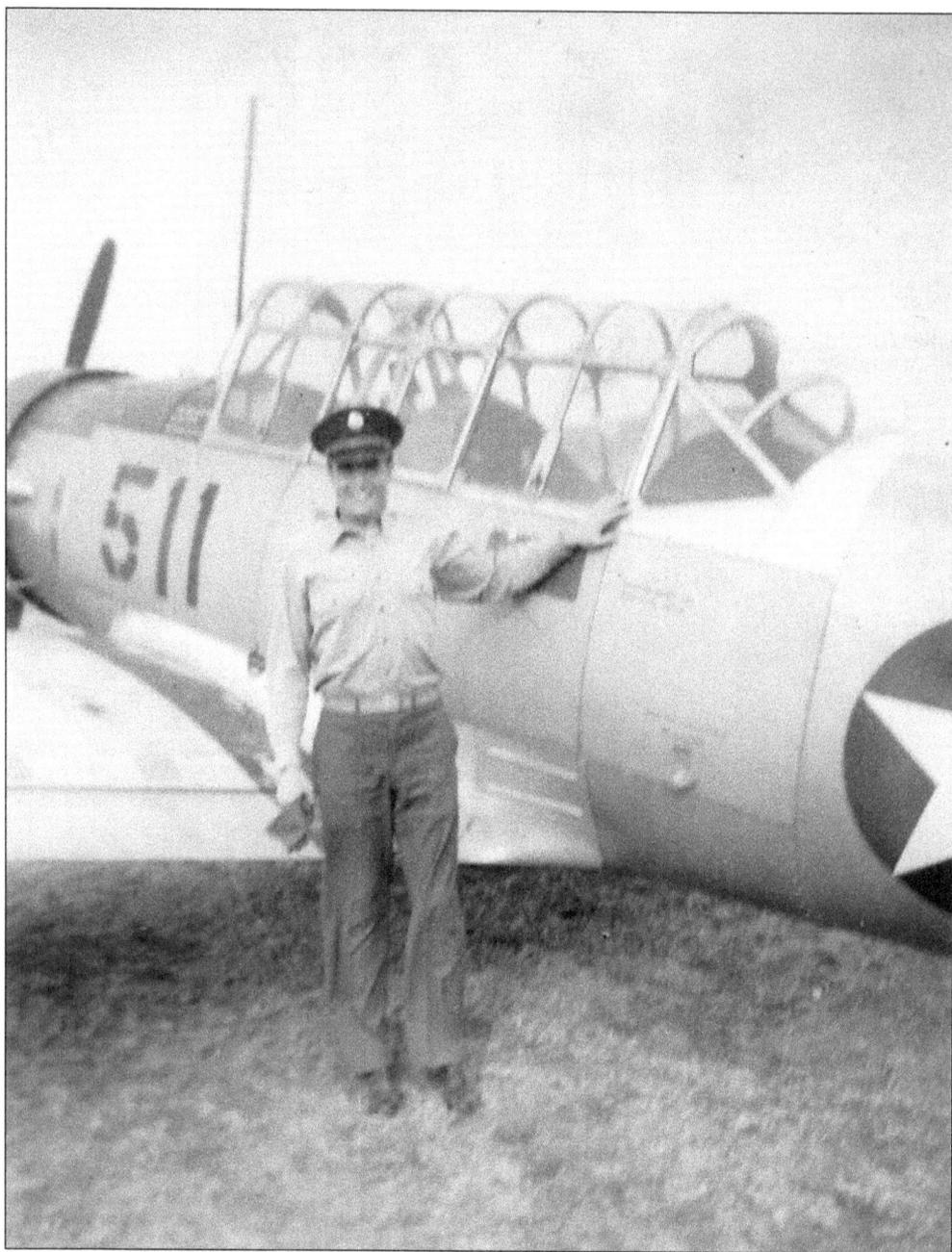

Barney O'Kane flew gliders over the Gulf of Mexico while he was in the US Army Air Corps during World War II. In the late 1950s, as Jefferson County's district attorney, he prohibited bingo and the use of pinball machines in the county's bars and clubs. His actions made him the enemy of the American Legion, the Jefferson County Republican Party, and owners of the county's bars and nightspots. (Courtesy of the O'Kane family.)

Navy Seabee William S. Bruce came back to Lakewood on leave in January 1945 and enjoyed his first furlough in 31 months. Bruce served in the South Pacific. Before joining the Navy, he worked at Safeway's warehouse in Denver. (Courtesy of Lakewood's Heritage Center.)

Earl Duston served in the Navy's medical corps as the chief pharmacist's mate. He graduated from Lakewood Highway School in 1939 and enlisted three years later. Duston spent two years in the South Pacific where he served in liberating the Philippines. His care for casualties at the Battle of Leyte earned him the Navy Citation for Service. Duston also served eight months in Europe. (Courtesy of Lakewood's Heritage Center.)

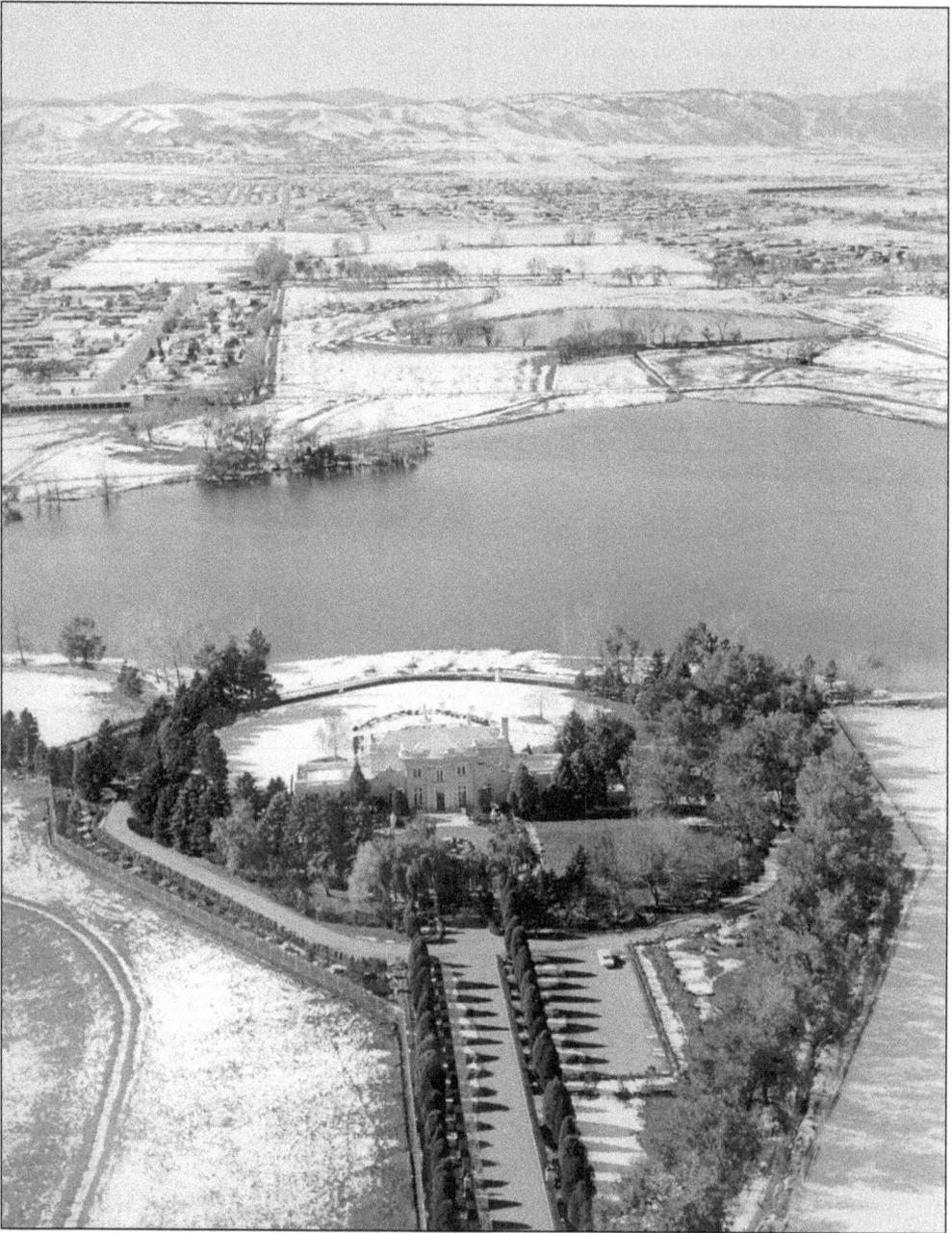

May Bonfils owned the Belmar estate by the man-made Kountze Lake. Known as Lakewood's most notorious millionaire, Bonfils also generously served as nurse for the Red Cross during the war years. After her death, the estate opened briefly to the public in 1970 and was demolished shortly thereafter. An office park currently occupies the site. (Courtesy of Lakewood's Heritage Center.)

HELP WANTED

Full or Part Time

Felix Drive Inn

7000 W. Colfax Ave.

ALE OR FEMALE. 21 YEARS TO 65 YEARS OF AGE.

NO EXPERIENCE NECESSARY — WE TEACH YOU.

OKS—If you can cook at home you can cook here.
AITRESSES—If you can serve your family you can serve here.
ARTENDERS—Elderly men wanted. We teach you.

These Jobs Will Be Yours After the War Is Over —
If Your Work Is Satisfactory.

PLEASANT SURROUNDINGS — PLEASANT WORK

SEE MR. MURRAY — After 4:30 p. m.
or Call Lakewood 510

According to the February 1, 1945, issue of the *East Jefferson Sentinel*, not all help wanted advertisements in the local papers during the war called for swing shift jobs at the DOP. Lakewood also needed carhops and short order cooks. The promise of jobs after the war was only a small bonus for those surviving the conflict. It was assumed that women would quit their jobs and return to housework, while returning servicemen expected to go back to work in factories and offices. Lakewood, like the rest of metropolitan Denver, faced a housing shortage in the years immediately after the war. In the 1950s, Lakewood turned away from agriculture and toward subdivisions and planned neighborhoods. At the war's close, Lakewood seriously considered its own community identity for the first time. (Courtesy of the *East Jefferson Sentinel*.)

BIBLIOGRAPHY

Anderson, James R., *West Colfax Avenue in Jefferson County and Lakewood, Colorado.* 1994.
Arvada Enterprise, 1909–1910.
Denver Post, 1870–1946.
East Jefferson Sentinel, 1938–1945.
Jefferson County Republican, 1923–1949.
Margolies, John, *Home Away from Home: Motels in America.* Boston, MA: Little, Brown and Company, 1994.
National Archives and Records Administration, Record Group 121, Boxes 6 and 13.
Rocky Mountain News.
Wilcox, Patricia K. *Lakewood-Colorado: An Illustrated Biography.* Lakewood, CO: Lakewood 25th Birthday Commission, 1994.
Wilcox, Patricia K. *76 Centennial Stories of Lakewood, Colorado.* Lakewood, CO: The Lakewood Centennial-Bicentennial Commission, 1976.

INDEX

Visit us at
arcadiapublishing.com

www.ingramcontent.com/pod-product-compliance
Lightning Source LLC
Chambersburg PA
CBHW080623110426

42813CB00006B/1589